MW00784372

THE BIRTH OF A REPUBLIC

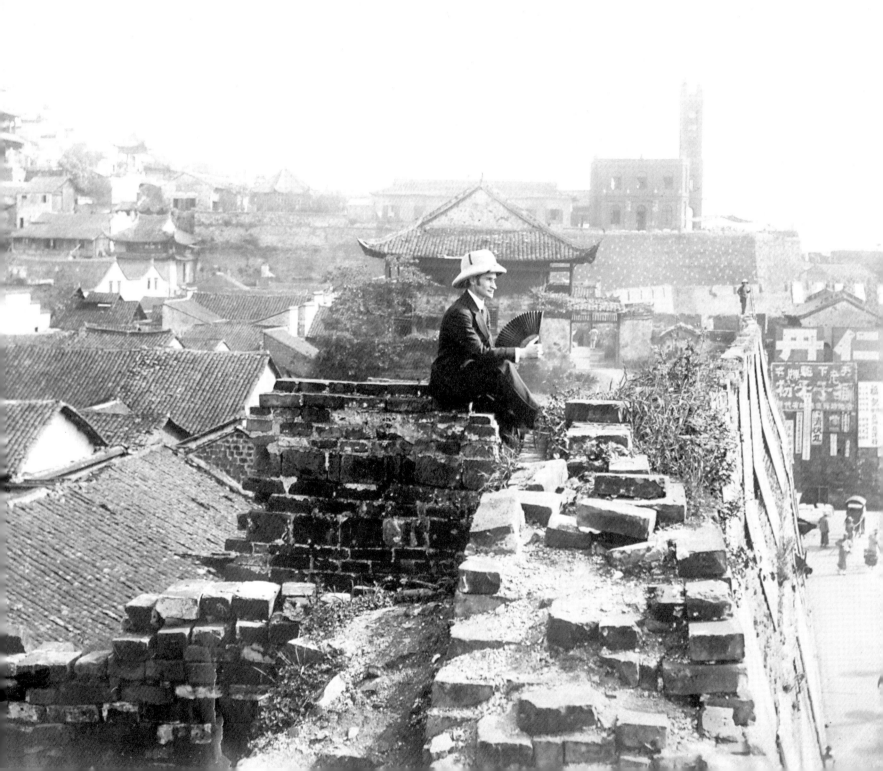

Hanchao Lu

THE BIRTH OF A REPUBLIC

Francis Stafford's Photographs of China's 1911 Revolution and Beyond

A CHINA PROGRAM BOOK

University of Washington Press
Seattle & London

This book was supported in part by the CHINA STUDIES PROGRAM, a division of the Henry M. Jackson School of International Studies at the University of Washington.

© 2010 by the University of Washington Press
Printed in the United States of America
Design by Thomas Eykemans
14 12 11 10 5 4 3 2 1

All rights reserved. No part of this publication may be reproduced or transmitted in any form or by any means, electronic or mechanical, including photocopy, recording, or any information storage or retrieval system, without permission in writing from the publisher.

UNIVERSITY OF WASHINGTON PRESS
PO Box 50096, Seattle, WA 98145 USA
www.washington.edu/uwpress

FRONTISPIECE Francis Stafford sits atop the city wall of Wutang.

LIBRARY OF CONGRESS CATALOGING-IN-PUBLICATION DATA
Stafford, Francis E., 1884–1938.
The birth of a republic : Francis Stafford's photographs of China's 1911 revolution and beyond / [edited by] Hanchao Lu.
 p. cm. — (A China program book)
Includes bibliographical references and index.
ISBN 978-0-295-98940-2 (hbk. : alk. paper)
1. China—History—Revolution, 1911–1912—Pictorial works.
2. China—History—Revolution, 1911–1912—Social aspects—Pictorial works. 3. China—Social life and customs—20th century—Pictorial works. 4. Wuchang Qu (Wuhan Shi, China)—History—20th century—Pictorial works. 5. Shanghai (China)—History—20th century—Pictorial works. 6. China—History, Local—Pictorial works. 7. Stafford, Francis E., 1884–1938—Travel—China. I. Lu, Hanchao. II. Title.
DS773.42.S73 2009 951'.036—dc22 2009033822

The paper used in this publication meets the minimum requirements of American National Standard for Information Sciences—Permanence of Paper for Printed Library Materials, ANSI z39.48-1984. ∞

Dedicated to Frances Eleanor Stafford Anderson

The Francis E. Stafford collection of photographs is held
by Stafford's grandson, Ronald E. Anderson,
who has generously provided a selection for use in this volume.

Contents

Acknowledgments

THIS BOOK WOULD not have been possible without the generosity of Ronald E. Anderson, who inherited the photographic collection of his grandfather, Francis E. Stafford, and digitized it before the technology became common. Ron and I first met in Singapore in 2001 and we started the project soon afterwards. I thank him for his thoughtfulness, patience, and goodwill during the lengthy process of making this book. I would also like to thank my brother, Hanlong, and his collaborator, Yanjie Bian, for introducing me to Ron.

For the research regarding the photographs, I obtained generous help from scholars and specialists at the Shanghai Museum, the Shanghai History Museum, and the Institute of History of the Shanghai Academy of Social Sciences, and I would like to express my gratitude to colleagues at these institutions: Xiong Yuezhi, Pan Junxiang, Qian Zonghao, Fu Weiqun, Hu Baofang, Gu Borong, and Qiu Zhengping. John Israel of the University of Virginia offered useful comments on the manuscript when we were "academic buddies" in Shanghai in the summer of 2008.

Special thanks to Ronald H. Bayor, who has consistently supported my research for well over a decade and, in particular,

as chair of the School of History, Technology, and Society at Georgia Tech, fulfilled my "wish list" for funding for this project. I would also like to thank Steven Henderson for his assistance with technical issues, often tackled in his off-duty hours.

At the University of Washington Press, Lorri Hagman was a constant source of help and inspiration. I am particularly grateful to her for securing two anonymous referees for the manuscript; their comments and criticism forced me to rethink, rewrite, and ultimately transform this book beyond a coffee table exhibit. I thank Marilyn Trueblood and Tom Eykemans for making the production process a pleasant and cooperative enterprise. Richard Gunde, who has helped me with virtually all my work since I was a graduate student, copyedited the manuscript and immensely improved it. I would like to thank the University of Washington's China Studies Program in the Henry M. Jackson School of International Studies for additional funding for this project.

This slender book has taken much longer to craft than I had expected, although that is not uncommon in today's world of academic publishing. A positive note is that during its prepara-

tion, as my children grew up they also grew helpful. Much to my pride, and sometimes embarrassment, Frederic was able to suggest better wording and Jeffrey became my computer guru at home. I thank Linlin for her love and support, especially at times when life can be stressful or mundane.

Finally, Frances Eleanor Stafford Anderson, Francis Stafford's daughter born in Shanghai in the wake of the revolution, carefully kept her father's photograph collection for well over half a century. Without her vision and care, a piece of Chinese history might have been lost. It is in admiration of her and in her honor that this book is dedicated.

THE BIRTH OF A REPUBLIC

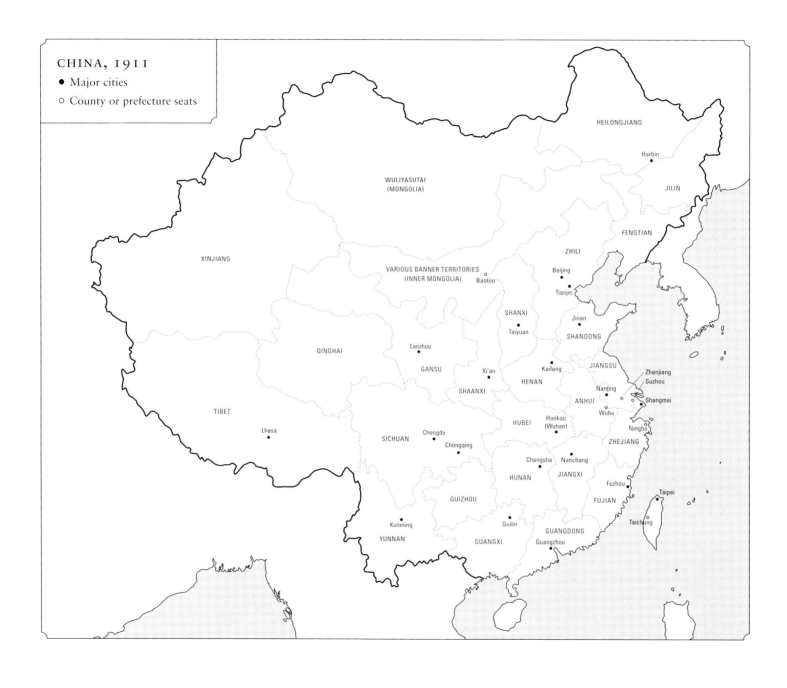

CHINA, 1911

● Major cities

○ County or prefecture seats

HEILONGJIANG

Harbin

WULIYASUTAI
(MONGOLIA)

JILIN

FENGTIAN

XINJIANG

ZHILI

VARIOUS BANNER TERRITORIES
(INNER MONGOLIA)

Baotou

Beijing

Tianjin

SHANXI

Jinan

Taiyuan

SHANDONG

QINGHAI

Lanzhou

GANSU

Kaifeng

JIANGSU

Zhenjiang
Suzhou

Xi'an

HENAN

Nanjing

Shangmai

SHAANXI

ANHUI

Wuhu

TIBET

Hankou
(Wuhan)

Ningbo

Lhasa

HUBEI

ZHEJIANG

SICHUAN

Chengdu

Chongqing

Changsha

Nanchang

Fuzhou

Taipei

HUNAN

JIANGXI

FUJIAN

GUIZHOU

Taichung

Kunming

Guilin

GUANGDONG

YUNNAN

GUANGXI

Guangzhou

Introduction

FEW REVOLUTIONS IN WORLD HISTORY were more dramatic and paradoxical than the 1911 Revolution of China, also known as the Nationalist or Republican Revolution. The specific chain of events that led to the revolution was set in motion by an accidental bomb explosion in the city of Hankou in central China late in the afternoon of October 9, 1911. By the next day a full-fledged uprising in the adjacent city of Wuchang had broken out, and before long it engulfed the rest of the country. In less than three months, the 267-year-old Manchu Qing dynasty was overthrown and the Republic of China was born. Most significantly, China's 2,000-year-old imperial system came to an end. Despite several farcical episodes of attempted restoration after the revolution, the monarchy in China was gone forever; and despite its feebleness, the Republic of China entered into history as Asia's first republic. In that regard, the 1911 Revolution was truly epoch-making.

The blast in Wuchang was fortuitous; the revolution was not. The downfall of the Qing dynasty was the outcome of decades of political and social crises. Since China's defeat by the British in the Opium War of 1839–42, the country had suffered a series of foreign encroachments and domestic uprisings. As a result, the ruling Manchu court, which had come across the Great Wall from Manchuria and established the Qing empire in 1644, found it increasingly difficult to maintain its grip on power. By the end of the nineteenth century, the Manchu dynasty had slipped into a terminal crisis. A series of anti-Christian peasant riots that began in rural Shandong province, through bizarre twists and turns—some of which were orchestrated by Chinese officials, including the Empress Dowager Cixi (1835–1908)— developed into a xenophobic movement, known as the Boxer Rebellion, that swept across north China. After much carnage, the Boxers were crushed by an allied force consisting of troops of eight nations. The allied troops occupied Beijing in 1900 and the Qing court fled to the ancient capital of Xi'an, about 750 miles to the southwest. To end the Boxer calamity, China signed a twelve-clause protocol with eleven foreign powers on September 7, 1901, allowing each power to maintain a permanent military guard in the foreign legation quarters in Beijing and establishing a foreign-controlled corridor from Beijing to the seaside fort of Shanhaiguan. It agreed as well to pay an indem-

nity of 450 million taels ($333 million), an amount equal to nearly twice the annual income of the Qing government.

By this time many Chinese had come to believe that major political reforms were imperative if the country was going to avoid being carved up by the foreign powers. The Qing court, headed by the aging Empress Dowager, who had been suspicious of previous reforms, launched a major reform movement, called the "New Policies" or "New Polity" (Xinzheng), aiming at extricating the court from its protracted crisis of legitimacy and saving the dynasty. The New Policies Reform put into action programs and ideas that had been proclaimed during the ill-fated Hundred Days' Reform of 1898 in which Emperor Guangxu (1871–1908) issued over forty edicts in support of broad changes in the country's political, economic, and educational institutions. That reform, however, ended abruptly with a court coup d'état and the house arrest of the emperor, staged by the Empress Dowager, who saw the reform as a threat to her power. Nonetheless, in the aftermath of the Boxer fiasco, the Qing court recognized that major reforms were inevitable. The New Policies did much more than revitalize the 1898 reform; they introduced new ideas and implemented sweeping changes that, to the consternation of the Qing rulers, undermined the already precarious foundation of the monarchy. Historian Douglas R. Reynolds has called the New Policies a "revolution." Whether or not the reform amounted to a revolution is arguable, but there is no doubt that, completely unintended, it helped pave the way for the 1911 Revolution and several crucial government policies in the early Republican period.

In 1905, as part of the New Policies Reform, the Qing government took the bold step of abolishing the civil service examination system in favor of a new school system based on Western educational standards and, more directly, on Japanese models. Historian R. Keith Schoppa has called this "the most revolutionary act of the twentieth century,"[1] as the civil service examination system had been a keystone of China's Confucian order for at least thirteen centuries. The next year, the court sent two missions led by five senior leaders abroad to observe political systems in Japan and the West and, in particular, to learn more about the model of constitutional monarchy. Suddenly, in this ancient empire, constitutionalism and self-government became the slogan of the day. Local assemblies and self-governing bodies were set up nationwide. All provinces, except for Xinjiang, established provincial-level assemblies in 1909, and a proto-national parliament was convened in the capital in October 1910, just a year before the revolution. The establishment of local assemblies as an apparatus for constitutional self-government soon proved to be momentous. In the months immediately after the Wuchang uprising, when the political situation was murky and the fate of the ruling court uncertain, many provincial assemblies declared independence from Beijing and thus played an important role in the final downfall of the Qing.

Two institutions that developed under the New Policies Reform had direct links to the outbreak of the Wuchang uprising: the New Army and the new railway system. The New Army, established in the mid-1890s as part of the Qing government's "self-strengthening" program to cope with the mounting challenges of the foreign powers, was reorganized with new vigor in 1902 under the leadership of reform-minded Yuan Shikai (1859–1916) and Zhang Zhidong (1837–1909). To modernize the military, it was planned to create thirty-six divisions of the New Army across the country; by the time of the revolution, fourteen—commonly known as the Beiyang Army, a name taken from the official title of its commander, Yuan Shikai—had materialized. The New Army was equipped, trained, and to

some extent indoctrinated according to Western standards. In the minds of those who joined the army, liberalism and nationalism were connected with modern weapons. Many soldiers and officers became sympathetic to the revolutionary ideas of Sun Yat-sen (1866–1925) and secretly joined cells of Sun's Revolutionary Alliance (United League), a coalition of anti-Qing societies founded in Tokyo in 1905. Ultimately, it was the New Army regiment stationed in Wuchang that fired the first shot of the 1911 Revolution.

The railway project under the New Policies Reform provided yet another fuse for the revolution. Between 1900 and 1905, more than 3,200 miles of railways were completed, compared to just a few hundred miles constructed in the nineteenth century. The Qing court, which regarded a centralized railway network as essential to economic development and political stability, in May 1911 announced it was going to nationalize China's railroads. This decision proved to be political suicide, since it attacked the interests of private investors in the fast-growing railway business. To make matters worse, the government ran up huge loans from Western banking consortia to finance railway construction. The Chinese people saw the Manchu government as scrambling for profits from its own people and selling out national resources to foreigners. From May to September, furious and massive rallies and demonstrations, some of which turned violent, occurred in the provinces of Hunan, Hubei, Guangdong, Henan, and, in particular, Sichuan, where the railway nationalization policy hit private investors' interests the most. The Railway Agitation, as it was called, served as a prelude to the Wuchang uprising.

On top of the reforms and the social unrest they engendered, intellectual trends turned against the Qing regime. Dissent arose from virtually every political and intellectual camp: those who advocated constitutionalism, nationalism, liberalism, anarchism, socialism, and others denounced the dynasty. Many new and radical ideas that originated in modern Europe came to China via Japan, where Chinese students, intellectuals, and sojourners of various sorts were craving an answer to the question of how this island nation, once China's disciple, rose from feudal lethargy to become within decades rich and powerful—recall that Japan had defeated the Russian empire in the Russo-Japanese War of 1904–5. In China, modern nationalism became intertwined with old anti-Manchu sentiments as reflected in the outcry "Expel the Manchu barbarians and restore the Chinese nation" (*quzhu Dalu, huifu Zhonghua*), a slogan that in 1906 became the guiding principle of the Revolutionary Alliance. Although the court proclaimed in 1908 that it would establish a constitutional government within nine years, the revolutionaries and radical intellectuals derided the claim as utterly insincere.

The most influential figure of the time was the revolutionary Sun Yat-sen. Sun had called for the overthrow of the dynasty long before the Wuchang uprising, and his dream of replacing the Manchu dynasty with a particularly Chinese republican polity had caught fire. It was in Japan in 1905 that Sun proclaimed the Three Principles of the People, namely, nationalism (*minzu*, or "nationhood"), democracy (*minquan*, or "people's rights"), and socialism (*minsheng*, or "people's livelihood"), as the foundation of his revolutionary program. Despite their ambiguity, the Three Principles of the People were the most systematic Chinese political theory of the time. While Sun's reputation as the "father of the Republic" might be a product of later developments in Chinese politics, as recent scholarship has indicated (see, for example, Marie-Claire Bergère's biography of Sun), Sun's pioneering blueprint for a new China inspired and to some extent catalyzed the revolution.

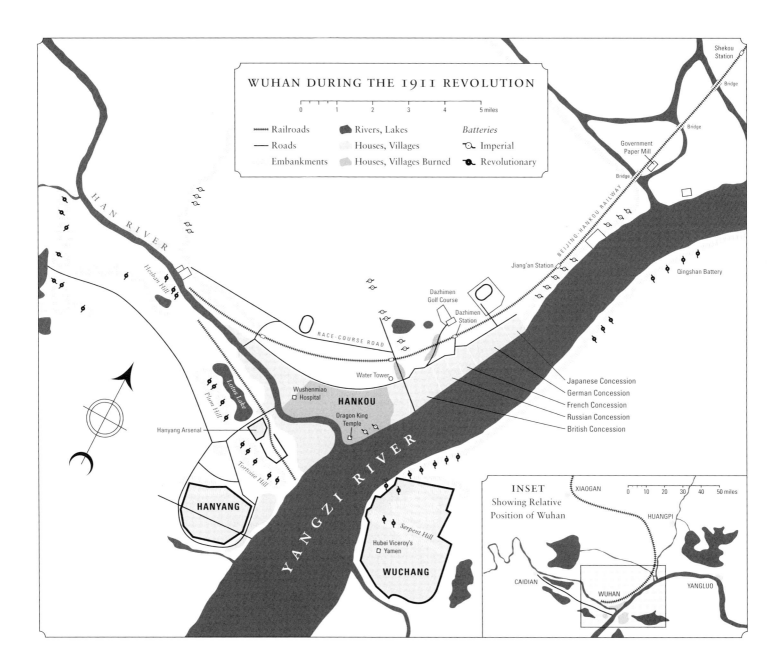

WUHAN DURING THE 1911 REVOLUTION

0 1 2 3 4 5 miles

- ┼┼┼┼┼ Railroads
- —— Roads
- Embankments

- Rivers, Lakes
- Houses, Villages
- Houses, Villages Burned

Batteries
- Imperial
- Revolutionary

HAN RIVER

Heshan Hill

Shekou Station

Bridge

Bridge

Government Paper Mill

Bridge

BEIJING-HANKOU RAILWAY

Jiang'an Station

Qingshan Battery

Dazhimen Golf Course

Dazhimen Station

RACE-COURSE ROAD

Water Tower

Wushenmiao □ Hospital

HANKOU

Dragon King Temple

Japanese Concession
German Concession
French Concession
Russian Concession
British Concession

Lotus Lake

Plum Hill

Hanyang Arsenal

Tortoise Hill

HANYANG

YANGZI RIVER

Serpent Hill

Hubei Viceroy's □ Yamen

WUCHANG

INSET
Showing Relative Position of Wuhan

0 10 20 30 40 50 miles

XIAOGAN

HUANGPI

CAIDIAN

WUHAN

YANGLUO

The 1911 Revolution, however, had a congenital deficiency, so to speak: it created little sense of mass participation and grassroots-level awareness of citizenship. The republic it established was merely a shell that lacked a truly representative government. As historian Joseph Esherick has pointed out, "Nineteen eleven scarcely touched the villages of China, except to demand more taxes. To a degree, the same was true of all the governments of the Republican era, up to and including Chiang Kai-shek's most promising years in Nanjing during the 1930s."[2] In a vast agrarian country like China, no revolution can be real and fundamental without significantly touching or transforming the peasantry. Consequently, the impact of the revolution on China's cultural landscape was limited and superficial. Several major movements that evolved in the years after 1911, notably the New Cultural Movement of 1915 to 1921 and the Communist Revolution, were in part efforts to complete the unfinished work of the newborn Republic. But the warlord domination of 1916–27, Chiang Kai-shek's dictatorship of 1928–49, and Mao Zedong's virtual monarchy of 1949–76 have proved that the task of the 1911 Revolution—that is, to establish an actual, not nominal, republic—remains a major challenge for the Chinese.

NEARLY A CENTURY has passed. In every textbook on modern China, the 1911 Revolution occupies a significant place. Most treatments of the revolution focus on its political and intellectual foundations. There is also a good amount of scholarly work that deals with a variety of subjects related to the revolution (see Further Readings at the end of this volume). But we have very little visual material left from that era. Because war correspondence was not an established profession and the camera was a rare apparatus in China at the time, very few photographs of the revolution were taken. For years, Edwin J. Dingle's *China's Revolution, 1911 to 1912*, which has thirty-six illustrations, was the major source of wartime pictures, although only a third of the illustrations are directly related to the war. Frederick McCormick, the correspondent sent to China by the Associated Press immediately after the revolution broke out, offers only six war-related photographs in his book *The Flowery Republic*, published in 1913. But we now know that Francis Eugene Stafford (1884–1938), an American photographer, was there and took and collected hundreds of photographs that have survived to this day.

Stafford was born in Boulder, Colorado, and from the age of seventeen he worked as a litho photographer for the Pacific Press in Mountain View, California. He arrived in China in 1909, two years before the revolution, and lived there until 1915, four years after the revolution. As a senior photographer for the Commercial Press, then Asia's largest publishing house, headquartered in Shanghai, Stafford was responsible for introducing color printing technology to China, as noted in Mary Gamewell's *The Gateway to China*.[3] His photographs were also published with captions in a 1911 textbook, *Geography of China*, edited by Horatio Hawkins, a work that went through no fewer than fourteen editions by 1924.[4]

As a professional photographer, Stafford took numerous pictures of scenes of the revolution from Shanghai to Wuchang, the heartland of the revolution, and beyond. Because he was a Westerner without political ties to either side of the conflict and because he represented a publisher that disseminated news to a large number of readers, Stafford was allowed access to the military of both sides. His images therefore bring us to a critical juncture in modern Chinese history to witness everything from horrific encounters on bloody killing grounds to staid scenes that reflect the politics behind the clash. Given the fact that the

uprising in Wuchang was hasty and largely unplanned, and that very few foreigners were there with a camera in hand, his photographs of the uprising could well be the only such collection that has survived to this day.

Moreover, during his sojourn in China, Stafford traveled extensively in the country, taking pictures wherever he went. The photographs he took cover a wide range of social and cultural scenes from that turbulent time. His lens recorded scenes from the gleaming streets of Shanghai to muddy trails through unknown inland villages and beyond. Viewers are taken back a century to witness rice paddy fields, factory workshops, imposing government buildings, common residential quarters, contemporary festivals, historical resorts and relics, the floors of retail stores, the grounds of open-air food markets, the inner chambers of Buddhist temples, and so on. Through his photographs, we can thus gaze on Chinese of all walks of life during this transformative era. Famous statesmen, politicians, generals, and diplomats came before Stafford's lens in private settings, but ordinary people in both ordinary and extraordinary circumstances were also his subject: farmers, coolies, porters, factory workers, carpenters, mechanics, artisans, soldiers, policemen, firefighters, shopkeepers, street peddlers, barbers, rickshaw pullers, sedan-chair carriers, beggars, fortunetellers, schoolteachers, clergymen, actors and actresses, office managers and clerks, typesetters, and many others. In other words, Stafford's diverse and wide-ranging photographs provide not only a rare visual documentation of this important revolution but also a panorama of life in China during that era.

The rich component of "social pictures" in the Stafford Collection confirms the assessment that the immediate impact of the revolution on Chinese society was limited and asymmetrical to its sweeping political impact. Through these pictures one can

observe the enormous political changes brought by the revolution, while also scrutinizing the nuances and distinctions that reflected the tenacity and continuity of Chinese culture and society. This was an era of transition, progress, and confusion. Through the Stafford Collection, readers can take a virtual tour of Chinese culture and institutions and get a sense of how the revolution that dramatically changed the political scene in China at the top may or may not have affected the nation's time-honored traditions and customs at the grassroots level.

Francis Stafford's grandson, Ronald Anderson, a sociologist at the University of Minnesota, inherited his grandfather's photo collection. As a historian of modern China at the Georgia Institute of Technology, I collaborated with Anderson in selecting and captioning 162 photographs from the Stafford Collection. Part 1, "On the Eve of the Revolution," features high-ranking Qing officials who were in large measure responsible for the collapse of the dynasty, the imperial New Army, imprisoned rebels, the destitute in both urban and rural areas, and the signs of social reforms. Together they depict a nation in crisis. Part 2, "The Wuchang Uprising," consists of pictures taken at the heart of the revolution: the revolutionaries and their enemies, soldiers of both sides of the conflict, battlefield scenes, the presence of foreigners, expressions of humanity in the midst of war, destruction in the cities of Hankou and Wuchang, and so on. Part 3, "The Politics of Chaos," presents images of the revolution beyond its birthplace in Wuchang, including revolts in Shanghai and other cities, key players in the negotiations between the government and the rebels, the arrival of Sun Yat-sen, and the activities of Yuan Shikai, the prominent late Qing official who dexterously played the dynasty off against the revolutionaries. Together, parts 2 and 3 constitute the essence of the book. Part 4, "A Society in Transition," contains scenes of the daily life

of the common people in towns and the countryside across the country at the time of the revolution. In part 5, "Stafford in China," a few pictures with the photographer in the scene provide further images of Chinese society in the age of revolution.

To contextualize these photographs, a map (p. 6) of the three cities that constituted modern Wuhan (Wuhan is a generic name, referring to the three linked mid-Yangzi River cities of Wuchang, Hankou, and Hanyang) and a detailed chronology of the 1911 Revolution are provided. The section on Further Readings at the end of the book lists major works in English on the Republican Revolution for readers who are interested in pursuing further study.

NOTES

1 R. Keith Schoppa, *Revolution and Its Past: Identities and Change in Modern Chinese History* (Upper Saddle River, N.J.: Prentice Hall, 2002), 129.

2 Joseph Esherick, *Reform and Revolution in China: The 1911 Revolution in Hunan and Hubei* (Berkeley: University of California Press, 1976), 259.

3 Mary Gamewell, *The Gateway to China: Pictures of Shanghai* (New York: Fleming H. Revell, 1916), 132–33.

4 Horatio B. Hawkins, *Geography of China* (Shanghai: Commercial Press, 1911–27).

1

ON THE EVE OF REVOLUTION

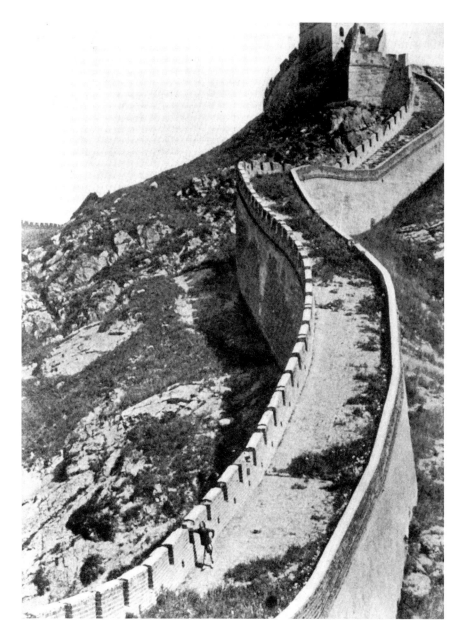

THE GREAT WALL was built in the third century BCE, connecting and consolidating segments of walls previous rival kingdoms had built to keep the northern nomads out of China proper (that is, lands where the majority of ethnic Han Chinese had traditionally lived). It has been renovated, rebuilt, and extended many times since then. This part of the Great Wall, near Beijing, was reconstructed in the fifteenth century during the Ming dynasty (1368–1644), the last dynasty ruled by the Han majority ethnic group. The Great Wall never functioned well in protecting the country. Indeed, this picture reveals a certain irony in this regard. Note the man standing on the wall with his right arm leaning on the battlements. His shaved head and braid were symbols of submission to the Manchus, the northern nomads who crossed the Great Wall to overthrow the Ming and found the Qing dynasty (1644–1911).

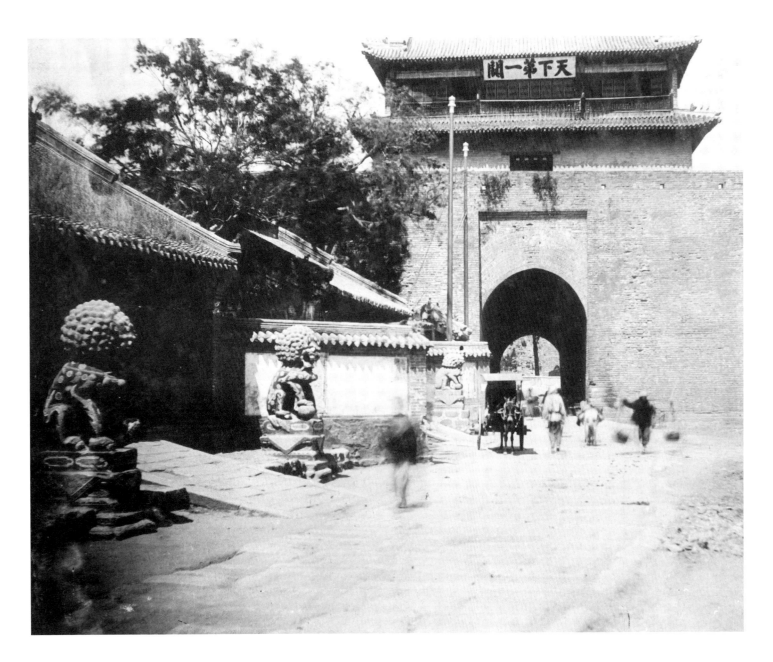

Preceding page SHANHAIGUAN, or the "Mountain and Ocean Pass," a fortification built in 1381 by the Ming government on steep cliffs abutting Bohai Bay, marks the eastern extremity of the Great Wall. The inscription on the horizontal board reads "Number One Pass under Heaven," a well-known epithet for this structure. Shanhaiguan is also known as the "Museum of the Construction of the Great Wall," for there is a Song dynasty temple dedicated to Meng Jiangnü, a legendary woman whose grief and spilt tears over her husband's death in constructing the Great Wall crumbled away a huge section of the wall. Whether this story is legend or hyperbole, the Great Wall did not fall, nor did it serve to guard the "Number One Pass under Heaven." It was through this gate in the spring of 1644 that the Manchu army came swarming into China to establish a dynasty that would last for more than two and a half centuries.

EMPRESS DOWAGER CIXI (1835–1908), arguably the last effective ruler of the Qing dynasty, pictured here with a court lady and a eunuch in 1903. For nearly half a century, from 1861 to the year she died, the Empress Dowager controlled the Qing court. "Holding court from behind a screen," as the Chinese describe it, Cixi more than anyone else was responsible for the course of politics in the late Qing, most notably the Hundred Days' Reform of 1898 and the Boxer Rebellion of 1900. It is tempting to think that if she had lived until 1911, the outcome of the revolution might have been different.

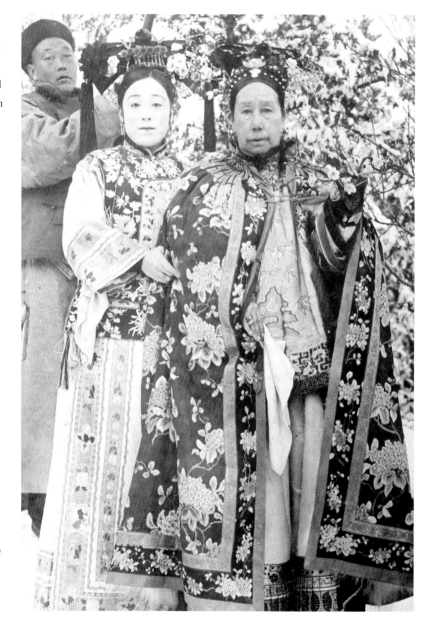

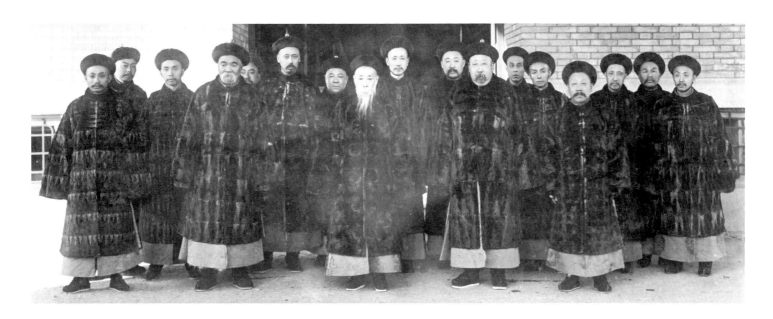

HIGH-RANKING QING OFFICIALS. The man at the center with a long
white beard is Prince Qing (personal name Yikuang, 1836–1918), the
prime minister of the Qing government at the time of the revolution.
A great-grandson of Emperor Qianlong (r. 1735–95) and an impor-
tant protégé of the Empress Dowager Cixi, Prince Qing had been a
key member of the imperial court since 1884, despite the fact that he
was known to be fatuous and corrupt. He was in charge of the cabinet
and the Ministry of Foreign Affairs and, together with Li Hongzhang
(1823–1901), negotiated with the foreign powers and signed the Boxer
Protocol of September 1901. After the Wuchang uprising, he was forced
to relinquish his position as prime minister to military strongman Yuan
Shikai (1859–1916). To his left is vice premier Natong (1857–1925).

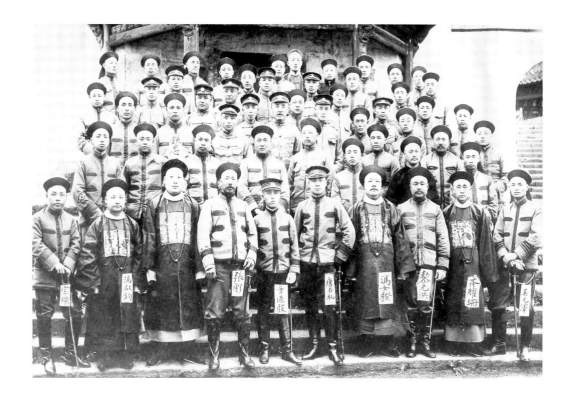

THE QING PROVINCIAL OFFICIALS and the leaders of the New Army regiments that fired the first shots of the 1911 Revolution. Photo taken in front of the Yellow Crane Tower (Huanghelou) in Wuhan, ca. 1905. Some of these men played critical roles in the revolution and had very different fates. In the first row, the third person from the right is Li Yuanhong (1864–1928), a regiment commander who during the revolution was pressed by insurgents in Hubei province to be the head of the Hubei Military Government. He later became president of the Republic of China. The fourth person from the right is Feng Rukui (d. 1911), a holder of a metropolitan degree (*jinshi*, the highest degree bestowed in the civil service examination system), who served as the salt commissioner of Hubei. At the time of the revolution, Feng was the governor of Jiangxi province and was pushed by the revolutionaries to serve as the head of the new government of Jiangxi, much like Li Yuanhong's situation in Hubei. Unlike Li, however, Feng, perhaps to escape the pressure, poisoned himself and died. Zhang Biao (fourth from the left) was the commander in chief of the Qing army that defended the imperial government in Hubei at the time of the Wuchang uprising. After losing the governor's mansion, he was rescued by a Japanese boat and fled to Hanyang on the night of October 10. The next morning, an eighteen-star red flag—the revolutionary flag symbolizing the unification of China's eighteen provinces—was raised atop the Yellow Crane Tower, signaling the victory of the uprising.

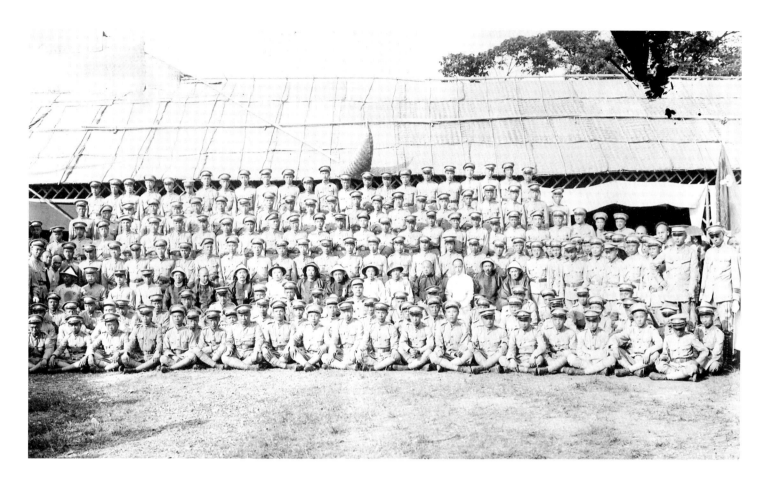

OFFICERS AND SOLDIERS of the Qing New Army, ca. 1910. The New Army was established in March 1895, starting with 5,000 soldiers organized along Western lines with infantry, cavalry, artillery, and engineer units. A modern staff system was also created. The Qing government had hoped to use this army to strengthen China's defenses in the wake of the Boxer Rebellion. By 1911, the New Army had fourteen divisions or about 170,000 men. Not only was the New Army unable to save the dynasty, but to some extent it accelerated its downfall. At its highest echelons, much of the New Army became the political turf of its commander, Yuan Shikai (1859–1916), who ingeniously built up his influence and then wielded it in a bid for personal power. At the lowest level, many soldiers and officers became sympathetic to Sun Yat-sen's revolutionary ideas and secretly joined Sun's Revolutionary Alliance (Tongmenghui, also translated as the United League). In the end, it was the New Army's Eighth Engineer Regiment, stationed in Wuchang, that fired the first shots of the 1911 Revolution.

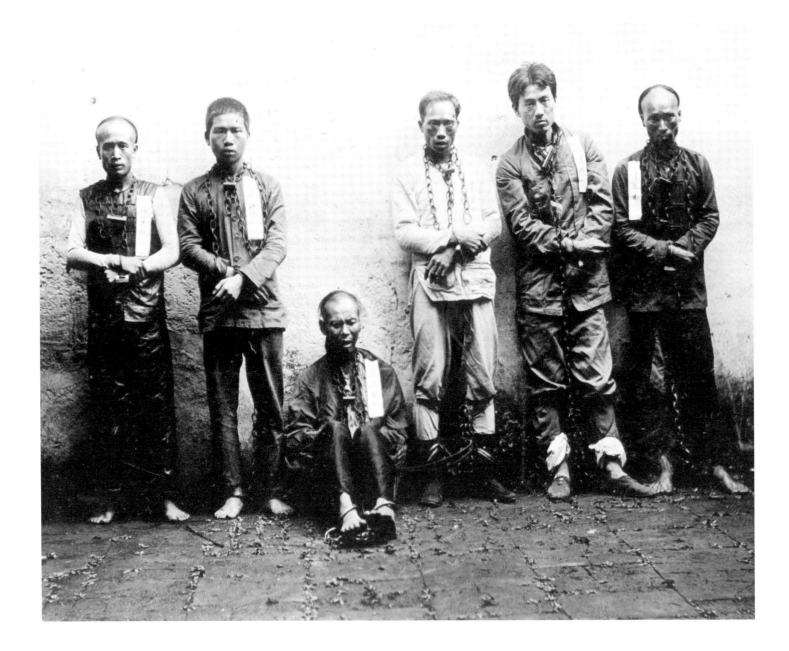

Opposite REBELS OF THE YELLOW FLOWER RIDGE UPRISING, the tenth military uprising against the Qing organized by the Revolutionary Alliance prior to the 1911 Revolution. Photo taken right before their execution. The uprising, which occurred on April 27, 1911, in Guangzhou (Canton), was organized by Huang Xing (1874–1916), Sun Yat-sen's foremost collaborator in the Revolutionary Alliance. Although the rebels were able to occupy the governor's mansion for a few hours and burn it, the insurgence was brutally suppressed. After the incident, a Revolutionary Alliance member named Pan Dawei toiled to recover corpses of the executed rebels; seventy-two were found, including the men pictured here. Pan secretly buried them on Red Flower Ridge in the eastern suburbs of Guangzhou. After the revolution, the place was renamed Yellow Flower Ridge in memory of both the dead and the uprising. Chinese history books usually consider the Yellow Flower Ridge uprising as a prelude to the 1911 Revolution.

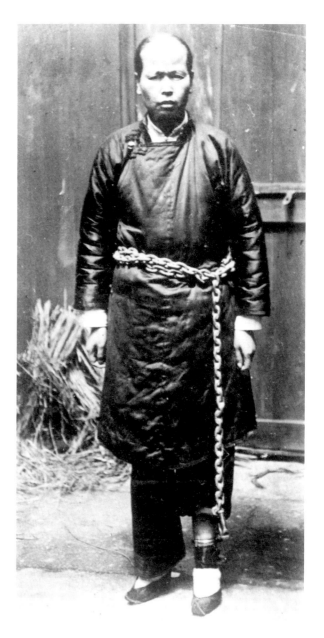

AN UNIDENTIFIED WOMAN PRISONER, possibly a member of the Revolutionary Alliance, which organized uprisings in south China from 1905 to 1911. Women were actively involved, most often helping by transporting weapons to secret sites prior to a planned uprising. The government's suppression of these female rebels was no less ruthless than that of their male comrades. A well-known case was the public execution of the woman revolutionary Qiu Jin (1875–1907), who organized a revolt in Zhejiang in July 1907. Her story became the central element of the short story "Medicine" (Yao), the masterpiece of Lu Xun (1881–1936), published in 1919. Note that the woman's bound feet did not save her from getting the heavy chain locked to her left leg, a treatment typically reserved for political prisoners.

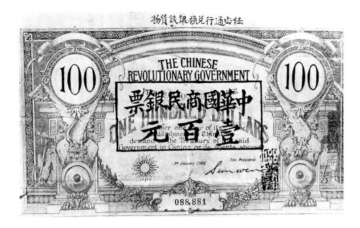

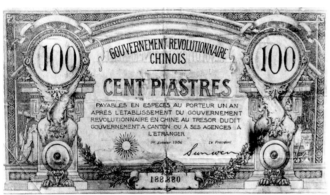

MILITARY BONDS ISSUED by the Revolutionary Alliance in 1906. In order to raise funds for uprisings against the Qing government, the Revolutionary Alliance printed 10,000 military bonds valued at 100 yuan each. The front of each bond is in English (*top*) and the back in French (*bottom*). Note Sun Yat-sen's signature "Sun Wen" (his legal name) on the lower right. After the 1911 Revolution, the Hubei Military Government stamped the bonds to authorize their circulation as official currency.

AS PART OF THE QING GOVERNMENT'S EFFORTS to modernize the nation, China held her first national exposition in Nanjing in 1910. The expo began on June 5, 1910, and lasted nearly six months. About one million products cataloged in 440 categories were exhibited in an area of about 120 acres in central Nanjing. The expo attracted about 30 million visitors and the volume of business transactions exceeded twenty million silver dollars. Promotional posters of the expo, printed by the Shanghai Commercial Press, provide a glimpse of the expo and Nanjing's famous scenery at the time.

The portrait at the center of Poster I (*opposite page, left*) is the Manchu Prince Regent Chun (personal name, Zaifeng, 1883–1951), father of the last emperor, Puyi, who at the time was just four years old. *Clockwise from the top of the poster*: the Confucian Temple on the Qinhuai River, the entrance tower to the Jiangnan Civil Service Examination Hall, the Drum Tower, the tomb of the founding emperor of the Ming dynasty, the Weifeng Gate, and the headquarters of the governor-general of Jiangsu, Anhui, and Jiangxi provinces. The portrait at the center of Poster II (*opposite, right*) is the governor-general Zhang Renjun, who was in charge of the expo. A year later, when the revolution broke out, Zhang managed to escape from Nanjing and was never found again. The background of the governor's portrait is a night view of the expo. *Clockwise from the top of the poster*: the open square and decorated arch in front of the entrance to the expo, the Hall of Education, buildings inside the expo, the main entrance to the expo, the Expo View Tower, and the Hall of Arts and Crafts.

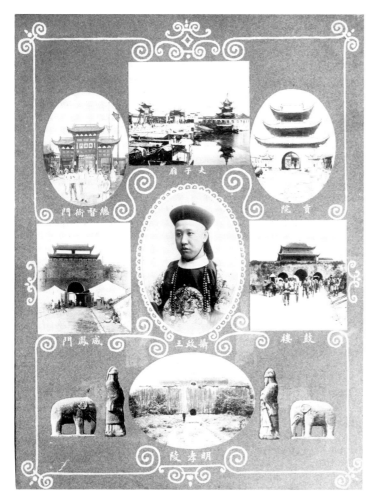

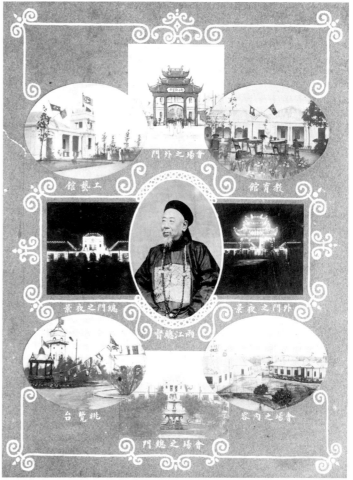

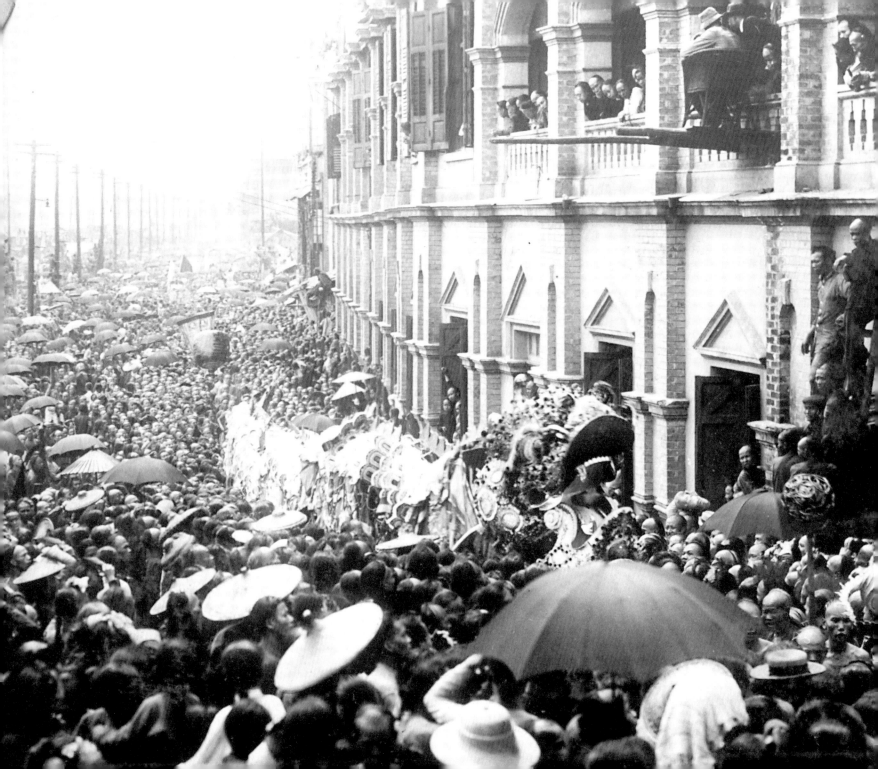

Opposite SIGNIFICANT SOCIAL CHANGE also occurred on the eve of the revolution. In December 1910 and January 1911, the issue of banning gambling was intensely debated in Guangdong's newly founded provincial assembly. A society for the ban on gambling was founded in the city of Guangzhou (Canton). To show their support for banning this social vice, thousands of people paraded on the streets of Guangzhou. The demonstration turned out to be a festive event but was effective nonetheless. On January 31, the Qing court approved the governor's proposal to ban gambling in the province, effective March 30, 1911.

Overleaf left EXCEPT FOR MEMBERS of the Manchu court, all Qing government officials were selected through the Confucian-based civil service examination system, an institution that dated back to the sixth century. As part of the New Policies Reform pursued by the Qing government in the wake of the Boxer catastrophe, the civil service examination system was entirely abandoned in 1905. This examination hall in Nanjing, built in 1168, was a place that for generations had conjured up dreams of a successful life for millions of anxious candidates. Typically, only about 5 percent of the candidates managed to pass the provincial-level examination. Fifty-two percent of the highest degree holders during the Qing dynasty took their examinations here. By the end of the nineteen century, with its 300 *mu* (50 acres) of land, 20,644 examination cubicles, and over a thousand offices, this was the largest civil service examination hall in the country. Since the ending of the civil service examination system in 1905, the examination hall has lain in waste, an unmistakable scene of decay and desolation.

Overleaf right THE GENERAL WATCH TOWER, Mingyuanlou, located at the middle of the examination hall in Nanjing. The name of the tower is derived from one of the Confucian classics, *The Great Learning*, and literally means "bright future." The examination hall was dismantled in 1918 to provide space for open-air markets and other commercial establishments; only this tower, built in 1534, survived. It is now China's oldest relic of a civil service examination hall.

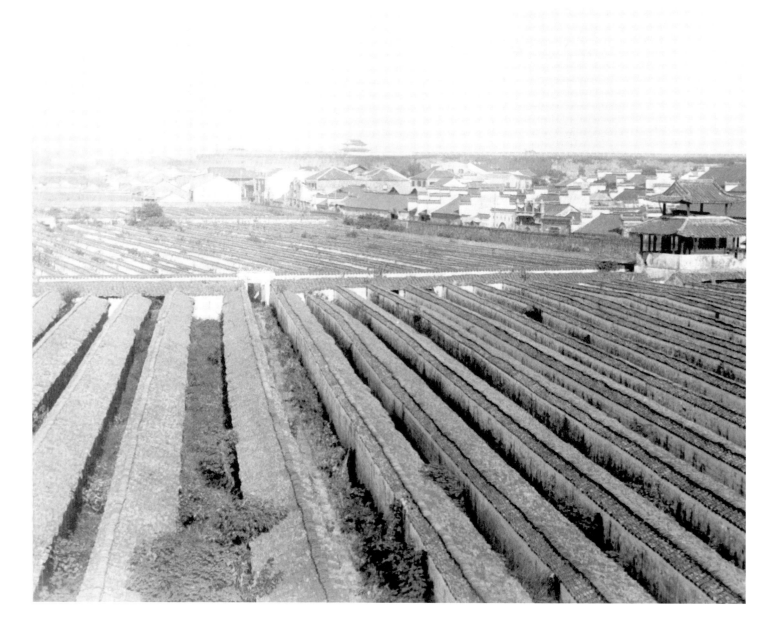

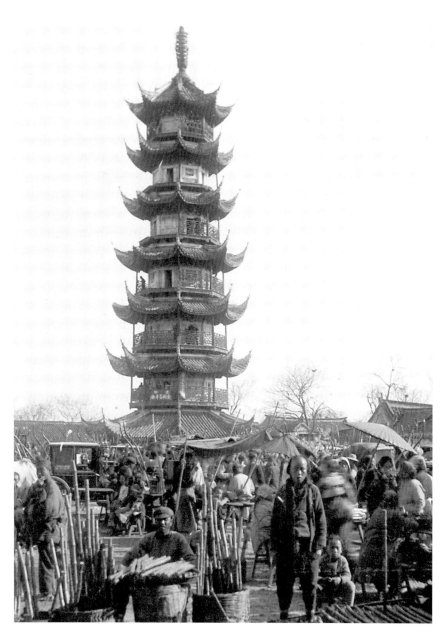

THE PAGODA OF THE LONGHUA TEMPLE in south-west Shanghai, ca. 1910. The Buddhist temple is having its annual Peach Blossom Festival on the third day of the third lunar month (which usually falls in early April of the Gregorian calendar). The bird's eye view (*opposite*) from the pagoda has an interesting blend of old and new, urban and rural. The temple, built in 977 during the Song dynasty, is one of the oldest surviving Buddhist temples in China. The annual temple fair at Longhua has been a tradition for at least three centuries. Behind this ancient place of worship, a modern factory, the Longhua Gunpowder Plant, is at work—it is ironic that a munitions plant was the neighbor of a religious institu-tion emphasizing compassion and nonviolence. And in spite of being located in China's largest city, the temple is adjacent to a well-tended plot of farmland.

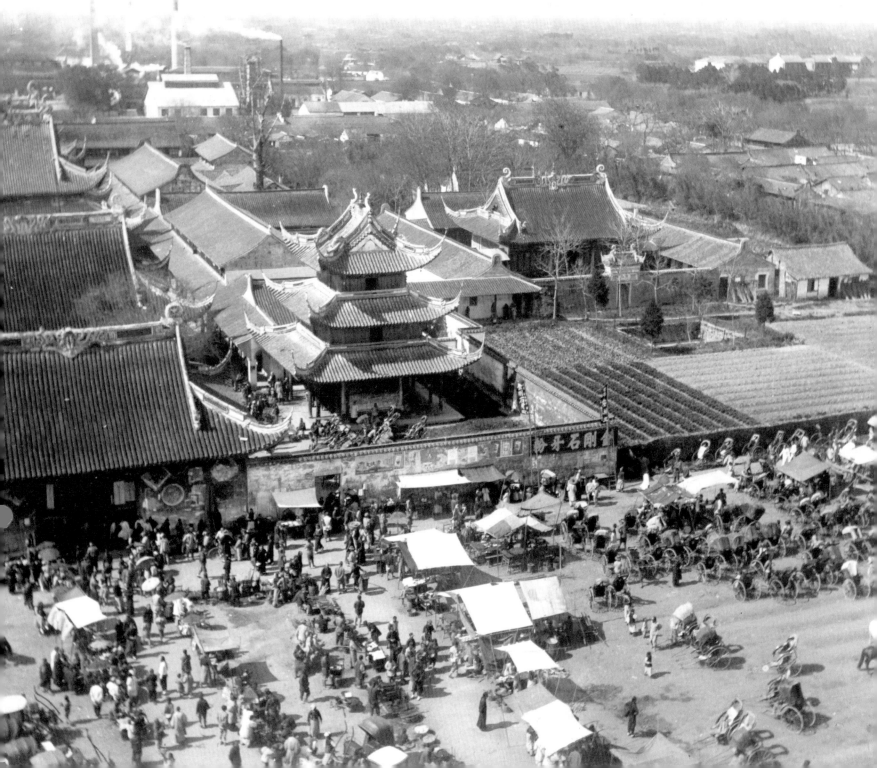

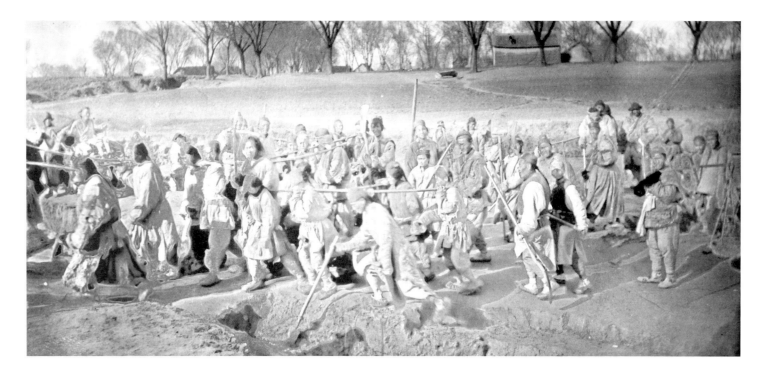

DRAFTING LABORERS for large public projects, such as construction of roads, canals, irrigation systems, imperial palaces and tombs, and the like, was a common form of taxation throughout Chinese history. Frequently, the government's mismanagement, extortion, and cruelty turned corvée laborers into a ready source of recruits for revolts and uprisings. China's first imperial dynasty, the Qin (221–206 BCE), for example, was overthrown by a rebellion that arose among laborers drafted to build the Great Wall. The 1911 Revolution was not directly triggered by corvée laborers, but the exploitation of common folk like those pictured here was a source of resentment that contributed to the sudden collapse of the dynasty.

Opposite ACCORDING TO CHINESE SUPERSTITION, ominous signs from heaven portend the fall of a dynasty. The disaster-ridden year before the 1911 Revolution seems to have borne out the myth. In December 1910 a horrendous plague spread through Manchuria, the homeland of the Qing rulers. By February 1911, the epidemic reached north China, in particular, Zhili (Hebei) and Shandong provinces. The Qing government took firm measures to deal with the situation. It established an epidemic control and prevention bureau, appointed five governors to be directly in charge of local quarantines, and spent a total of 10 million taels ($7.4 million) on fighting the epidemic. Still, the plague lasted for over five months and killed about 60,000 people. Pictured here is an epidemic control team sent to Harbin, a major Manchurian city that was badly hit by the plague.

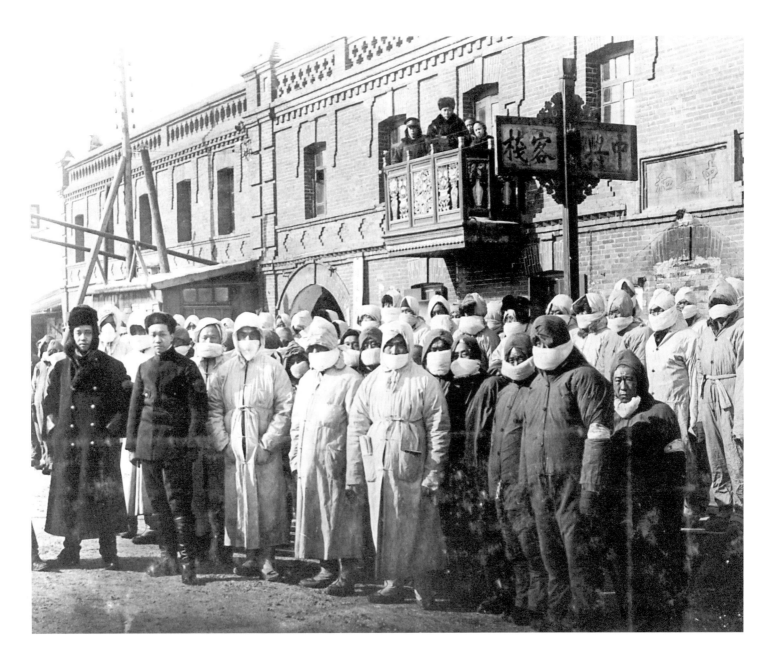

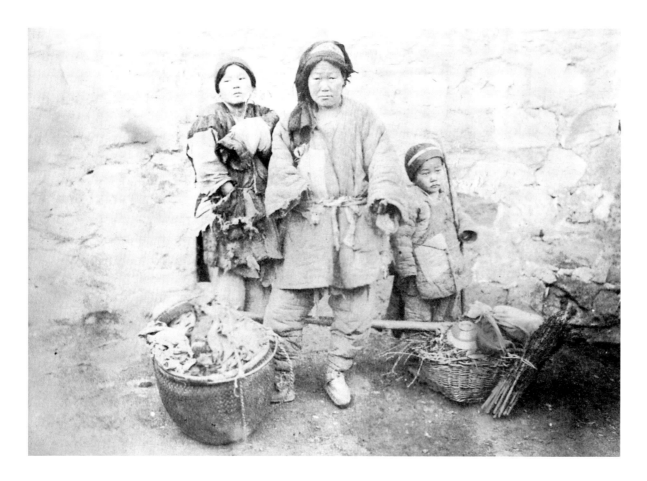

In 1910–11, natural disasters hit many parts of the country. Particularly bad was an unprecedented flood of the Yangzi River that claimed millions of lives. By the end of March 1911, in two lower Yangzi valley provinces, Jiangsu and Anhui, floods took nearly one million lives and left three million more homeless. Rural refugees like the peasant woman (whose husband died in the flood) and her three children pictured here were a common scene in towns and cities across the country at the time of the revolution.

Opposite In contrast to the flooding in the Yangzi River valley, drought struck north China in the summer of 1910. Here in a village near Yantai, Shandong province, women and children are washing in a river with so little water that its bed is barely covered. The naked boy in the foreground is relieving himself.

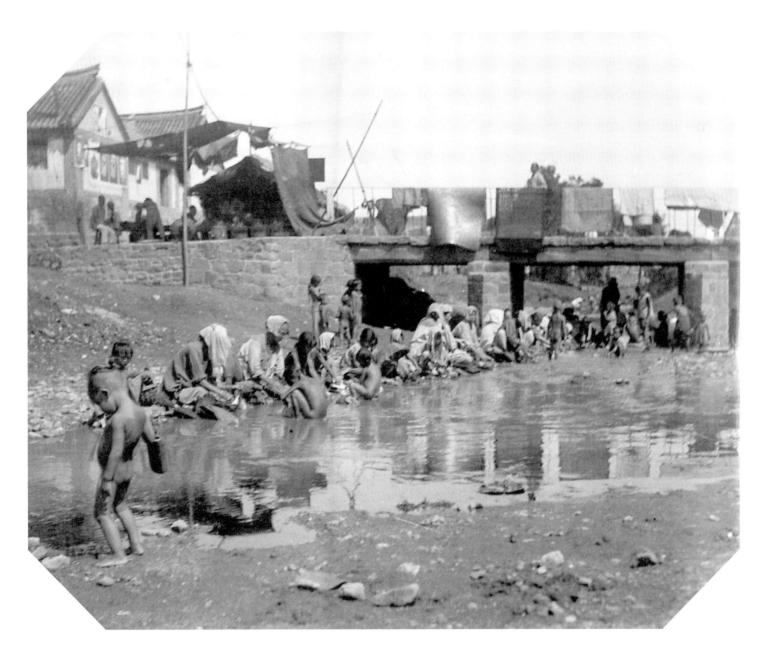

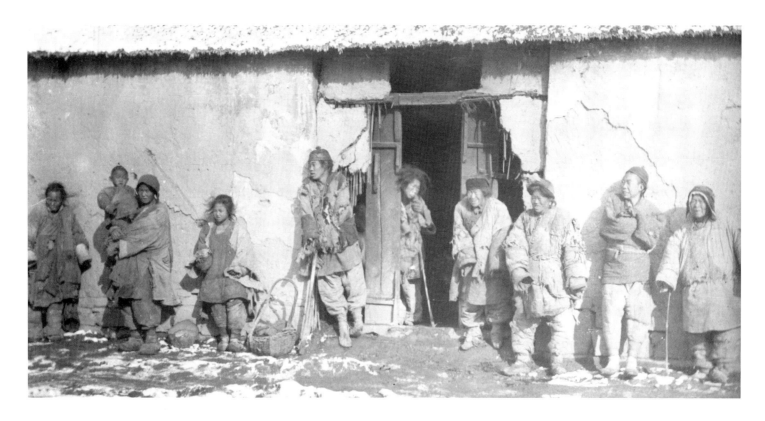

BEGGARY AND THE PEASANTRY were inseparable in late imperial China. Many poor peasants begged in urban areas during the winter slack season and returned to their villages when the farming season started. Because the state did little to help the poor and philanthropies of all sorts were overwhelmed by the enormous problem of poverty, beggars spontaneously organized themselves into guild-like groups that provided mutual help and a sense of belonging. As a beggars' ditty put it, "People who have a family want to leave the family; people who do not have a family look for a family. Brothers and sisters, let's hug one another: All beggars under heaven belong to one family!"

Opposite A DISFIGURED BEGGAR surrounded by a crowd. Note that among the bystanders one on the left is offering cash. Street beggars were ubiquitous in early twentieth-century China, ominous evidence of the widespread poverty that fed the social roots of the revolution.

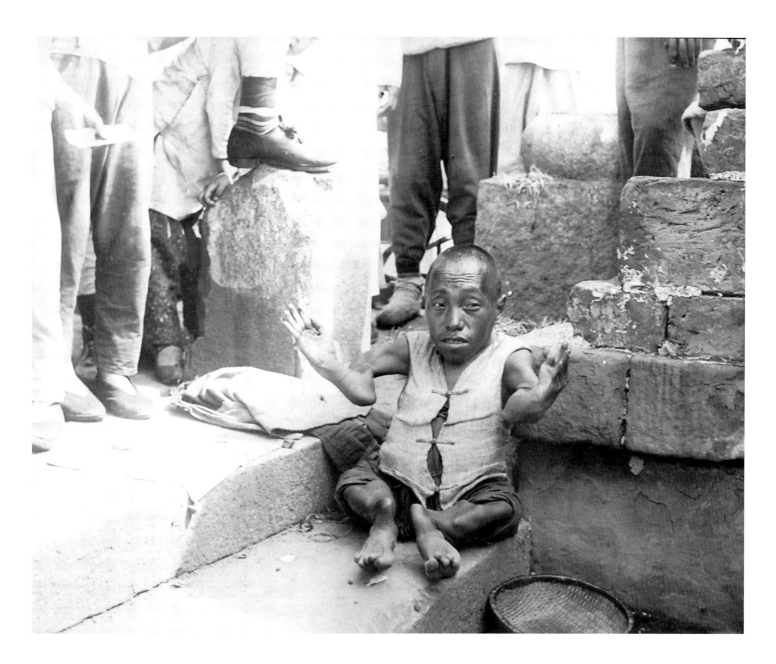

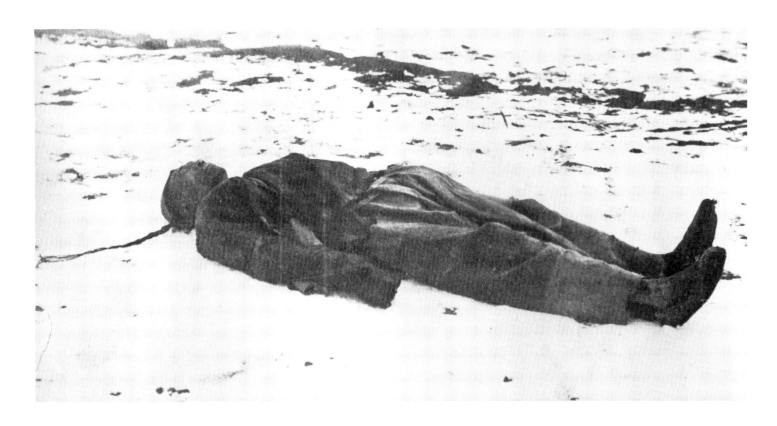

THE RENOWNED TANG DYNASTY POET Du Fu (712–70) wrote
a famous line that starkly described the social inequality of his time:
"Behind the vermilion gates meat and wine go to waste while out on
the road lie the bones of those frozen to death." Such scenes were still
common in the early twentieth century. Calamities and abject destitu-
tion have always been classic social causes for revolution, but the 1911
Revolution failed to solve China's enormous problem of poverty. Scenes
like this recurred (though the victims no longer wore queues) on a vast
scale in the late 1920s and early 1930s and again during the great fam-
ines caused by Mao's Great Leap Forward in 1959–61.

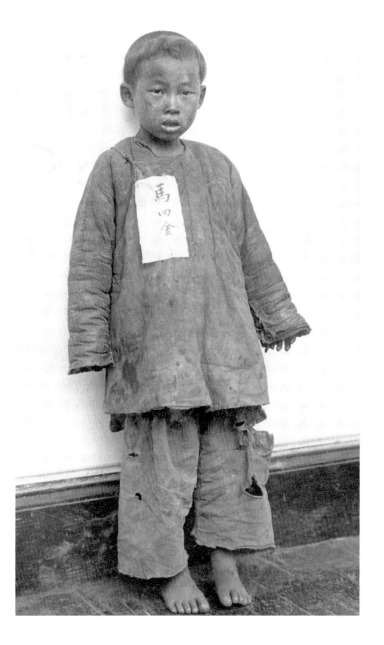

This child, Ma Sijin, is for sale. His name literally means "Ma the fourth gold," suggesting that he is the fourth son of the Ma family. Using auspicious characters such as "gold," "fortune," "wealth," "prosperity," and so on to name a child is a common practice in China; in the poverty-ridden country, it often reflects the wishful thinking of parents. Selling children to eke out a meager existence was common among the poor in late Qing and Republican China. The writer Li Baojia (1867–1906) coined the expression "selling sons and vending daughters" (*mai er yu nü*) in his novel *A True Record of the Current Officialdom* (*Guanchang xianxingji*), published in 1905, to describe the social reality of his time. Since then the expression has entered the Chinese lexicon as standard idiom. Selling children for adoption or into slavery or prostitution was so common in the early twentieth century that some towns even periodically held an open-air market for that purpose. Chinese law did not explicitly prohibit child trafficking until 1935, and even then the law was not truly enforced.

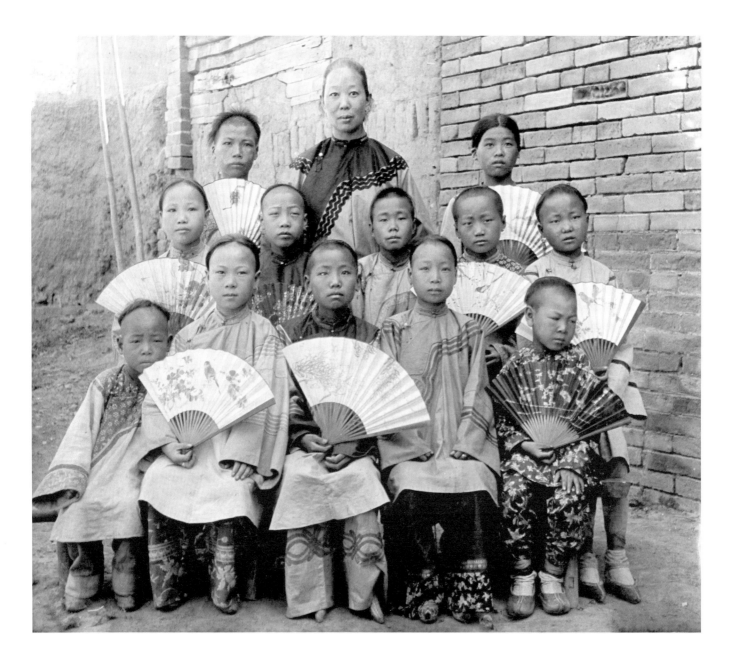

Opposite THESE CHILDREN under the care of some missionaries are obviously more fortunate than Ma Sijin (p. 35), although none of them seem cheerful. The pose with big folding fans for the camera is perhaps to satisfy certain viewers' taste for Oriental exoticism.

AMIDST THE PERVASIVE POVERTY in early twentieth-century China, Western expatriates were strikingly affluent and privileged. Here in Shanghai the so-called Public Park, a riverside recreational area built in 1865, had been reserved exclusively for Westerners for decades. Chinese protests over the years against the park's discriminatory rules resulted in giving upper-class Chinese limited vouchers for occasional entrance. A Shanghai guidebook published in 1909 warns that "Chinese entering the park must be dressed in a Western business suit or Japanese attire." The park would not be fully opened to the Chinese public until 1928.

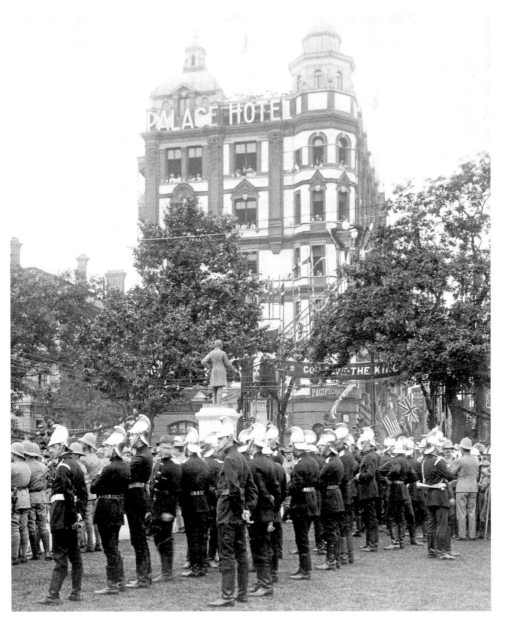

JUNE 22, 1911, was the coronation day of King George V of the United Kingdom. On Shanghai's renowned riverside boulevard, the Bund, the British and Americans are holding a grand ceremony and a parade for the occasion. Virtually the entire Anglo-Saxon community in Shanghai, including the Shanghai Volunteer Corps and the Shanghai Fire Brigade, have come out for the celebration. Note that the windows of the Palace Hotel are teeming with onlookers. The Palace Hotel (today's south wing of the Peace Hotel), is located at the intersection of the Bund and Nanjing Road, Shanghai's most famous avenue. This building was completed in 1908. The next year, the first meeting of the World Anti-Narcotics League was held there. In December 1911, on his way to Nanjing to assume the post of provisional president of the Republic of China, Sun Yat-sen stayed at this hotel and, during a welcome reception held by the revolutionaries for him in the hotel's Central Hall, gave a well-known speech declaring to his countrymen that the "revolution is not yet completely successful, comrades; continue to strive for it!"

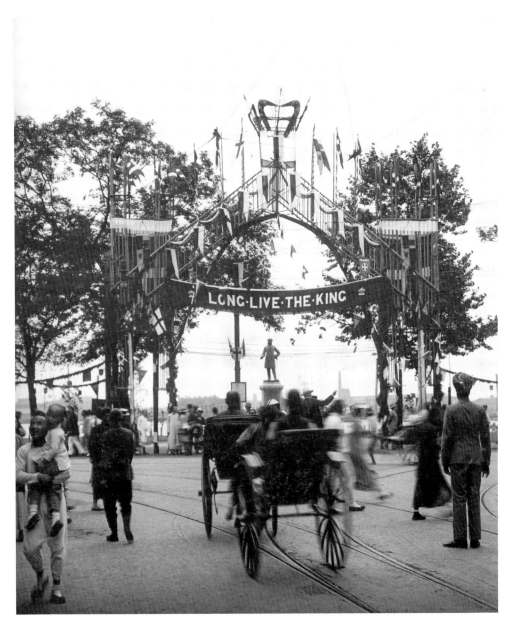

IN FRONT OF THE PALACE HOTEL is a statue of Sir Harry Smith Parkes (1828–85), who served as British consul in Shanghai in 1863 and then British envoy in Japan and China. The statue was unveiled in 1890 on the Bund and stood there until 1942 when the Japanese, who occupied Shanghai's foreign concessions after the outbreak of the Pacific War, tore it down. The foundation of the statue was rediscovered in 1984, and it is now stored in the Shanghai Museum.

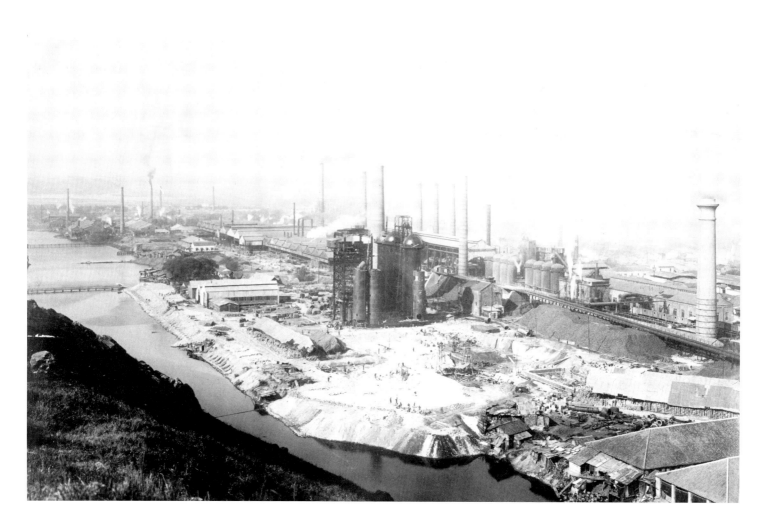

THE HANYANG PLANT, a part of China's first great coal, iron, and steel complex, known as the Han-Ye-Ping Company, in central China. The plant, located in the heartland of the 1911 Revolution, was established in the early 1890s as part of the government's Self-Strengthening movement, which aimed to appropriate Western technology and establish modern industries. It started production in May 1894. By the time of the 1911 Revolution, it had spawned a number of branch plants in the area, and with a workforce of over 3,000, produced 70,000 tons of iron annually. The plant was occupied by the revolutionaries the day after the Wuchang uprising began.

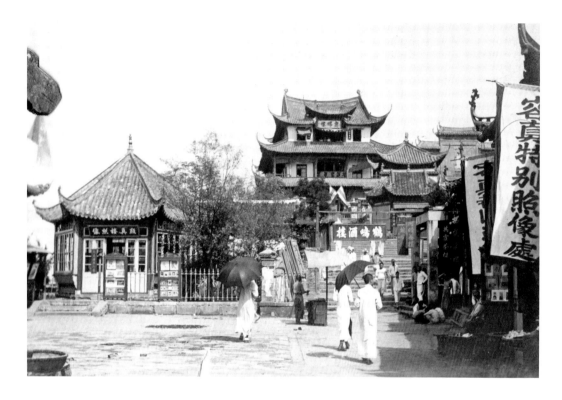

THE AOLÜE TOWER, also known as the Fengdu Tower, in Wuchang. This traditional structure was built to honor Zhang Zhidong (1837–1909), one of the most prominent reformists in the late Qing, who resided in Wuhan for almost eighteen consecutive years when he served as the governor-general of Hunan and Hubei provinces. A Confucian scholar-official, Zhang was best known for formulating the so-called *ti-yong* principle: "Chinese learning is the essence (*ti*), while Western learning is for practical use (*yong*)." To carry out his policy of selectively adapting Western learning for the purpose of preserving the Qing dynasty and, ultimately, China's Confucian tradition, Zhang effectively pressed for a number of modernization programs, including building a railway line from Hankou to Beijing, setting up a modern coal, iron, and steel complex, establishing a military academy, promoting Western-style education, and sending students overseas. These programs brought modern technology and institutions to China, but to a degree accelerated the downfall of the Qing. Reform-minded students trained in Zhang's programs became sympathetic to the radical idea of overthrowing the dynasty, and many of them eventually joined the revolutionary camp against the Qing. The Literature Society, one of the two organizations directly responsible for launching the 1911 Revolution, was founded in this building that, ironically, was dedicated to the man who wished to save the dynasty.

2

THE WUCHANG UPRISING

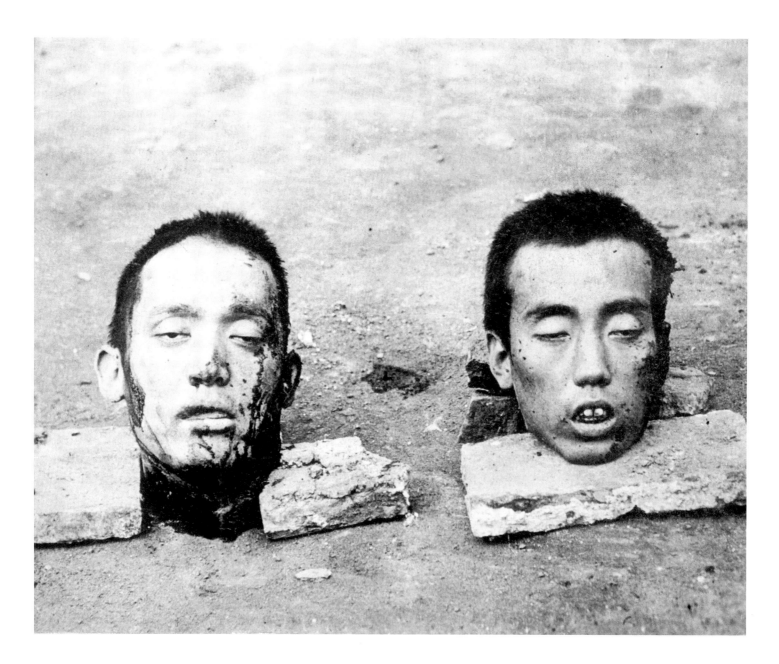

Opposite THE HEADS of Liu Fuji (1883–1911) (*right*) and Peng Chufan (1884–1911), prominent leaders of the Wuchang uprising. Both men were responsible for the on-site planning of the uprising. But on the evening of October 9, right before the planned uprising, they were arrested and early the next morning they were beheaded. A few hours later, the revolution began. Tortured before their execution, Liu and Peng steadfastly refused to divulge any information on the insurgents' scheme. The public display of beheaded rebels and criminals as a warning to the people had a long history in China, as expressed in the metaphorical saying "killing the chicken to scare the monkeys." In this case, however, the brutality only alerted those planning the revolt and caused them to accelerate its launch. The victory of the revolution soon transformed Liu and Peng from criminals to heroes. They and another executed leader, Yang Hongsheng (1886–1911), were honored by the Republican government as the "Three Pioneering Martyrs of the Revolution."

Above and overleaf LATE ON THE AFTERNOON of October 10, 1911, the revolutionary army occupied Mount Sheshan and used vantage points on the ridge to bombard the governor's mansion in Wuchang. Sheshan, or "serpent hill," is a 1,790-meter-long, 25- to 30-meter-wide ridge winding along the south bank of the Yangzi River. It resembles a serpent, hence the name. The summit, which from a distance appropriately looks like a snake head, overlooks the Yangzi River and the city of Hanyang on the north shore of the river, making it, since the era of the Three Kingdoms (220–80), of crucial strategic importance.

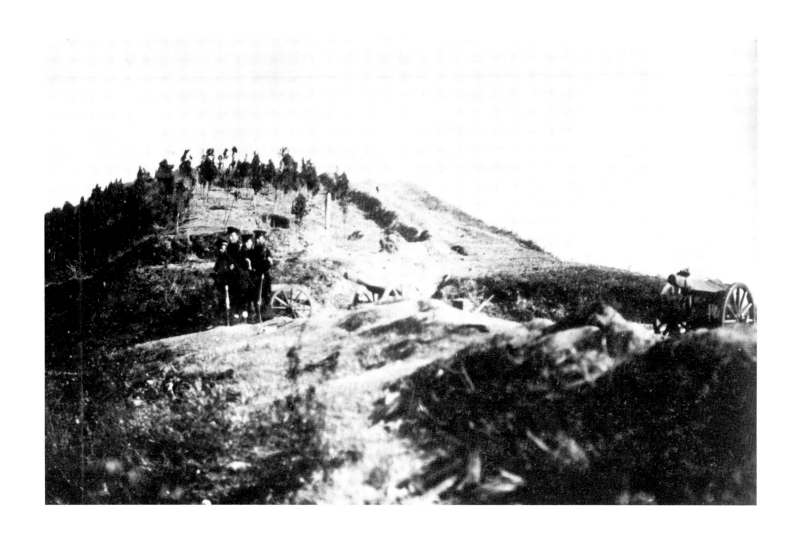

Opposite REVOLUTIONARY SOLDIERS moving a cannon across a rail yard.

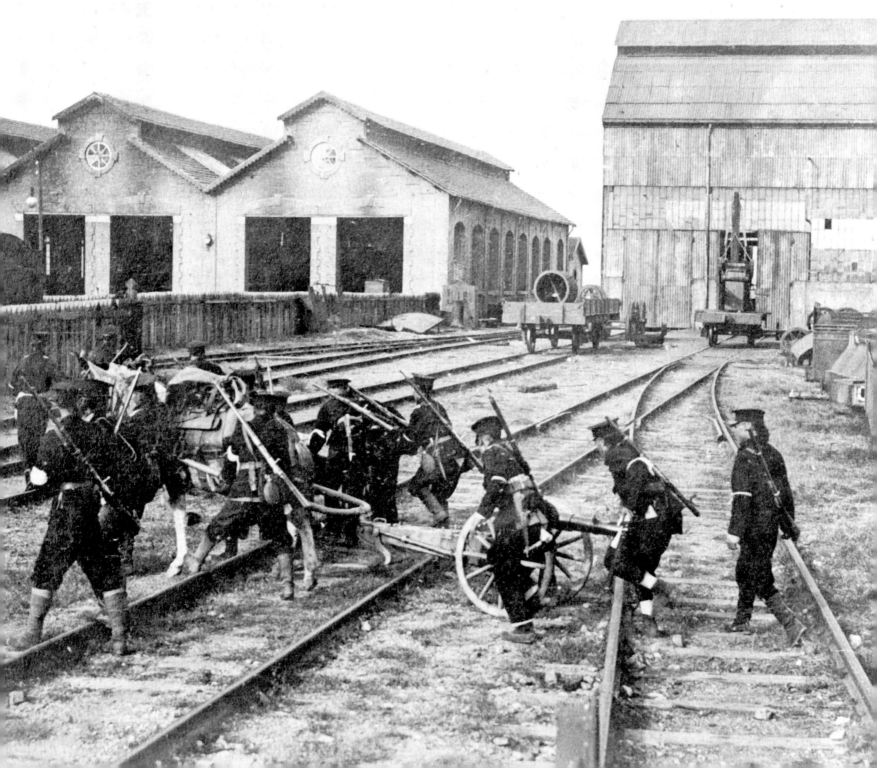

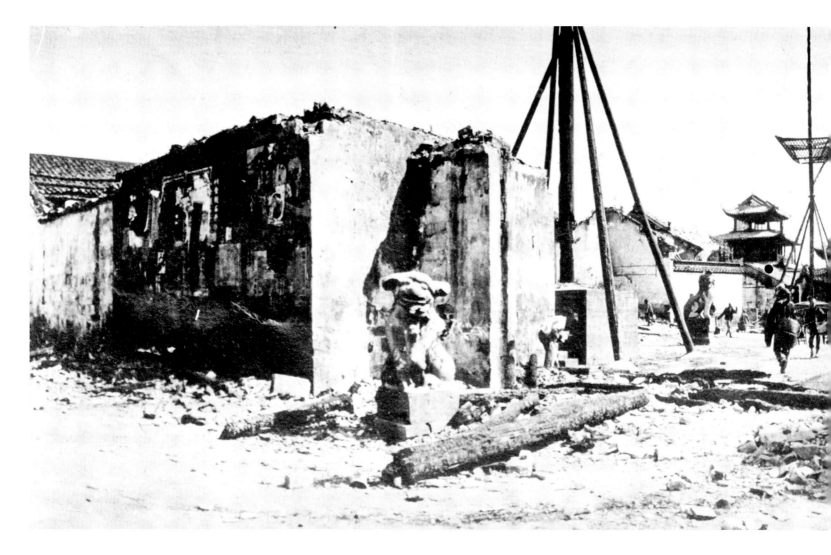

THE HUBEI VICEROY'S YAMEN (government headquarters) imme-
diately after it was destroyed by artillery fire from the revolutionary
forces. Note that the stone lions flanking the entrance are heavily
damaged while a few wooden arches remain intact, including one
with a horizontal inscription reading: "Governing with Both Civil
and Military Statutes."

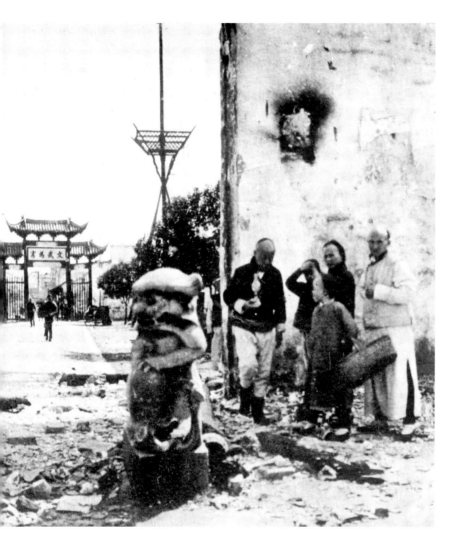

Overleaf THE HEADQUARTERS of the Hubei Military Government, originally built in 1908–10 to house the newly founded Hubei Provincial Assembly. On October 12, 1911, the insurgences established the Hubei Military Government in this building and from here commanded the rebels in their ongoing battles and issued a number of proclamations condemning the Qing monarchy and calling for the establishment of a republic. This 100,000-square-foot, two-story edifice, known among the locals as the Red Mansion (for its red brick walls and tiled roof), was a symbol of progressiveness during this revolutionary period. Its transformation from Qing assembly hall to Republican government office building exemplified how constitutionalism and local self-government under the Xinzheng Reform contributed to the revolution. The Hubei Provincial Assembly was one of twenty-one provincial assemblies established in October 1909. Although the vast majority of the members of the Hubei assembly (ninety-two out of ninety-seven) were holders of old civil service examination degrees, many of them had received some sort of new education and nine had studied abroad. Here the influence of Japan was notable: the nine assembly members who studied aboard had all gone to Japan, and seven attended law schools there. The chairman of the Hubei Assembly, Tang Hualong (1874–1918), studied law in Japan in 1906. (Nationwide, of the total of sixty-seven men who served as provincial assembly chairmen or vice-chairmen, twenty-three had studied in Japan or made investigative trips to Japan prior to being elected to office.) When the Wuchang uprising broke out, Tang and the assembly sided with the insurgents; since the Hubei viceroy's mansion was burned down, the assembly hall naturally became the headquarters of the revolution.

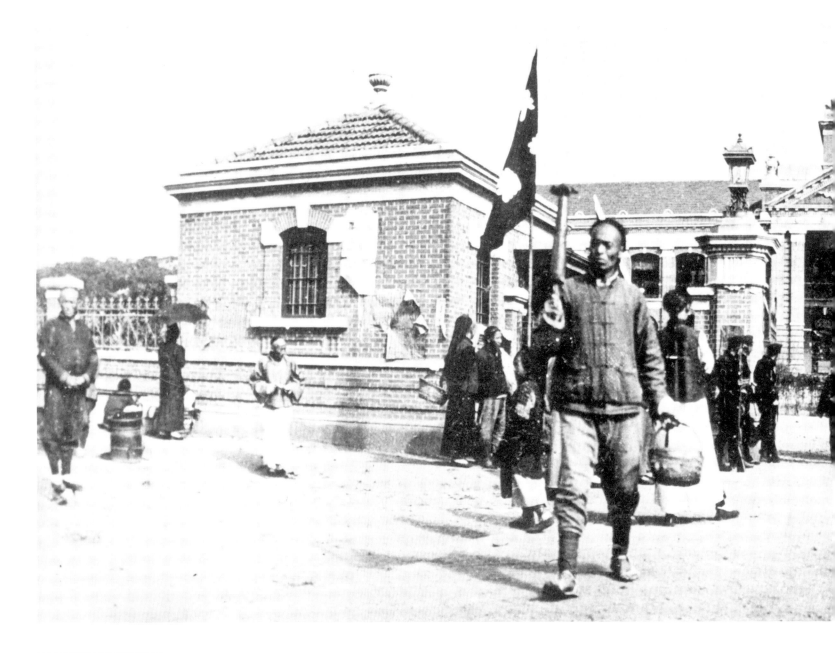

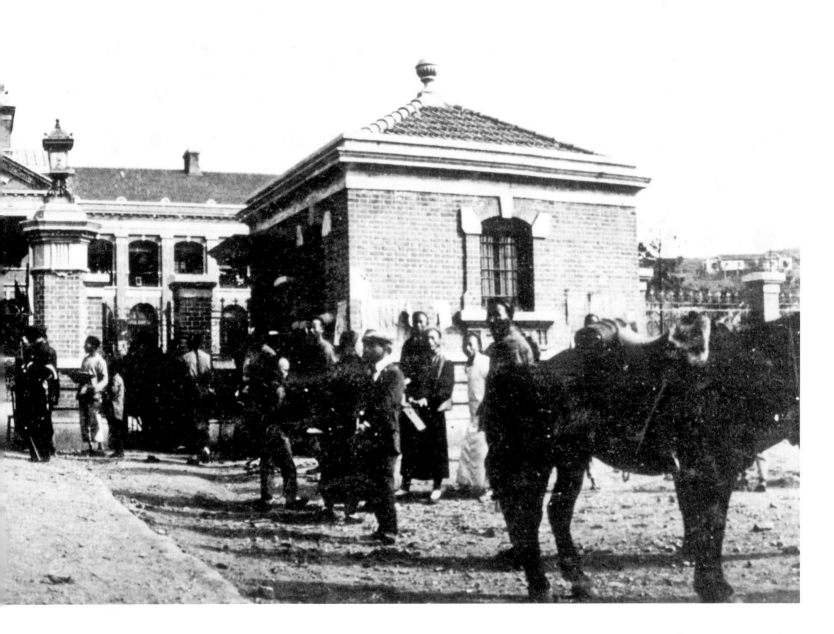

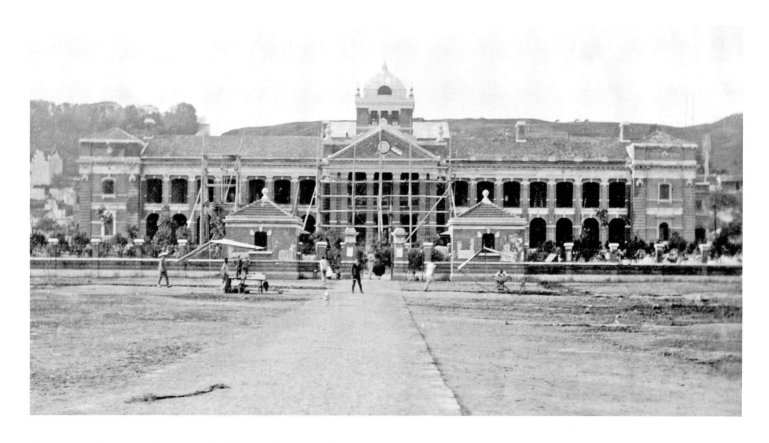

THE HUBEI MILITARY Government's office was hit by a bomb
on December 1, 1911. The building underwent repairs soon after.

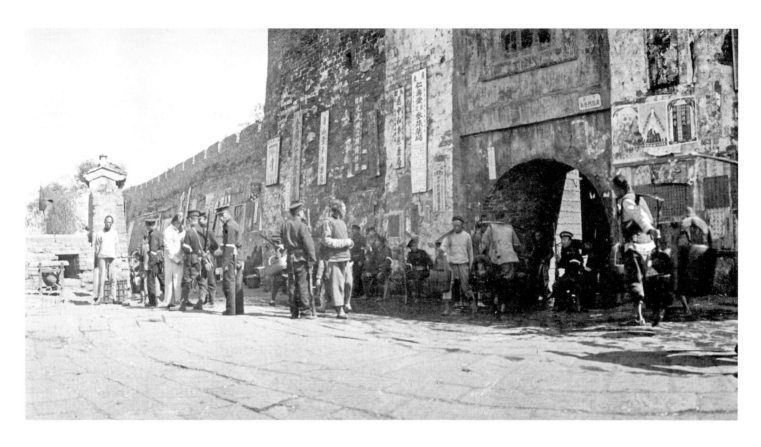

AFTER OCCUPYING WUCHANG, the revolutionaries quickly sent troops to secure the major city gates. Here insurgent soldiers are guarding the Hanyang Gate, the main access to the Yangzi River, and screening pedestrians.

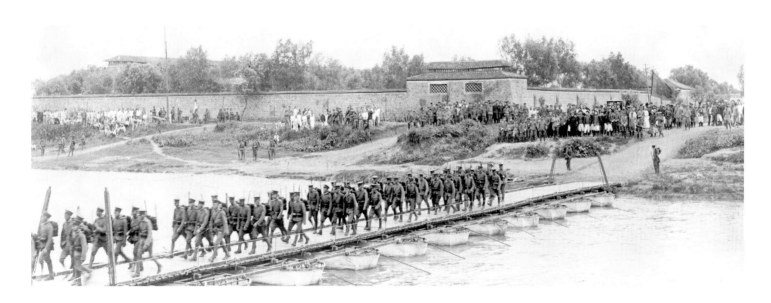

Revolutionary troops crossing the Yangzi River from Wuchang to Hankou on the second day of the uprising. At this spot the river is 1,126 meters wide, one of its narrowest points.

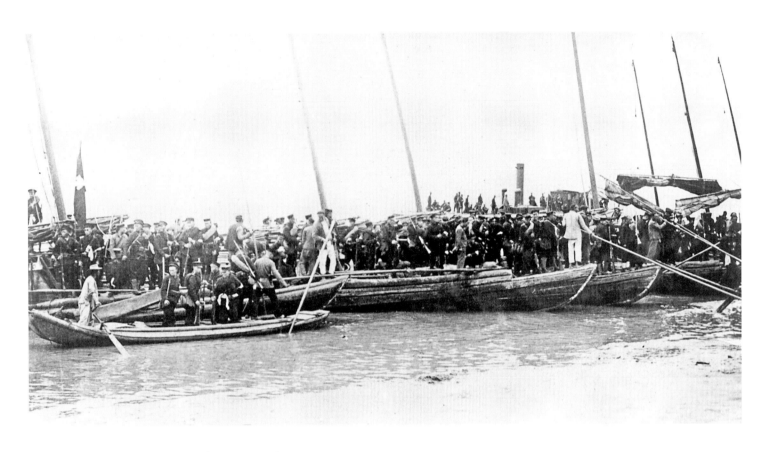

WITH THE HELP of local volunteer boatmen, revolutionary troops
reached the shores of Hankou.

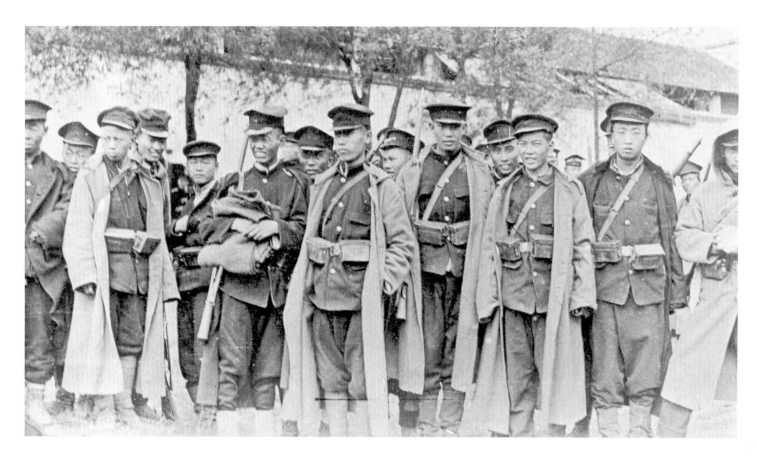

AFTER CONQUERING HANYANG on October 11, the revolutionary army needed to recruit soldiers to battle the imperial army that was marching southward to the area. The recruitment was surprisingly smooth. In just a week more than 30,000 volunteers from the Wuhan area had joined, reflecting the popular support of the revolution in the region. However, the new soldiers hardly had a chance to be trained before they went into battle. As Edwin Dingle observed at the time, the story of revolutionary recruits was often "enlisted on Tuesday, drilled on Wednesday, shot on Thursday."

Opposite INSURGENTS RESTING on the banks of the Xiang River, a branch of the Yangzi River that runs through Hankou. Note a dog is snoozing by the soldiers in the foreground, reflecting a peaceful moment between battles.

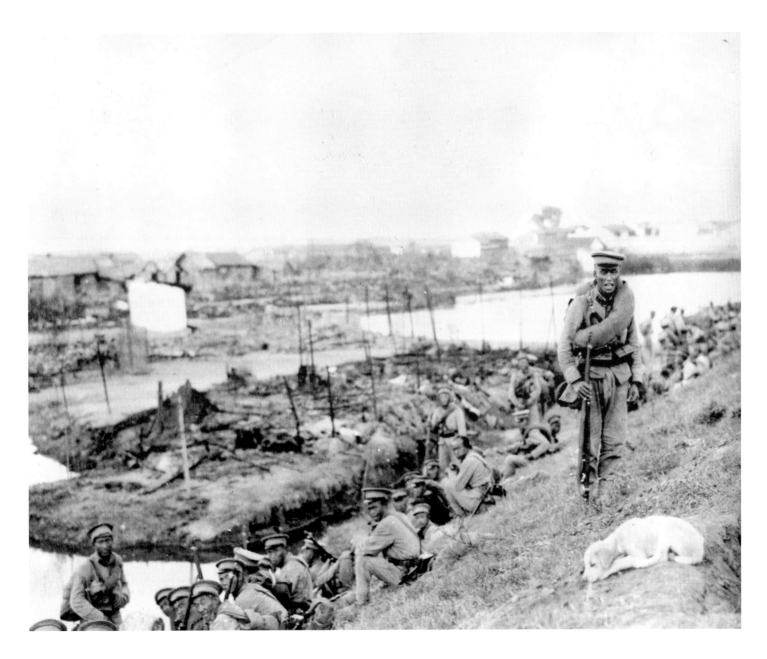

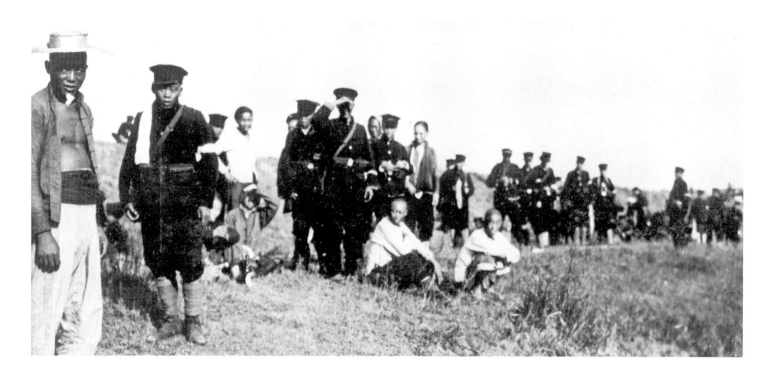

IT WAS REPORTED that during the war the people of Hankou often offered food to the insurgents as a way of showing their support of the revolution.

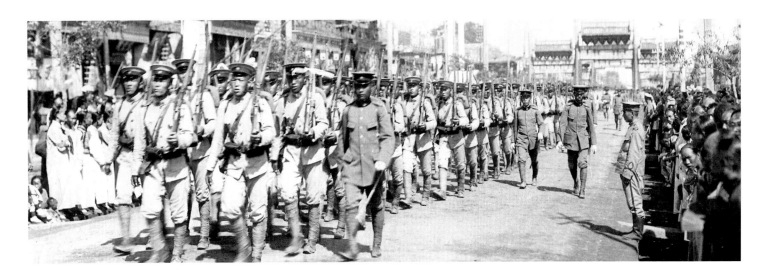

ON OCTOBER 11, an emergency cabinet meeting presided over by Prince Qing was held in Beijing to deal with the uprising in Wuchang. The German-trained Manchu general Yinchang (1859–1928) was appointed commander in chief and ordered to lead two divisions of the army to suppress the rebels. The next day, the imperial army left Beijing for Wuhan.

Overleaf QING ARTILLERY preparing for action against the rebels in the south. Photo taken in October 1911 at the Autumn Drill Ground in suburban Beijing.

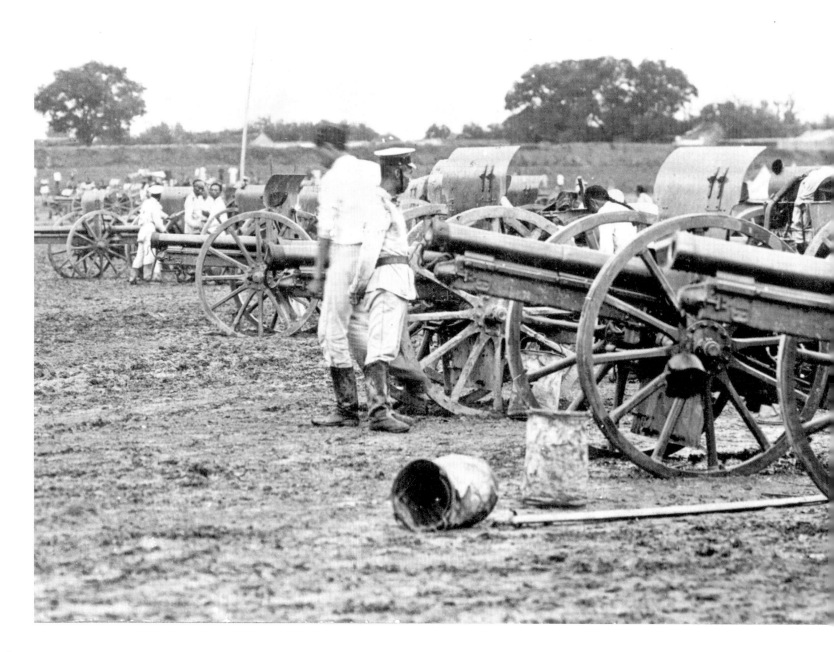

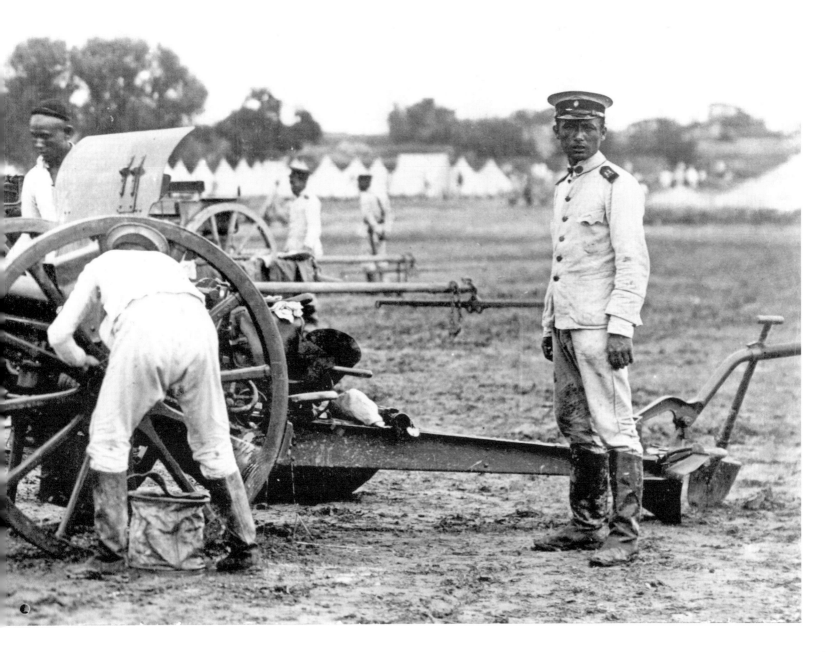

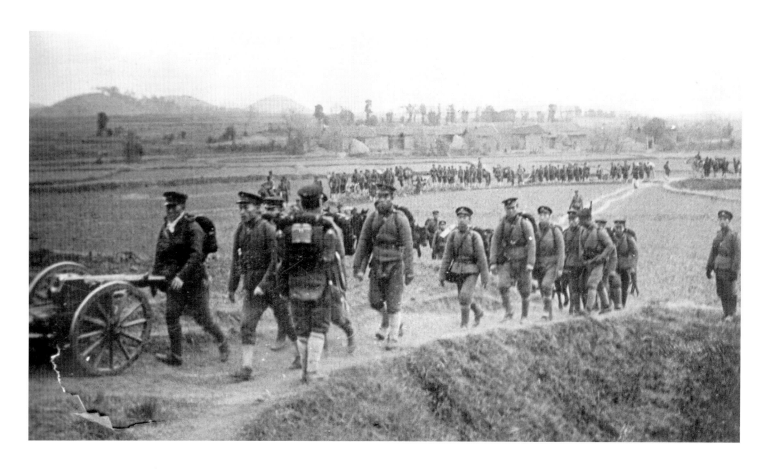

FROM SHEKOU, A town about twenty miles north of Hankou, imperial artillery troops crossed the plain between the two towns and on October 24 attacked the rebels at Liujiamiao, near Hankou.

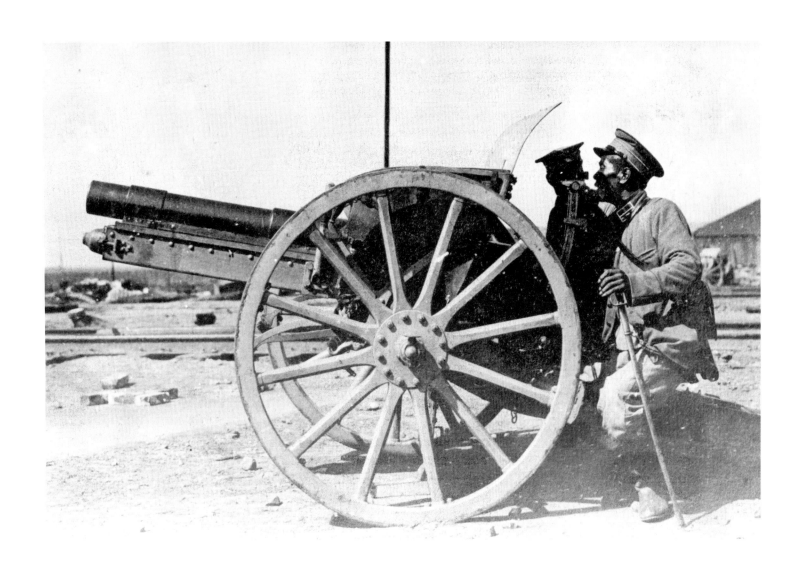

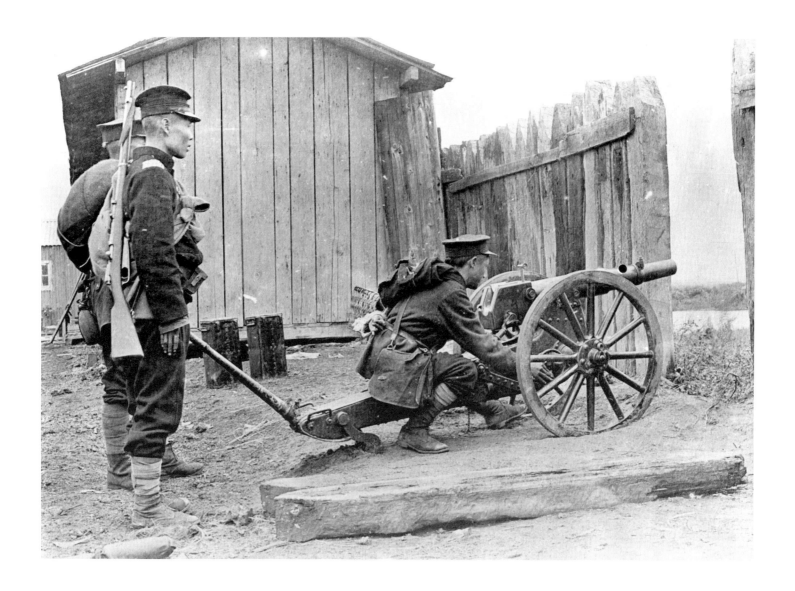

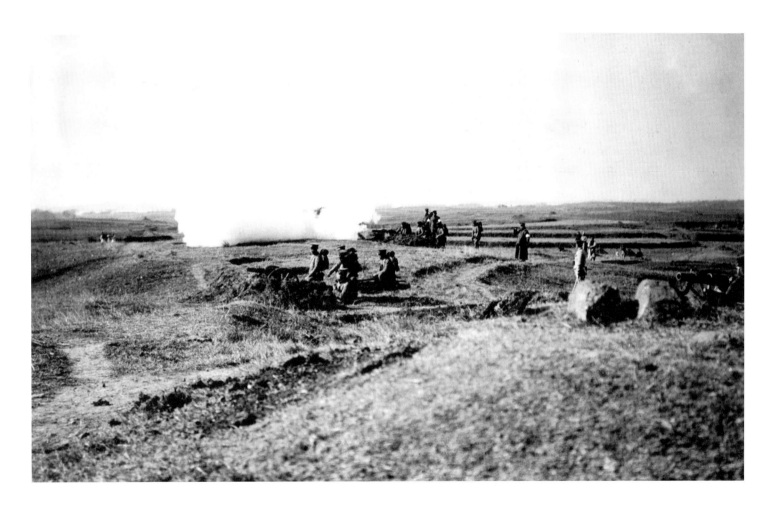

THE REBELS FOUGHT BACK fiercely but were disadvantaged by outdated equipment. The imperial troops had the latest type of heavy-duty mountain artillery and high-yield explosives; the revolutionaries had neither.

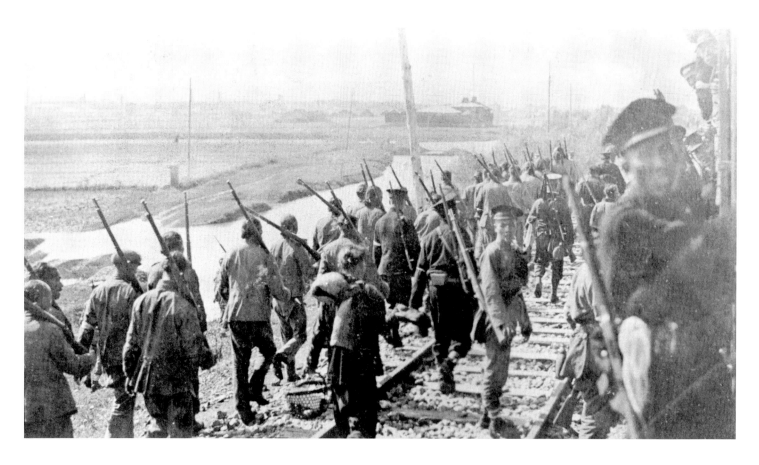

REBEL TROOPS RETREATING from Liujiamiao to Dazhimen after the
bombardment of Hankou by imperial artillery on October 27, which
caused over five hundred military and civilian casualties.

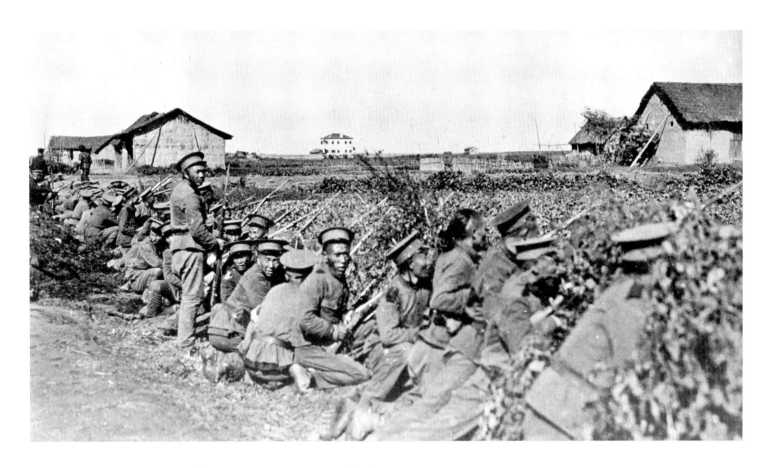

SINCE THE HUBEI REBELS came from New Army regiments outfitted
by the provincial government, their supplies and equipment were
inferior to those of the Qing imperial forces from the north. Many
insurgent troops were sent to the front lines without even basic rifle
training. Here, in defending Hankou, about a hundred rebel soldiers
are deployed in a field near the Dazhimen Railway Station.

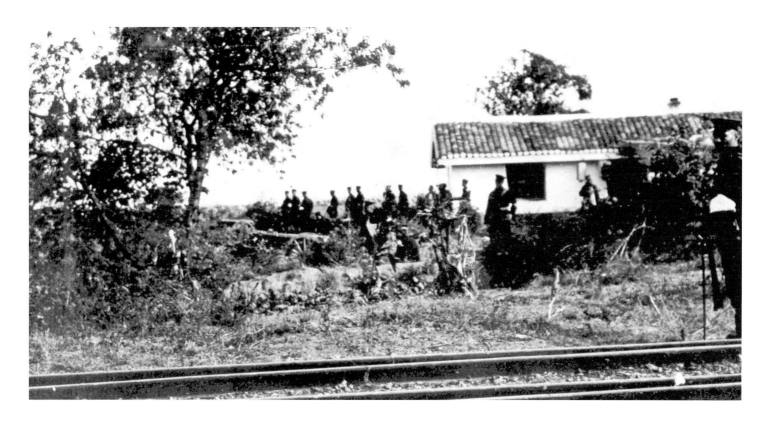

INSURGENTS MOVING ALONG the railroad track near Dazhimen, in
suburban Hankou. After forty-nine days of fierce fighting in defense of
Hankou and Hanyang, the rebels lost Hankou to the imperial troops
on November 1 and then had to abandon Hanyang on November 27.

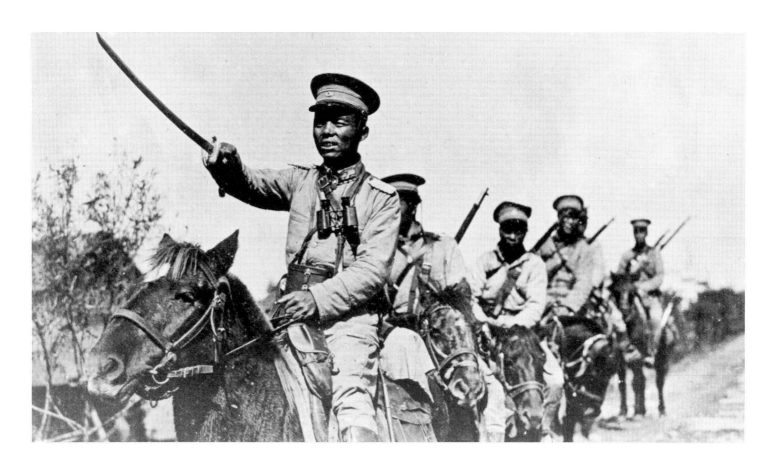

IMPERIAL SCOUTS ENTERING Hankou. Equipped with modern
telecommunications devices, these cavalrymen collected intelligence
and contributed significantly to the Qing government's recapture of
Hankou and Hanyang in November 1911.

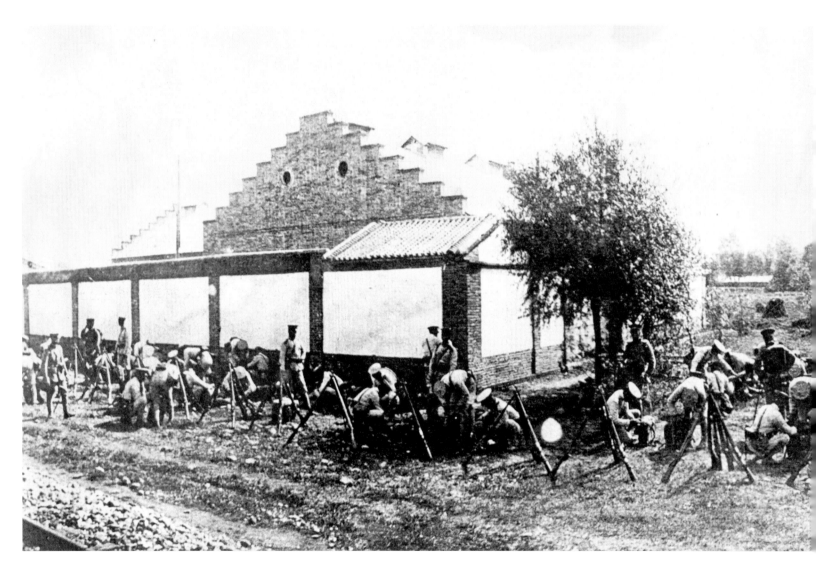

SOLDIERS OF THE IMPERIAL ARMY in the Dazhimen Railway Station preparing for battle. Most of the imperial units sent to suppress the rebels were from the New Army. Except for the suppression of the Boxers in Shandong in 1899, the battle against the revolutionaries marked the New Army's first real combat since its founding in 1895.

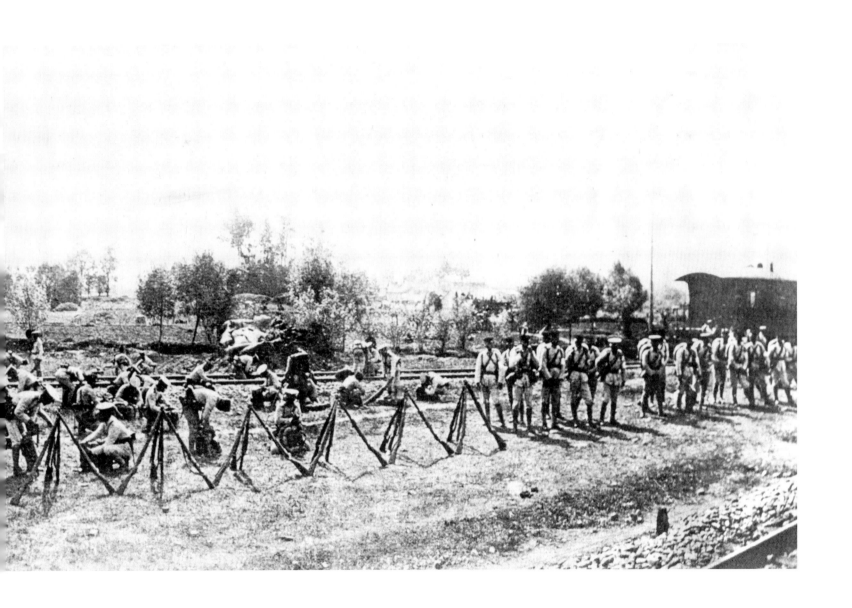

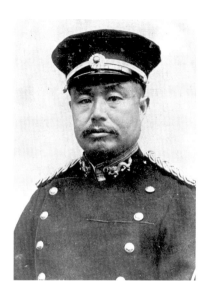 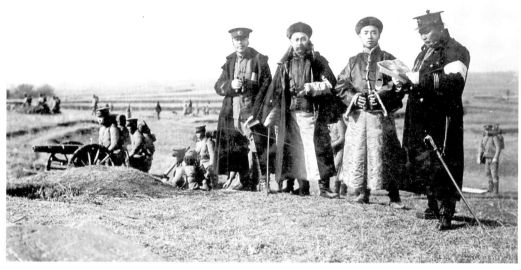

Left THE WUCHANG UPRISING made Li Yuanhong (1864–1928), then the head of the 21st Regiment of the New Army, which was stationed in Hubei, an instant political star. The revolutionaries were mostly lower-ranking army officers. After the initial victory in Wuchang they needed a person of high status and good reputation to preside over the new government. All the high-ranking officials had fled, with the exception of Li, who happened to be the only one in town who fit the bill. Li was forced to serve as governor of the newly founded Hubei Military Government. Not particularly sympathetic to the revolution—in fact, he had personally shot two rebels at the beginning of the uprising—Li waited for three days before he agreed to serve. It was rumored that the insurgents had to physically drag him out from under his bed to serve as the figurehead of the revolution.

Right ON THE BATTLEFIELD in Hankou, Li Yuanhong (far right, holding an urgent document) and his advisors are commanding the rebel artillery arrayed against the imperial army.

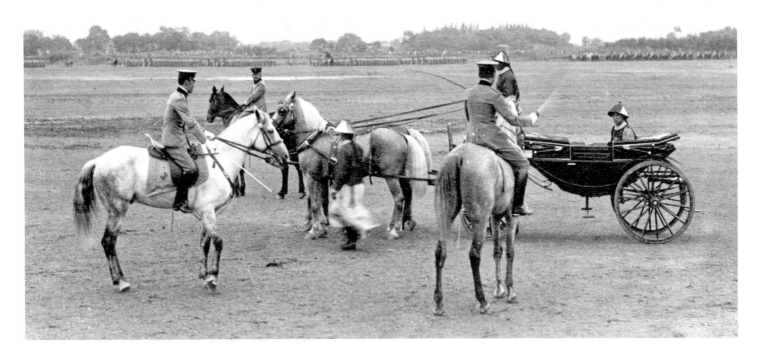

ON THE OTHER SIDE of the conflict, at Beijing's Autumn Drill Ground, Qing officials are reporting the situation in Wuhan to the Manchu Prince Regent Chun (sitting in the carriage). In 1909, Prince Chun forced Yuan Shikai to retire in order to concentrate power in the hands of the Manchu court. It was said Prince Chun dismissed Yuan Shikai because he hated him for betraying his half-brother (the Guangxu Emperor) in the 1898 reform, which paved the way for the Empress Dowager to place the emperor under house-arrest for the rest of his life. Whatever his motivation, Prince Chun was incapable of handling complex political issues and lacked the base that Yuan had in the military. By October 21, the imperial court had brought Yuan back and appointed him prime minister.

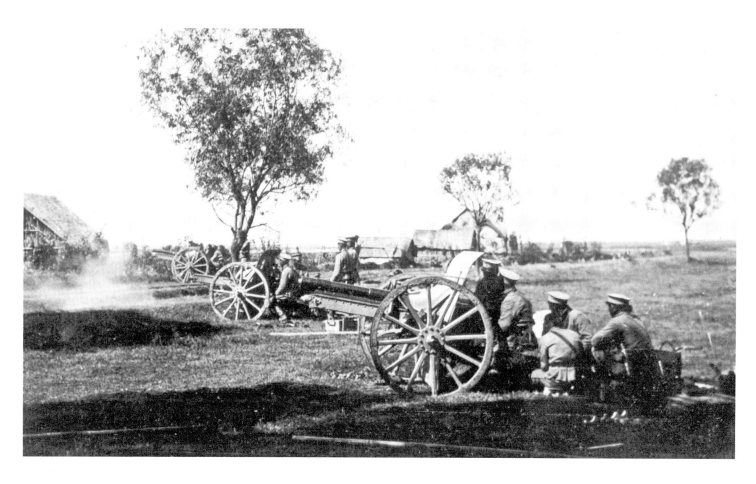

ARTILLERY TROOPS in battle in Hankou. These soldiers were part of the Qing imperial army that moved into the Wuhan area to fight the insurgency in October and November of 1911. These batteries were positioned on the Dazhimen European Golf Course adjacent to Hankou's foreign settlements. Artillery shells from these batteries were partially responsible for setting fire to the Chinese section of Hankou. However, most of the damage to the city came from artillery shells fired by imperial navy ships on the Yangzi River on the other side of the city.

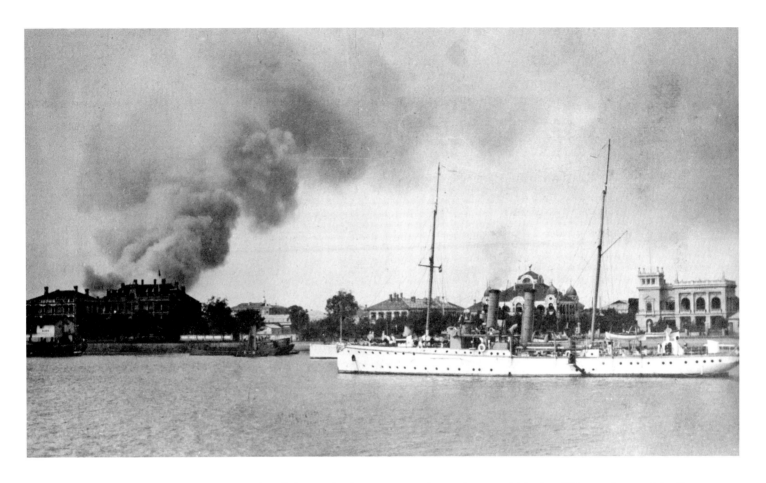

WESTERN GUNBOATS on the Yangzi River anchored close to the shore alongside the foreign concessions while smoke from fires touched off by the artillery bombardment rises from the city. The foreign powers declared neutrality during the war, but by October 22, twenty foreign gunboats—eight British, five German, three American, two Japanese, one Russian, and one Austrian—had navigated up the Yangzi River to Hankou and were on high alert. This area is part of the German Concession in Hankou: the building on the far right is the Deutsche Asiatische Bank (a German bank founded in Shanghai in 1889; this Hankou branch was established in 1897); next to it is the German consulate.

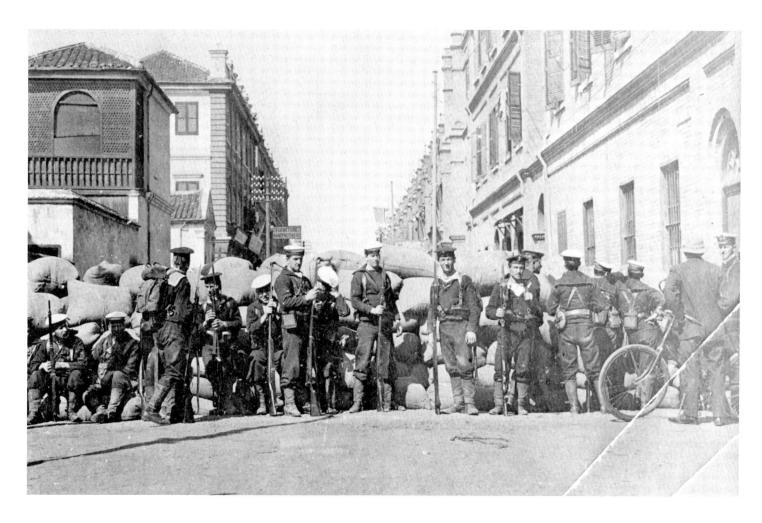

As a result of the Second Opium War (1856–60), Hankou was opened as a treaty port in 1862. By the early twentieth century, the British, Russians, French, Germans, and Japanese all had concessions in Hankou situated side by side along the north embankment of the Yangzi. Pictured here are Western sailors setting up street barricades in the foreign concessions during the revolution, preventing any possible intrusion by either side of the conflict.

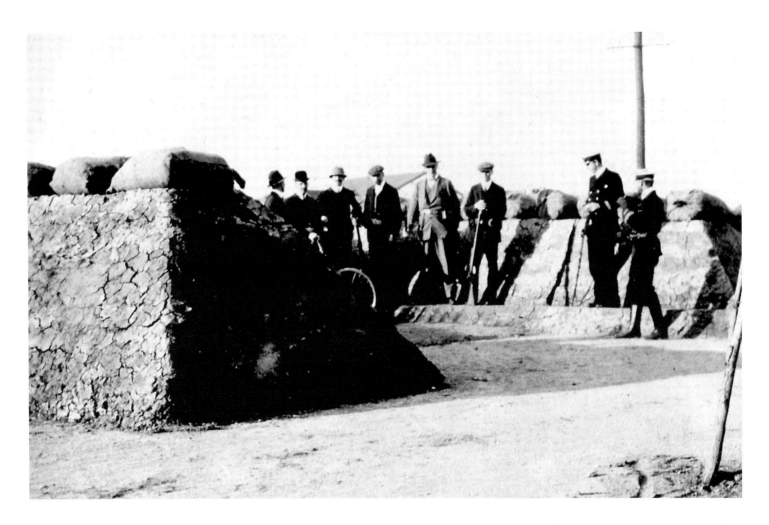

A DETACHMENT IS WORKING on a fortification to protect the British Concession in Hankou.

Overleaf FROM THE ROOF of the Japanese consulate in Hankou foreigners are watching the street battle that followed the imperial army's counterattack on October 18, 1911.

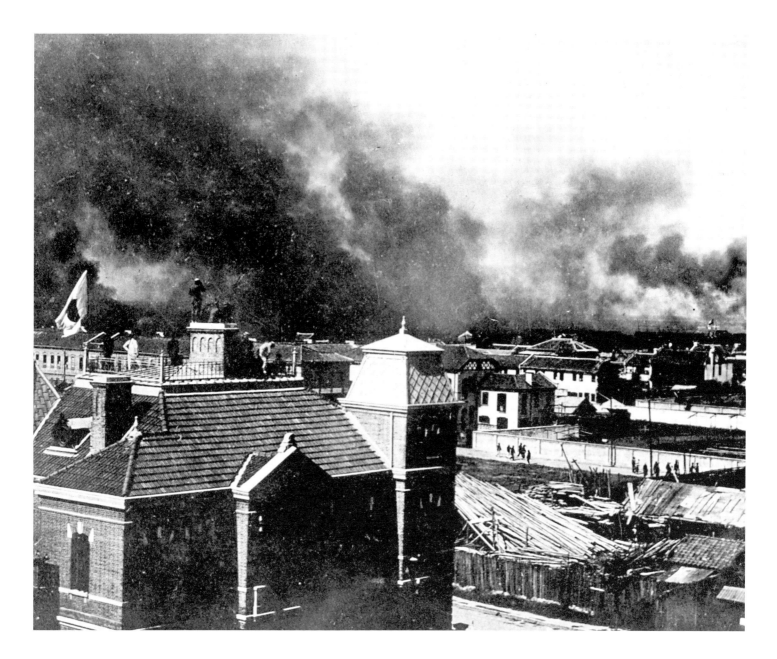

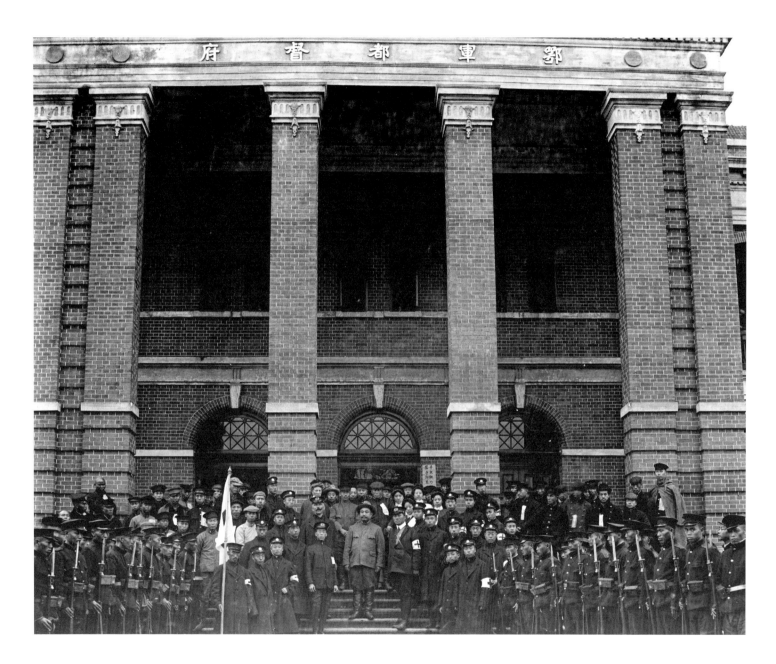

Preceding page LI YUANHONG (*center*), who spoke some English, receives members of the Red Cross in front of the governor's office of the Hubei Military Government. To his right is Dr. Stafford M. Cox, the chief medical officer of the Red Cross Society. The Shanghai-based Red Cross team arrived in Wuhan on October 28. It did more than provide medical aid to the rebels: secretly arriving with the Red Cross team was Huang Xing (1874–1916), a top leader of the Revolutionary Alliance whose prominence in the revolution was second only to that of Sun Yat-sen. On November 3, Huang was formally appointed the commander in chief of the revolutionary army battling against the Qing troops counterattacking Wuhan.

ON NOVEMBER 7, on behalf of her husband, Mrs. Li Yuanhong (in the middle, behind a seated soldier) visited a Red Cross hospital, giving out oranges and silver dollars to wounded soldiers of both sides. The revolutionaries' cooperation with the Red Cross indicated an understanding of the modern notion of humanity in warfare, which at the time was still a new concept in China.

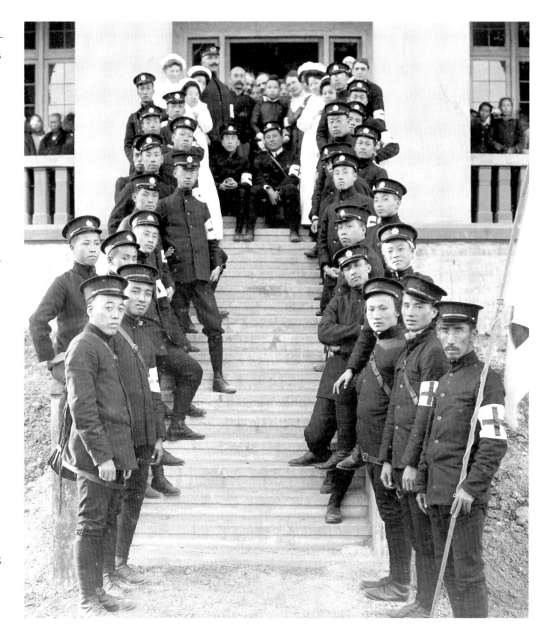

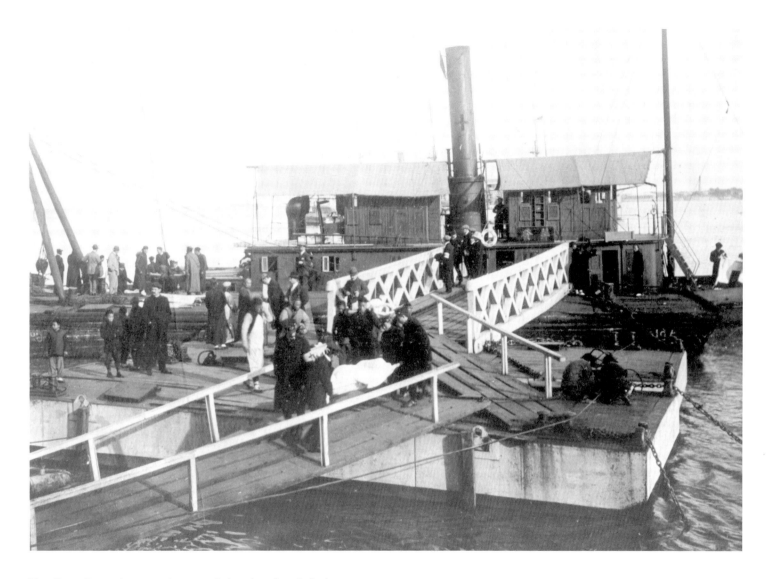

THE RED CROSS is evacuating wounded to three hospitals that were established for the war victims in Hankou, Wuchang, and Hanyang, respectively.

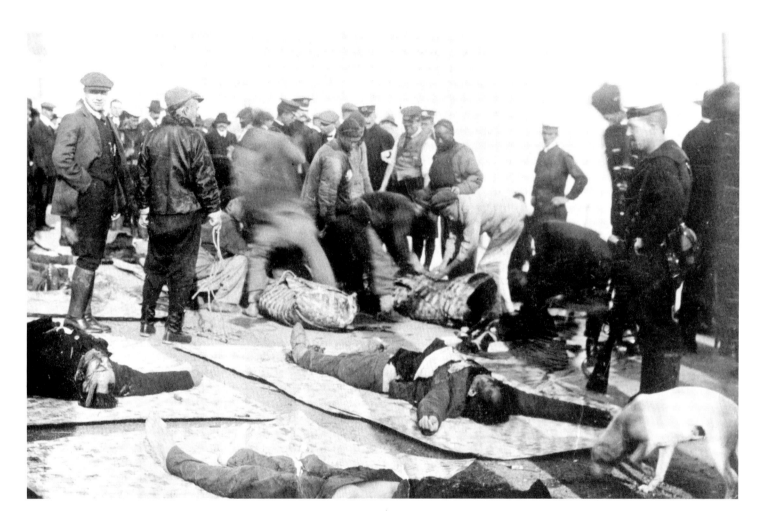

ON NOVEMBER 27 the rebels retreated via small boats from Hanyang to Wuchang across the Yangzi River. Drifting along the river, some of them were rescued by the Red Cross; many others drowned or were hit by the imperial army's Maxim guns. The dead were taken to this Red Cross boat anchored in Hankou's British Concession.

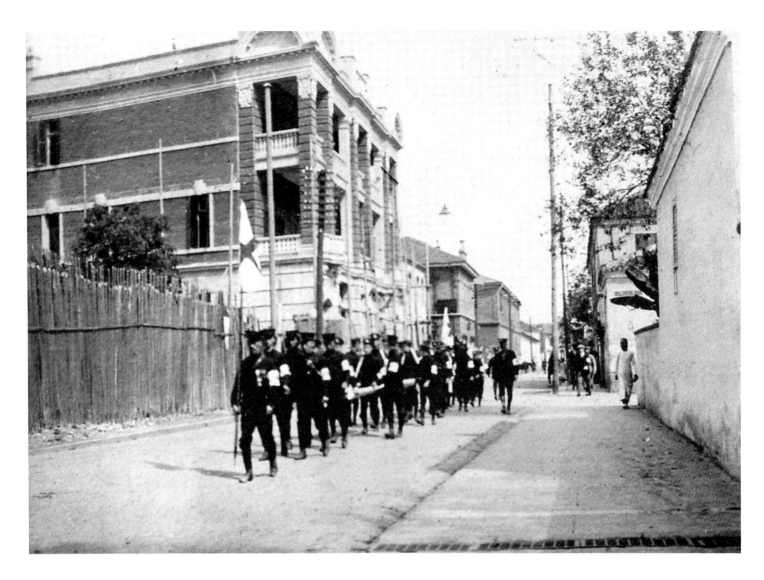

Revolutionary soldiers working with the Red Cross to
evacuate the wounded to the Wushenmiao Hospital in Hankou.

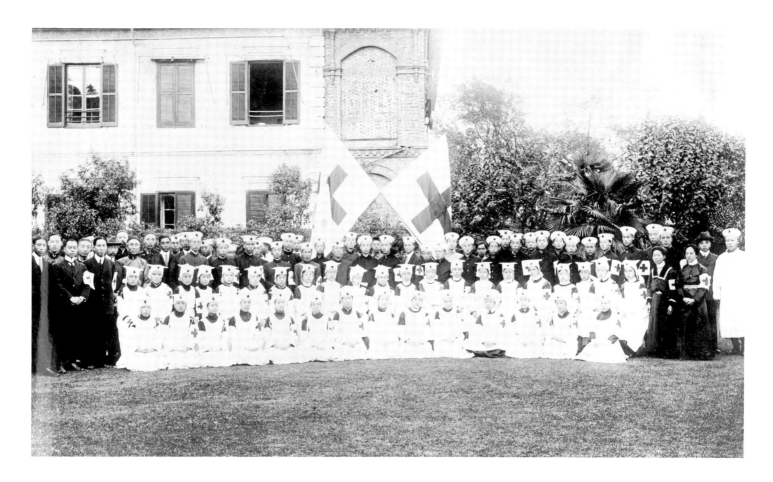

AFTER MORE THAN A MONTH of intensive rescue work on the front lines in Wuhan, the Red Cross team returned to Shanghai on December 28 and received a warm welcome. The team leader was Zhang Zhujun (1876–1964; in this picture, second woman from the right in the second row), founder of the Shanghai Red Cross and the Shanghai Women's Medical School. Zhang was a well-known doctor trained in a missionary-sponsored medical school in her hometown of Guangzhou (Canton) and had founded two hospitals there before she came to Shanghai in 1904. Although not a perfect analogy, Zhang's work during the revolution earned her the reputation as "another Florence Nightingale," referring to the famous British nurse who had just passed away the year before. The fourth person from the left in the second row is Wu Tingfang (Ng Choy, 1842–1922), the so-called Peace Commissioner who represented the revolutionaries in negotiations with the imperial government.

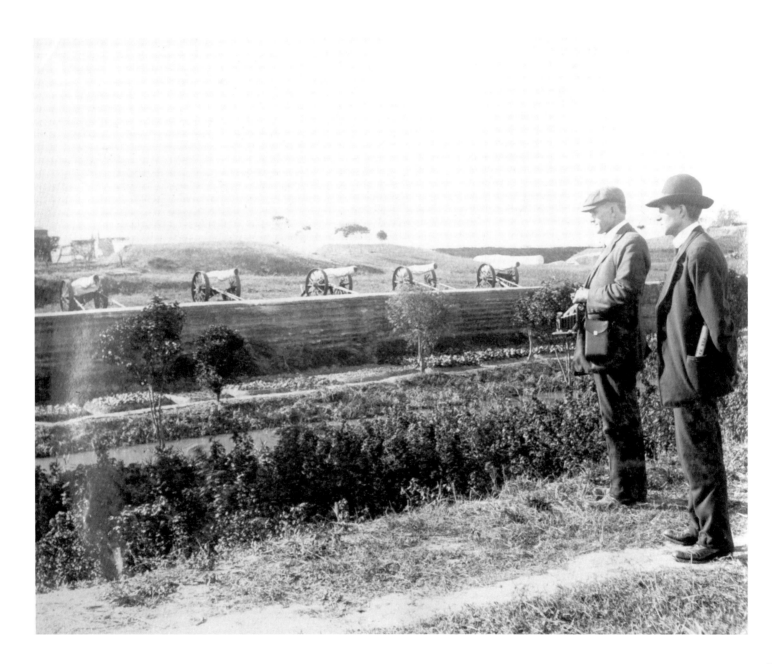

Preceding page WESTERNERS, with no documents but courage, could go to the front lines to observe the war and conduct interviews with both sides. For instance, Edwin J. Dingle of the *China Press*, a newly launched English-language newspaper in Shanghai, was one of the few foreign reporters in Hankou at the time of the revolution. The Associated Press sent its Asian correspondent, Frederick McCormick, to Wuhan soon after the outbreak of the war. Each man published a monograph on the Chinese revolution immediately after the war.

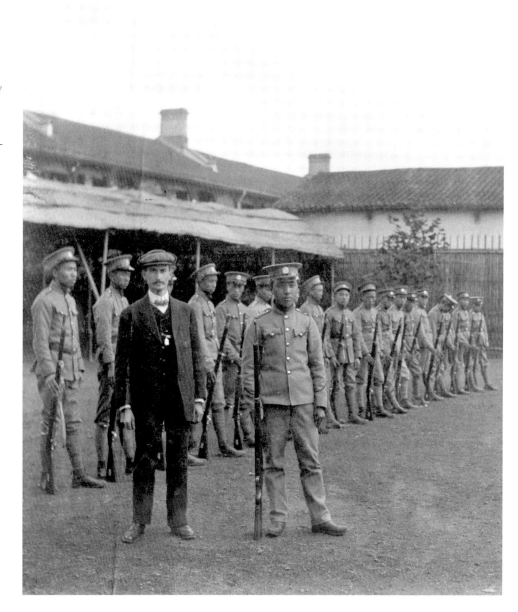

FRANCIS STAFFORD POSING with Qing imperial army troops. Because he was a foreigner without political ties to either side and because he represented a publisher that disseminated news to a large number of readers, he was allowed access to the military on both sides of the conflict.

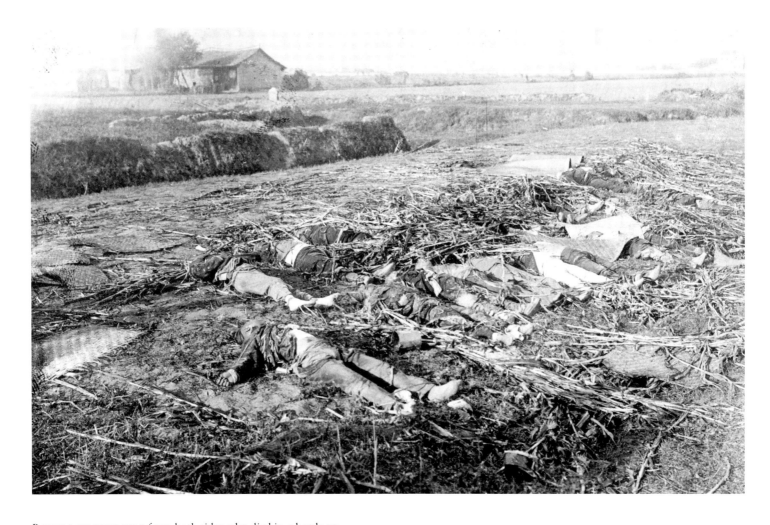

BODIES OF SOLDIERS from both sides who died in a battle on
October 18 near Liujiamiao Station on the outskirts of Hankou.
The insurgents defeated the Qing army in that battle.

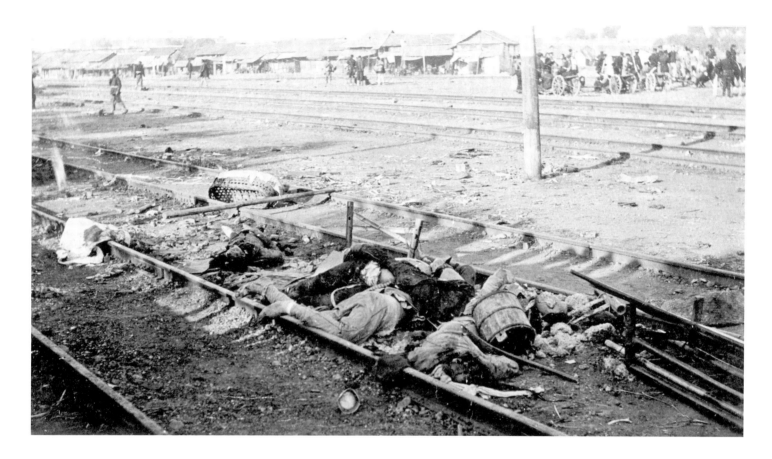

DURING COMBAT near the Liujiamiao Railway Station, imperial
soldiers on a running train gunned down rebels. To prevent a recur-
rence—and also to take revenge—the revolutionaries broke open several
coffins containing imperial army dead and threw the corpses onto the
railroad tracks.

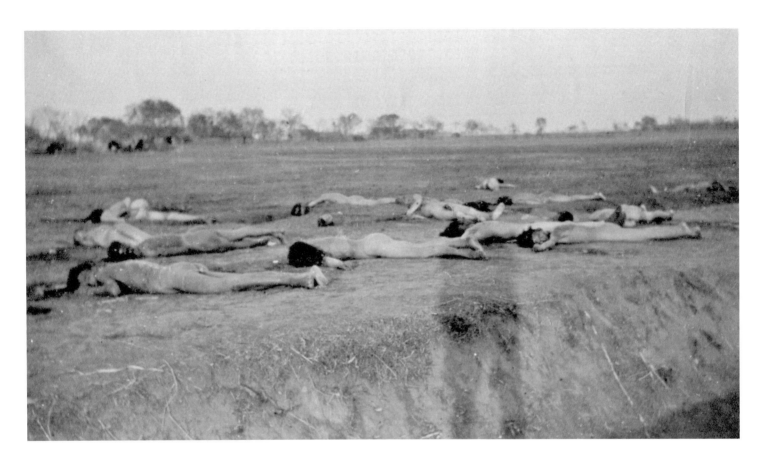

ON THE AFTERNOON of November 27, after seven days of heavy resistance, the revolutionaries lost Hanyang to the imperial army. Corpses lay unattended on the battlefield for days afterward. The clothes of the dead might have been scavenged by the poor in the town or nearby villages. An estimated 3,300 insurgents died or were wounded in the failed defense of Hanyang. The Wuchang uprising is not among the most violent rebellions in Chinese history; still, there was considerable bloodshed. More than 5,000 insurgents died during the two months of combat in the Wuhan area; only 32 were identified by name. Thousands more were wounded.

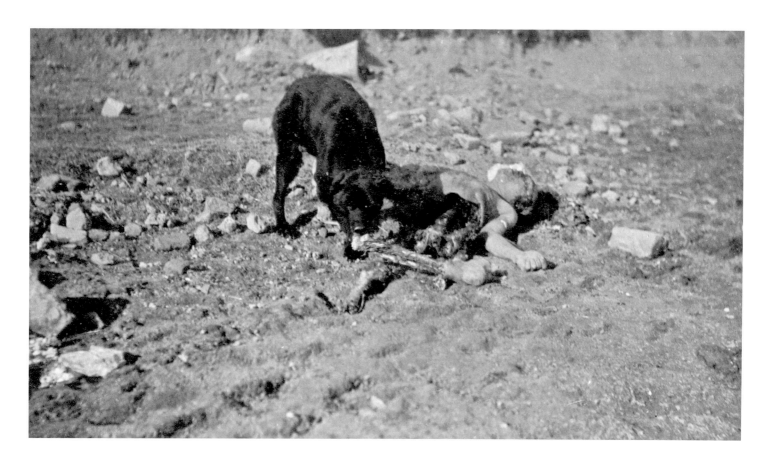

A STRAY DOG scavenging a corpse.

BOTH SIDES SUFFERED heavy casualties in the Dazhimen battle on
October 27. As Edwin Dingle noted, after the heavy fighting around
Dazhimen, "nearly all the work of collecting the dead for burial fell to
the lot of foreigners." With the help of foreigners, cartloads of bodies
were shipped to makeshift burial grounds.

A BAMBOO SHED used as a mortuary. The wooden coffins were typically made of low-priced willow. This type of rudimentary facility for the dead was usually provided by charities and, despite its crudity, helped prevent large-scale epidemics during the war.

Opposite AFTER THE IMPERIAL ARMY retook Hankou in late October, the commander, Feng Guozhang (1857–1919), ordered his troops to set fire to the city. From October 30 to November 2, Hankou was aflame, leaving hundreds of thousands of people homeless.

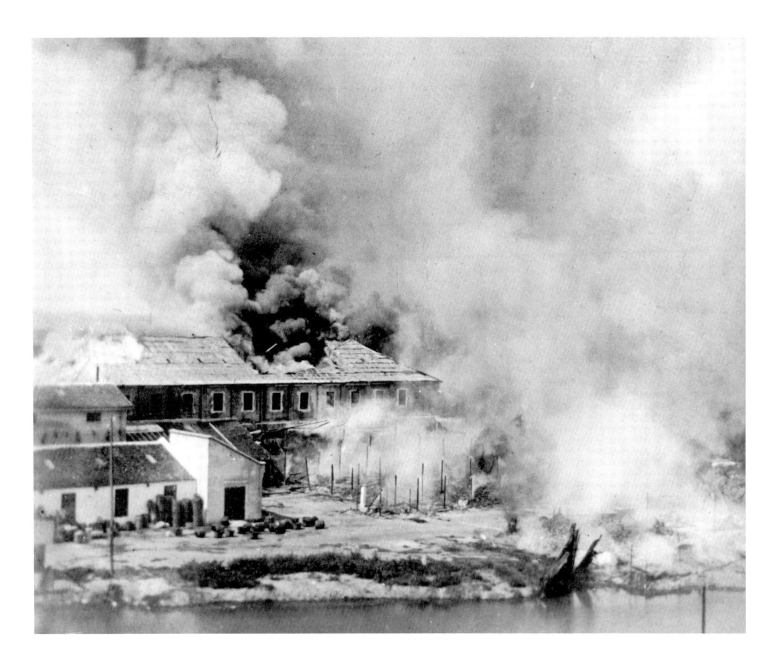

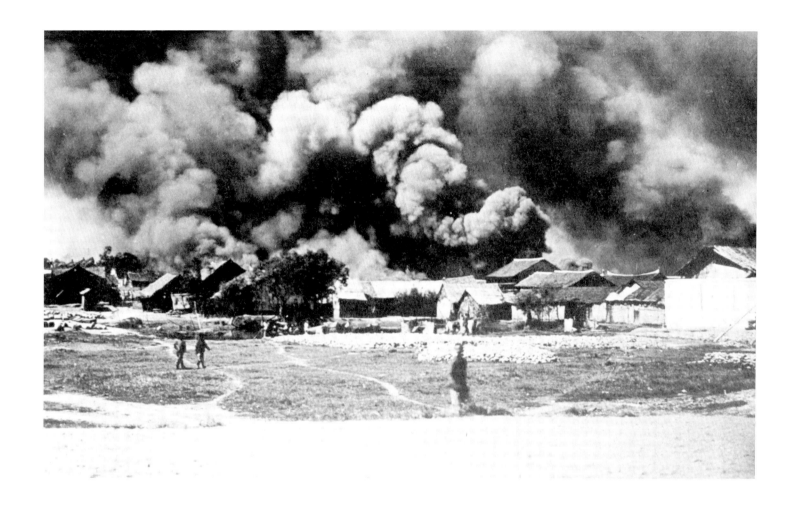

Opposite Hankou in early November, after the fire. About a
fifth of the city was totally burned down. To the right, a few shop signs
are still visible. The large vertical sign that reads "Making Wonderful
Cakes of All Nations," which apparently belonged to a bakery, is a sad
reminder of the cosmopolitanism of the city before the war.

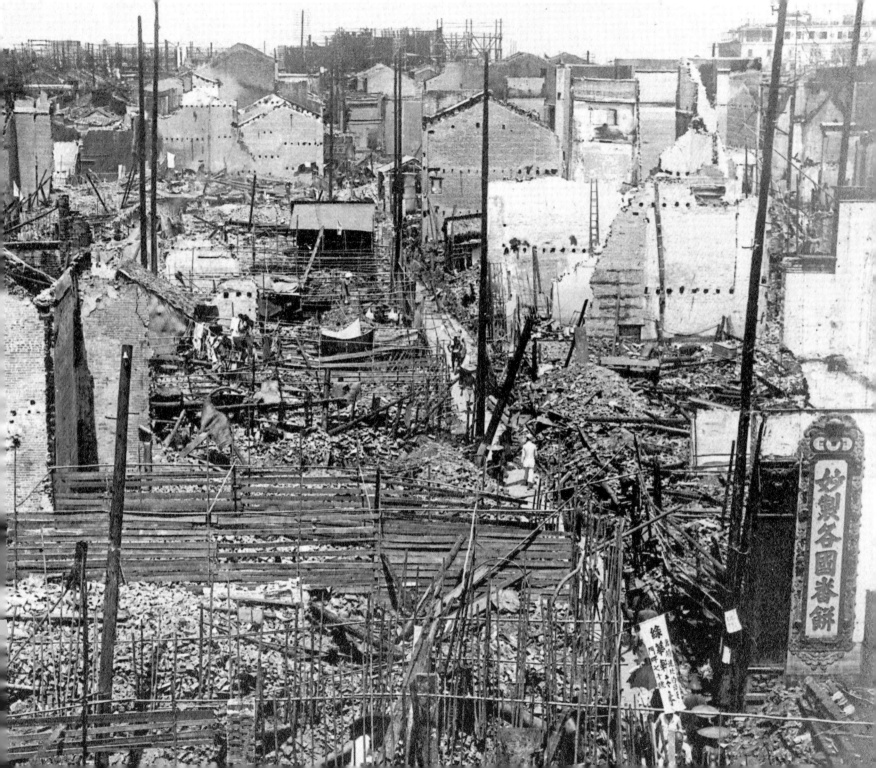

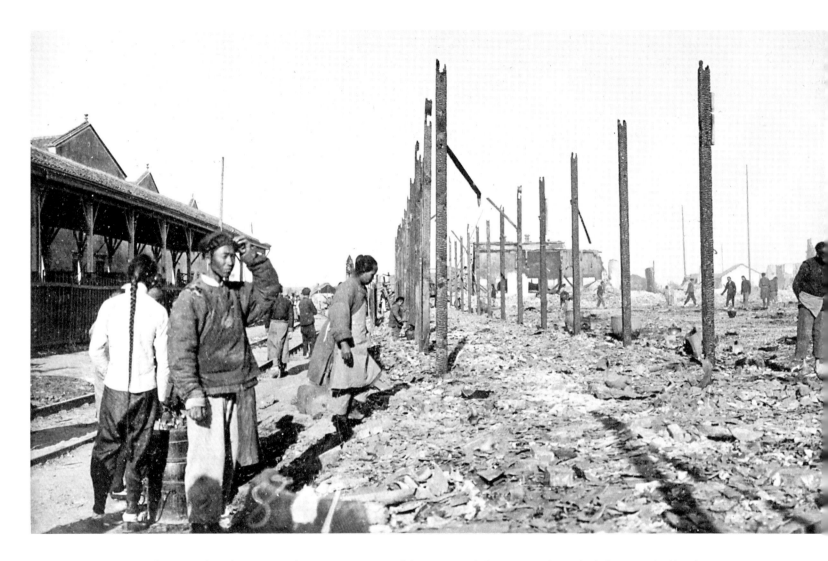

Although in terms of property loss the 1911 Revolution was not among modern China's most destructive wars, this formerly busy commercial district adjacent to the Hankou Railway Station was totally razed during the fighting. As the intensity of the war waned at the end of the year, people began returning to look for any valuables that may have been left among the ruins. These men and women could be former occupants or just "treasure hunters."

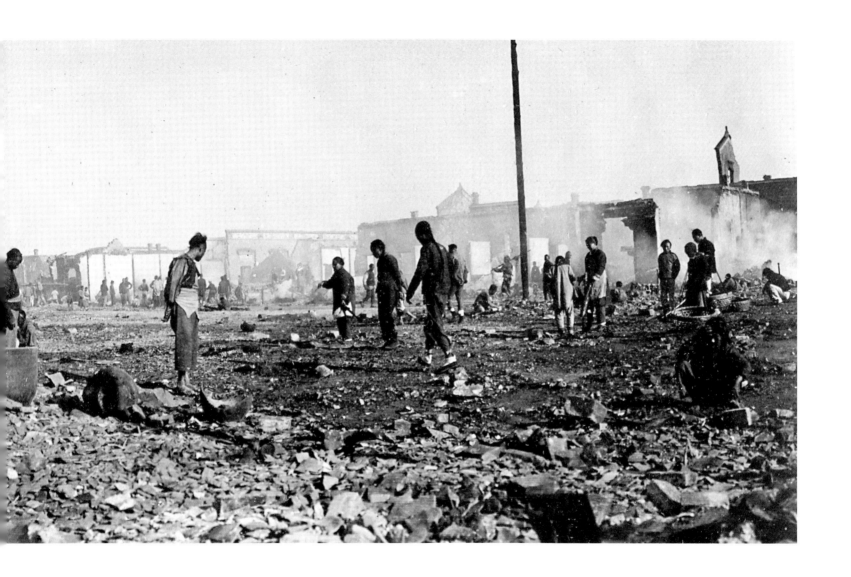

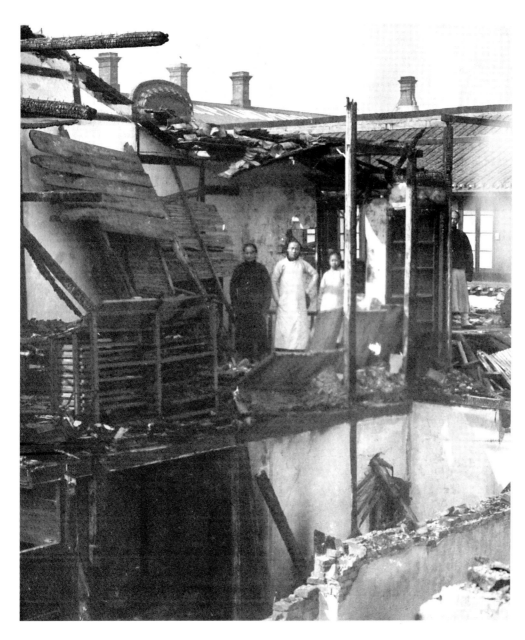

MEMBERS OF AN AFFLUENT FAMILY return home after the combat, only to find that bombs have left it in ruins.

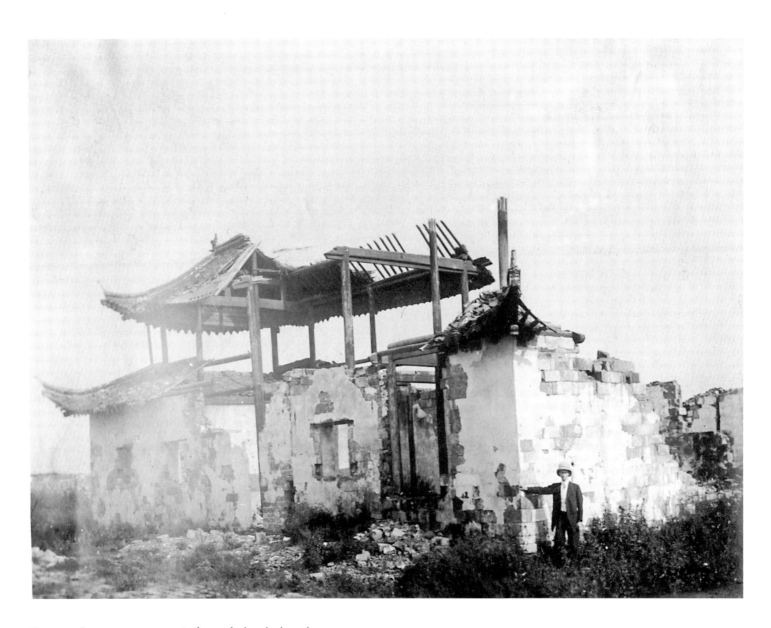

FRANCIS STAFFORD STANDS in front of a bombed-out house.

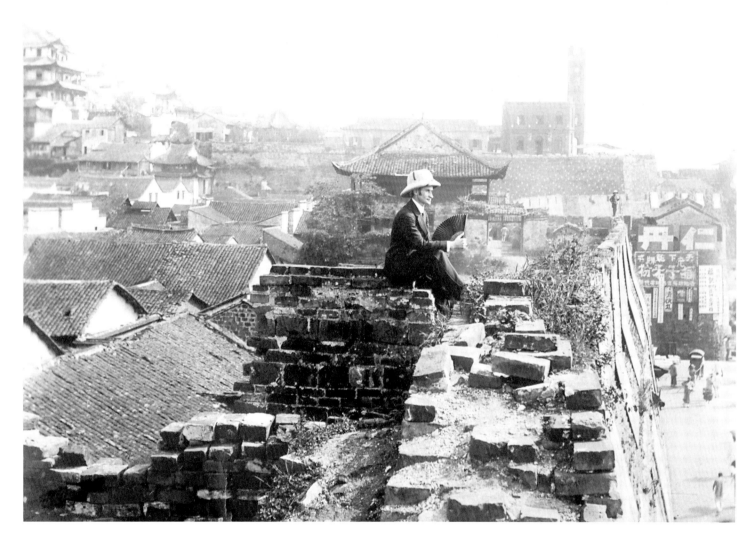

Francis Stafford sits nonchalantly on top of the city wall of Wuchang, probably after the revolution. In the background is the bell tower where the revolutionaries once hung a huge banner displaying the popular slogan "Lift up the Han, Wipe out the Manchus" (*Xing Han Mie Man*), aiming to use the "race card" to mobilize the majority Han Chinese against their Manchu rulers.

3

THE POLITICS OF CHAOS

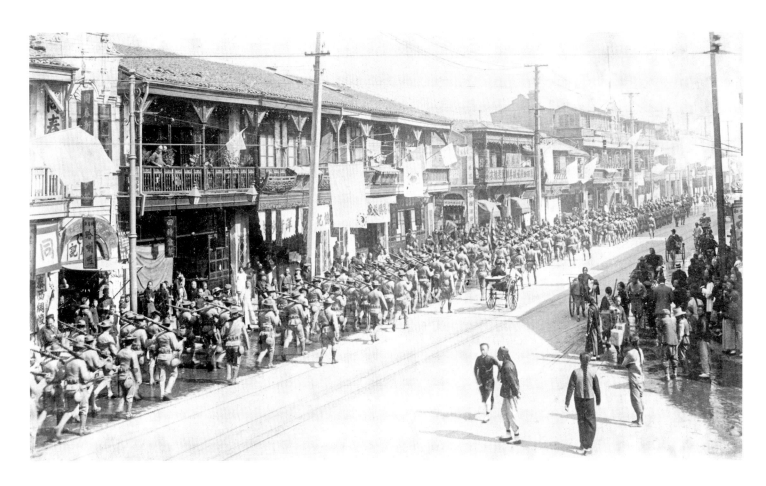

Troops of the Shanghai Volunteer Corps (SVC) on Nanjing Road, Shanghai's main thoroughfare, during the 1911 Revolution. Founded in April 1853 by the British, American, and French consuls in Shanghai to protect the foreign settlements from the Small Swords, a local rebellion against the imperial government, the SVC was a paramilitary organization. After the revolution broke out in Wuchang, Shanghai—with the exception of the foreign concessions—was occupied by revolutionary troops in early November. The revolutionary govern-ment in Shanghai declared independence from Beijing while the West-ern powers claimed neutrality and sent SVC troops to patrol Shanghai's main streets. Similar policies of neutrality were adopted by the Western authorities in Shanghai during the Taiping Rebellion of 1850–64, the warlord battles in 1924, and the Sino-Japanese War in 1937, effectively making Shanghai "a state within a state" for nearly a century. The SVC was disbanded in June 1942 by the Japanese, who had occupied Shang-hai after the outbreak of the Pacific War.

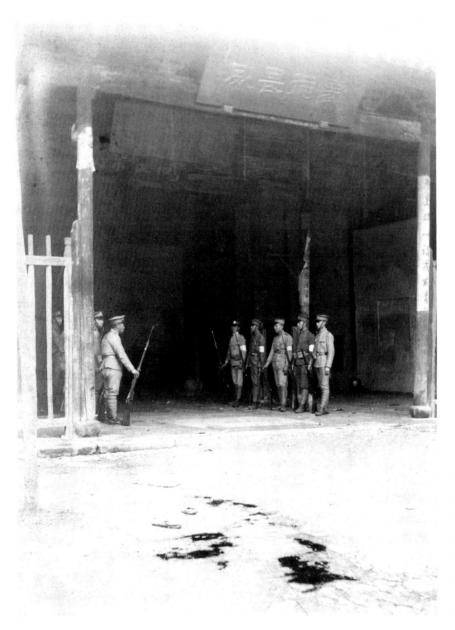

THE SHANGHAI COUNTY YAMEN was seized by the revolutionaries on November 3, 1911. The horizontal board atop the gate reads "Cherish Morality to Enforce Authority." Since many Qing soldiers stationed in Shanghai crossed over to the revolutionaries, the revolt was not particularly violent. Still, the yamen was set afire and there was bloodshed. Note that in the foreground blood is still visible.

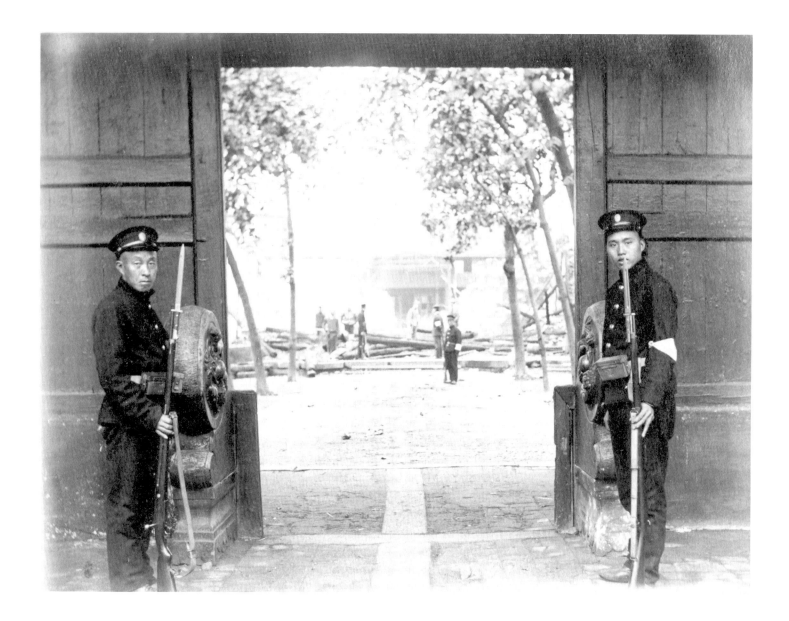

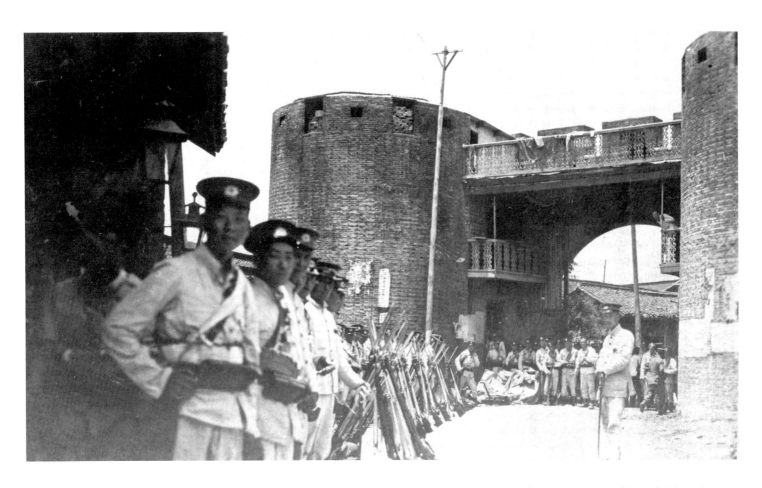

Opposite ON NOVEMBER 3, 1911, the revolutionary troops took over the headquarters of the Shanghai Daotai ("Circuit Superintendent") in the old walled city and burned down the buildings in the Daotai's compound. The Shanghai Daotai, Liu Yanyi, and the Shanghai county magistrate, Tian Baorong, both fled to Shanghai's foreign concessions. Here in the picture two soldiers are guarding the gate of the Daotai's just-captured headquarters. In the background, smoke is still billowing out of the ruins of the main building.

ON NOVEMBER 4, 1911, after sixteen hours of fierce fighting, the revolutionaries seized the Jiangnan Arsenal, located in the southern outskirts of Shanghai, just beyond the city wall. The arsenal, established in 1865 as part of the Qing government's Self-Strengthening movement, was China's most important munitions factory as well as its major military depot. Occupying this arsenal was critical to the success of the revolution in the Yangzi delta region. This photo was taken soon after the revolutionaries captured the arsenal's east gate.

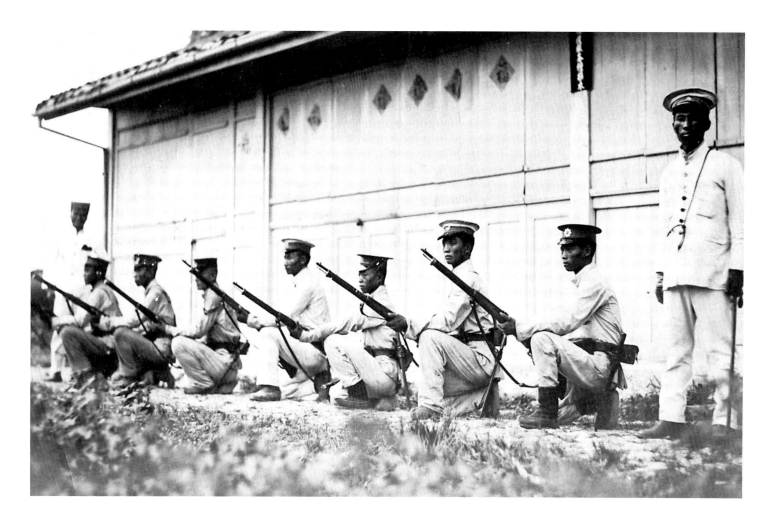

WHILE THE INSURGENTS in Hankou were being defeated by the impe- rial troops in early November, the victory in Shanghai fortified the foundation of the revolution in the rich Yangzi delta area and inspired insurgents in other parts of the country. It also effectively cut the supply of arms to the imperial troops on the Hankou front. Consolidating this victory was thus vitally important to the revolutionaries. Here rebel soldiers in the Jiangnan Arsenal are on high alert for possible counter- attacks by imperial troops.

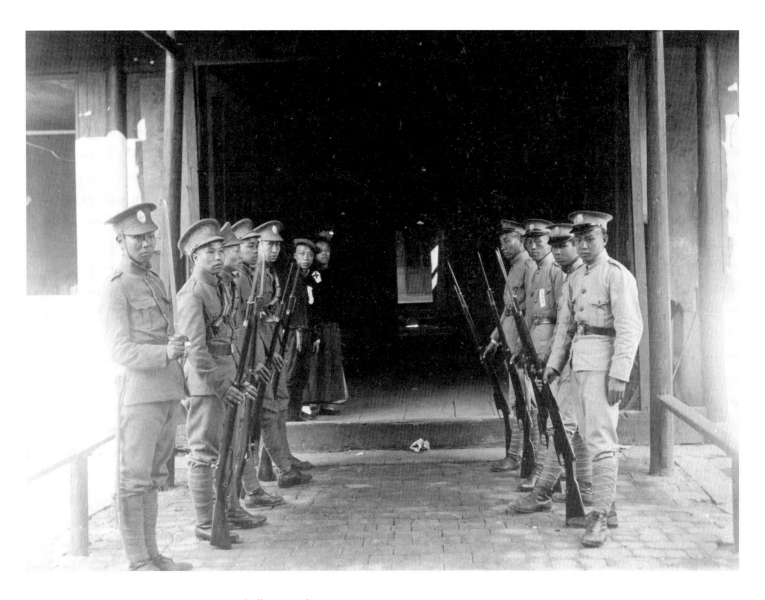

REVOLUTIONARY SOLDIERS GUARDING a hallway inside
the Jiangnan Arsenal.

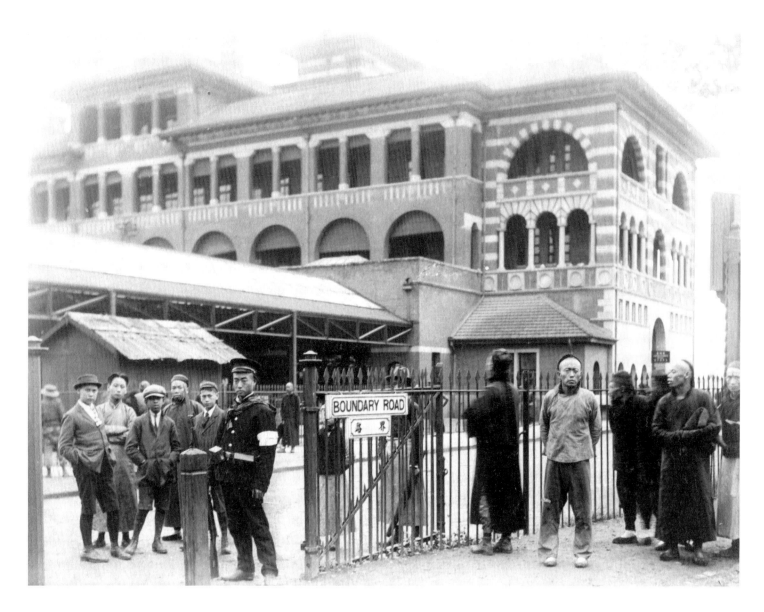

A REVOLUTIONARY SOLDIER guarding the Shanghai Railway Station.

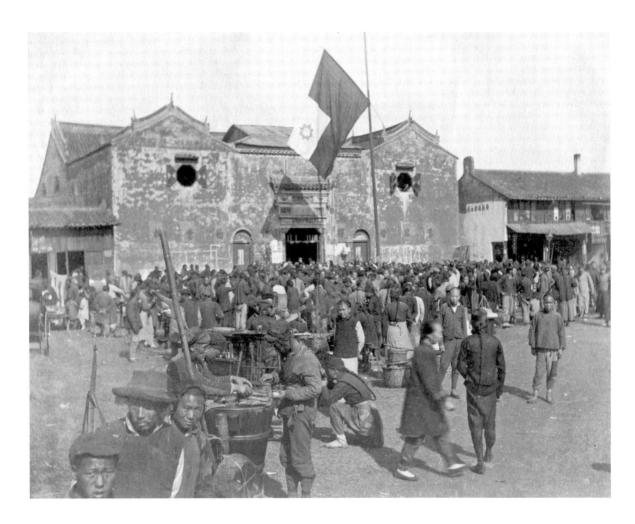

THE REVOLUTIONARIES IN SHANGHAI repurposing Jingtuan ("Pure Land Convent"), a Buddhist temple in Zhabei (the Chinese district of the city north of the International Settlement), as an induction center. In the foreground, street peddlers are serving snacks and pedestrians are idling along, reflecting the generally calm atmosphere in the city at the time of revolution. Hanging from the roof of the building is the revolutionary army flag, designed by a few members of the Revolutionary Alliance in 1906. Although Sun Yat-sen was strongly in favor of using it as the national flag of the Republic, it was not until 1928, when Chiang Kai-shek (1887–1975) established the Nationalist government in Nanjing after the Northern Expedition, that it became the flag of the Republic of China.

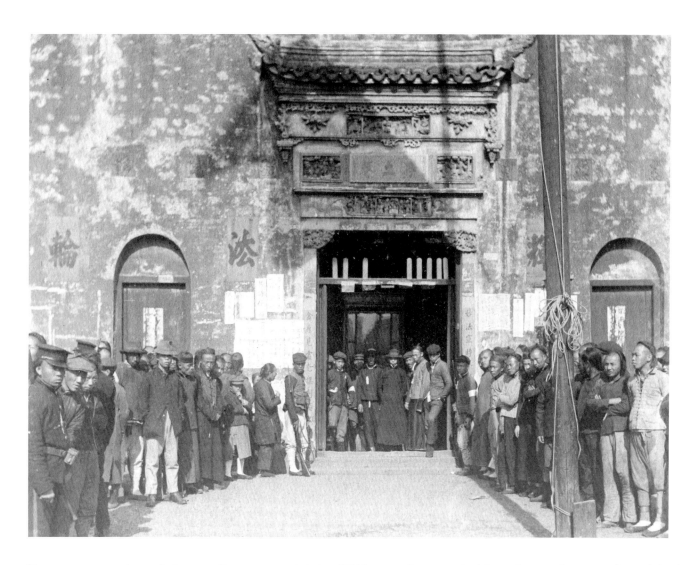

THE RESPONSE to the revolutionary call-up was overwhelming. Within three days all the quotas were filled and the Shanghai military authorities suspended the recruitment. These young men lined up in front of the induction center are eager to join the army. Later, over four hundred students organized themselves as volunteers and joined the Shanghai revolutionary troops in a military campaign in Shandong province. Another five hundred young men formed a "dare-to-die" corps and went to Wuchang to join the troops at the heart of the revolution.

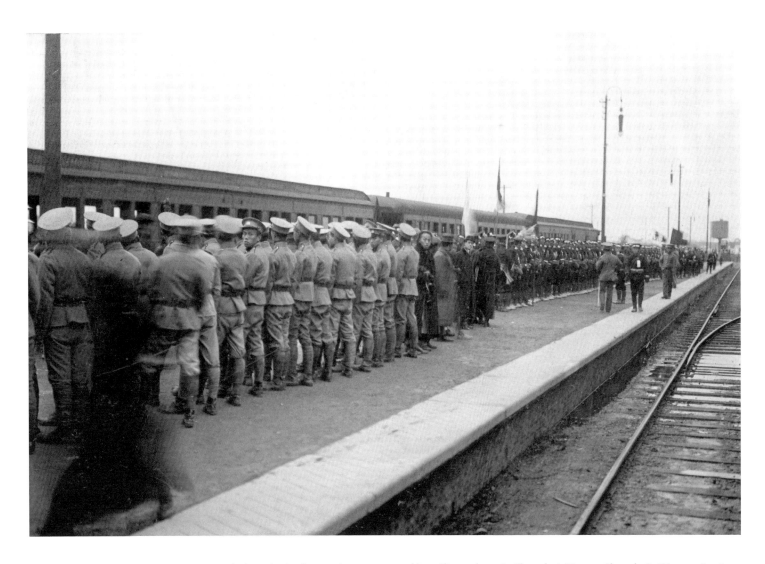

AFTER THE SHANGHAI UPRISING, revolutionaries in the provinces of Jiangsu and Zhejiang formed a military alliance in mid-November aimed at capturing Nanjing, the major city in the region. The alliance set up its headquarters in Zhenjiang, a city forty miles east of Nanjing, and its military depot in Shanghai. Here at Shanghai's Wusong Station allied forces are entraining for the 162-mile trip to Nanjing.

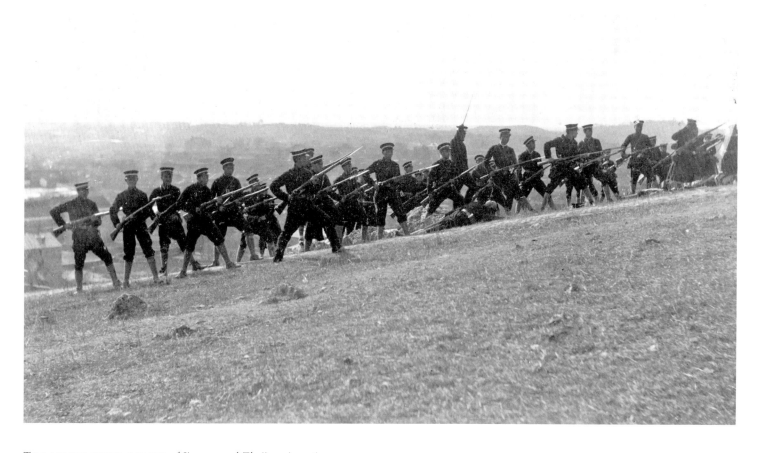

THE ALLIED REBEL FORCES of Jiangsu and Zhejiang in action.
Headed by former New Army general Xu Shaozhen (1861–1936), the
allied forces seized Nanjing on December 2.

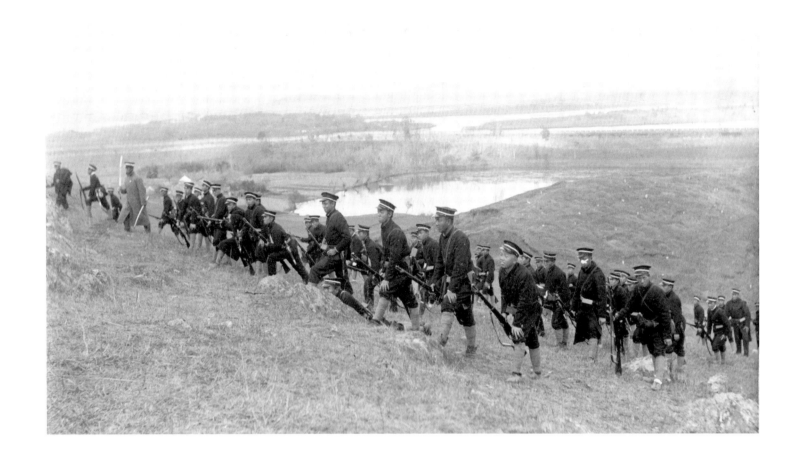

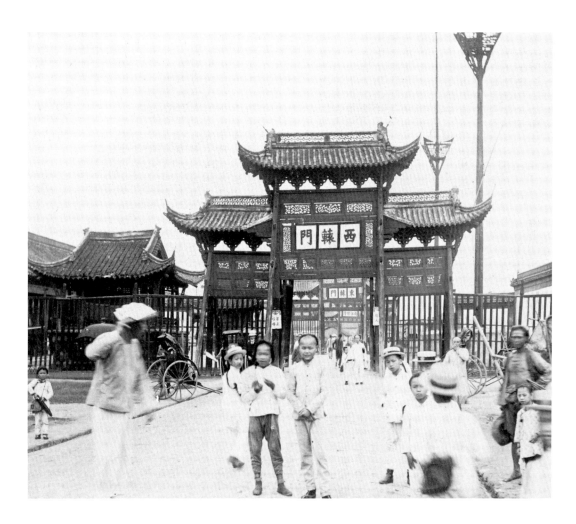

THE HEADQUARTERS of the governor-general in Nanjing. The revolutionary army began the conquest of Nanjing on November 23. After ten days of fighting on the outskirts, the troops marched into the walled city on December 2, 1911, without further bloodshed. According to eyewitnesses, "the residents peacefully welcomed the army, with cheers resounding like rolls of thunder." Seizing Nanjing was a watershed in the revolution: it cleared the way for the revolutionaries to designate the city as the capital of the new government. A month later in Nanjing Sun Yat-sen announced the founding of the Republic of China.

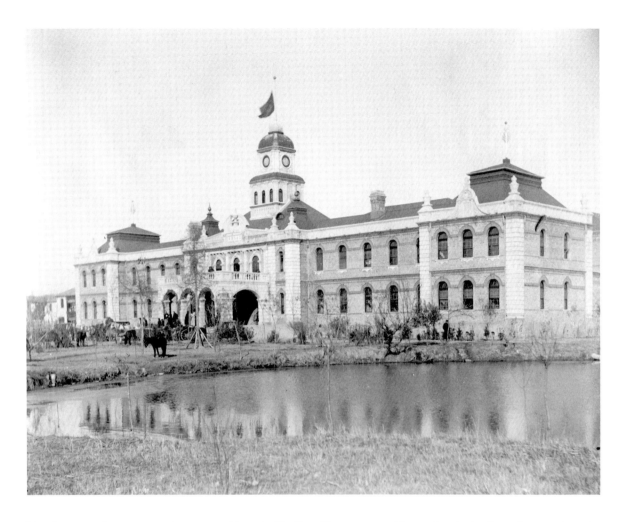

THE JIANGSU PROVINCIAL ASSEMBLY HALL in Nanjing. The assembly was headed by Zhang Jian (1853–1926), a Jiangsu native whose dual identity as a successful Confucian scholar (he was one of China's last Number One Scholars, the highest honor bestowed on candidates in the imperial civil service examination system) and a prominent entrepreneur made him a unique figure in modern China. From this building Zhang played a leading role not only as the assembly chairman but also as a national leader for the constitutional reforms promoted by the Qing government. Zhang shifted his support to the Republic immediately after the revolution and was appointed the minister of industry of the new government.

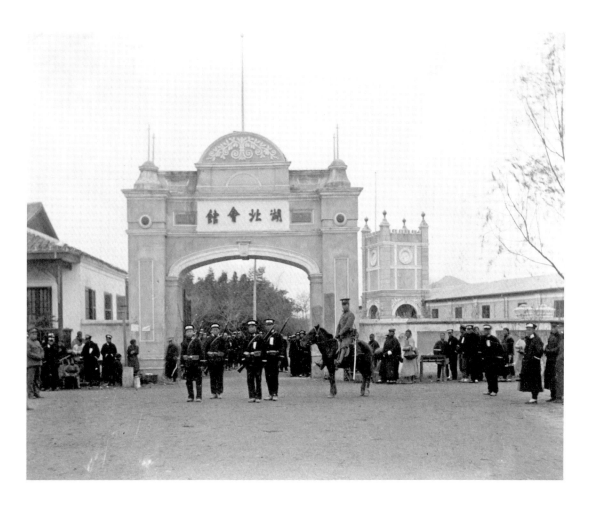

REVOLUTIONARY SOLDIERS STATIONED in the Hubei Native Place Association in Nanjing. Native place associations were very common in Chinese cities for centuries. Sojourning Chinese, as "strangers in a strange land," often found self-identity and mutual help through these organizations, where they could meet and mingle with people from their hometowns. Since the revolution started in Hubei, the Hubei Native Place Association in Nanjing seemed to be the natural "home" for the insurgents when they occupied the city.

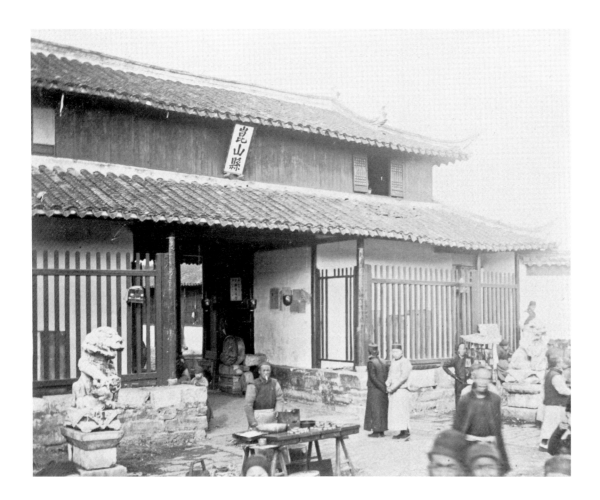

THE YAMEN OF KUNSHAN COUNTY, Jiangsu province. Before the Qing dynasty was overthrown, county governments were the lowest local level of administration, with county magistrates directly appointed by the emperor. China in the early twentieth century had about two thousand counties, with an average population of a quarter million each. For ordinary people, a county yamen like this was a concrete manifestation of the state's reach into their lives: an awe-some place where taxes were levied, lawsuits were tried, and official orders were issued. The pair of lions, standard at the entrance of all yamens, were not only ornamental but also symbolic guardians. With the dynasty gone, this yamen presents unmistakable signs of decay: birdcages hang from the wooden railings, children are playing in front of the gate, and a peddler has set up a table to sell snacks.

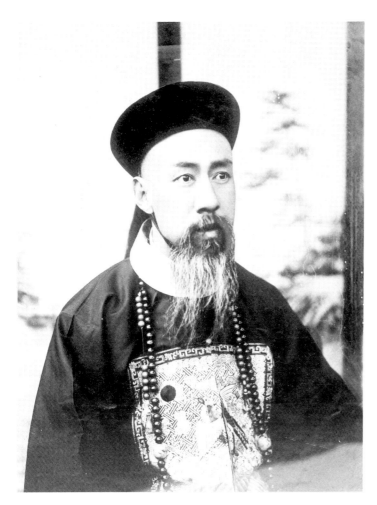

AFTER THE WUCHANG UPRISING, much of the revolution across the country unfolded as a series of bloodless coups in which provincial leaders declared "independence" from the Beijing government and sided with the revolutionaries. Many imperial governors could, and did, change sides overnight. Needless to say, their support of the revolution was often lukewarm and opportunistic. The governor of Shandong, Sun Baoqi (1867–1931), pictured here in the garments of a Qing official, was one of these opportunists. On November 13, Sun declared Shandong independent, only to cancel the declaration twelve days later. In Sun's own words, this was "like a store changing its signboard." Sun served as foreign minister and acting premier after the revolution.

Opposite left TANG SHAOYI (1860–1938), the Peace Commissioner of the imperial government, negotiated with the revolutionaries during the 1911 Revolution. In 1874 Tang was among the first group of students sent by the Qing government to study in the West. He attended Columbia University and New York University and returned to China in 1881. After the revolution, he was appointed the first prime minister of the Republic of China in March 1912 but resigned three months later. Tang continued to be active in politics during the Republican period until he was assassinated in Shanghai, reportedly by an agent of Chiang Kai-shek, who suspected Tang might be collaborating with the Japanese.

Opposite right WU TINGFANG (Ng Choy, 1842–1922), the Peace Commissioner of the revolutionaries, who negotiated with the imperial government during the 1911 Revolution. Wu, a Singapore-born Cantonese, studied law in Britain and was twice (in 1896 and 1907) appointed the Chinese envoy to the United States. A follower of Sun Yat-sen, he served as the minister of justice, minister of foreign affairs, and acting prime minister of the Republic of China.

THE QING COURT, represented by Tang Shaoyi, and the revolutionaries, represented by Wu Tingfang, started negotiations on December 18, 1911, in the Shanghai City Hall. On December 20, the consuls general of six foreign powers (Britain, France, Germany, Japan, the United States, and Russia) in Shanghai visited Wu in the City Hall to explore the possibility of foreign mediation of the conflict. In this picture the German and Russian consuls are in the midst of a conversation at the entrance of the City Hall.

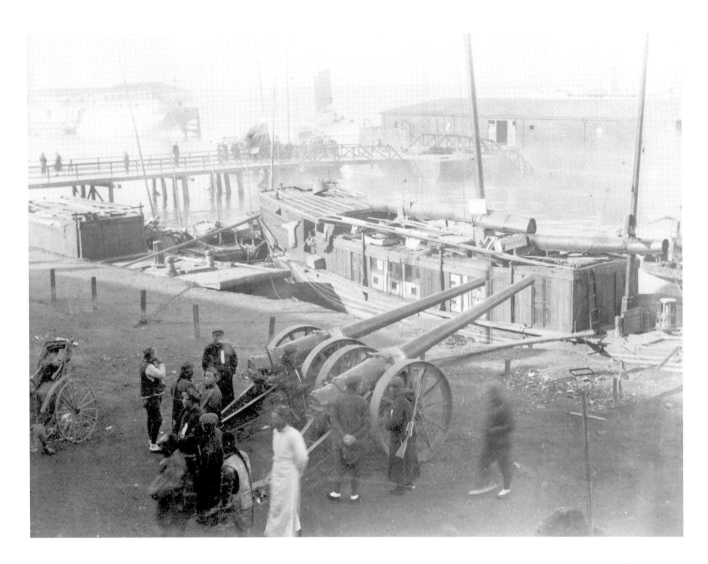

WHILE THE NEGOTIATIONS were going on, the insurgent army launched several campaigns to the north in order to strengthen the revolutionaries' bargaining power and pressure the Qing court to step down. Pictured here are insurgent cannons that have been shipped across the Yangzi River to the port of Pukou in Nanjing.

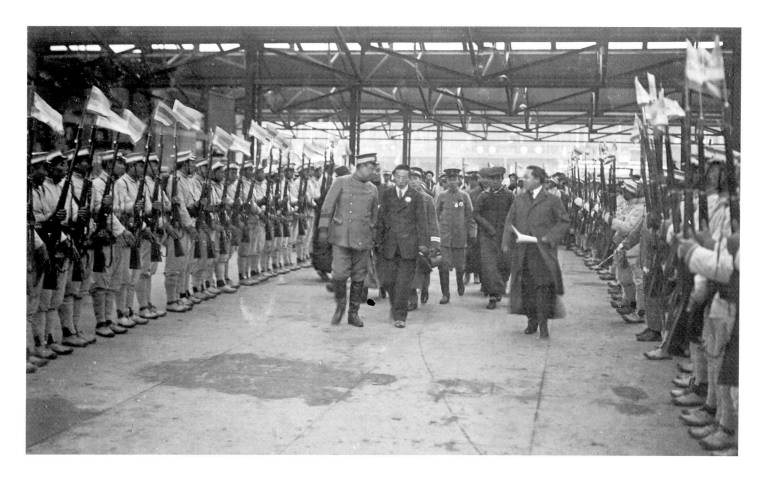

ON NEW YEAR'S DAY 1912, leaders of the revolutionaries came to the Shanghai Railway Station to see off Sun Yat-sen as he departed for Nanjing. Three days earlier, sixteen provincial assemblies met in Nanjing and elected Sun the "provisional president" of the new Republic. The man in the middle in the Western suit is Chen Qimei (1877–1916), then the governor of the Shanghai Military Government. Trained in military and police schools in Japan, Chen was a senior member of the Revolutionary Alliance and a boss in Shanghai's Green Gang, one of modern China's most powerful mafias. Chen was also known as a mentor of Chiang Kai-shek. It was during the 1911 Revolution that Chiang became Chen's confidant.

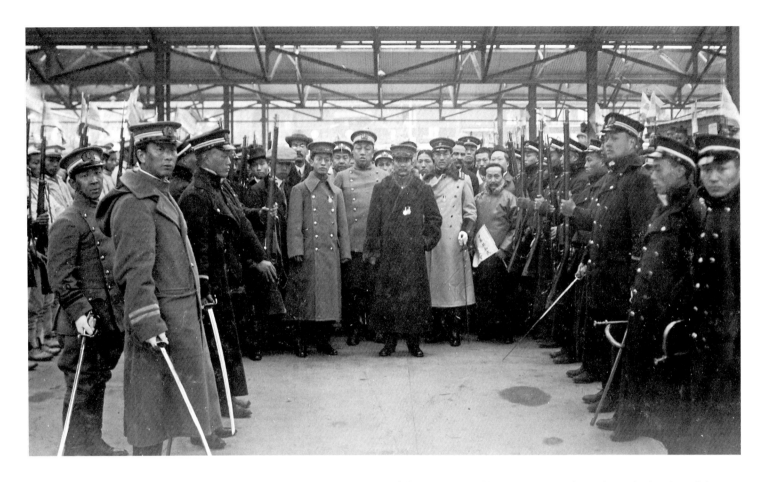

TEN O'CLOCK in the morning of January 1, 1912, on a platform of the Shanghai Railway Station. Sun Yat-sen (center) is about to board the train to Nanjing to proclaim the founding of the Republic of China and to assume the post of its first provisional president. Representatives of all circles have come to see Sun off. A gun salute was fired as Sun's train left the platform. The event drew a crowd of more than ten thousand people in and outside the station. The man standing in front and to Sun's right is Hu Hanmin (1879–1936), one of Sun's principal followers. Sun and his allies were realistic about the fragility of the military coalition forged by the revolutionaries and recognized that Yuan Shikai, as commander of the most powerful army in China, had to play an important role in the post-Qing government. Despite the solemn ceremony honoring Sun, on the same day Yuan was officially offered the presidency if he would cooperate with the revolutionaries in overthrowing the dynasty.

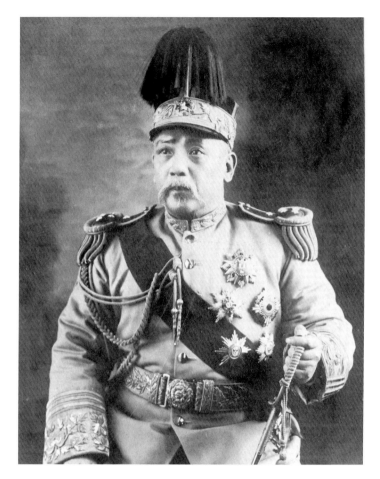

YUAN SHIKAI (1859–1916) was one of the most prominent political figures in late nineteenth- and early twentieth-century China. A loyalist of Empress Dowager Cixi, Yuan built up his power base in the New Army, of which he was the commander after 1901. Yuan was forced into retirement three months after the death of the Empress Dowager in 1908. A picture of him idly fishing in his hometown of Zhangde (Anyang) in Henan province taken at the time was circulated in Beijing, aiming to send the Qing court the message that he was truly retired and had no political ambitions. However, Yuan's influence in the New Army and the loyalty of his protégés among army officials were irreplaceable. After the Wuchang uprising broke out, Yuan was brought back to command the army and negotiate with the revolutionaries. Yuan then played the incompetent dynasty off against the politically naive revolutionaries. By November 1911, his forces recaptured Hankou and Hanyang and were ready to attack Wuchang. Meanwhile, numerous provinces, some under Yuan's direct influence, declared independence from Beijing. By March 1912, the Manchu emperor had abdicated, Sun Yat-sen had stepped down from the provisional presidency, and Yuan was named first president of the Republic of China.

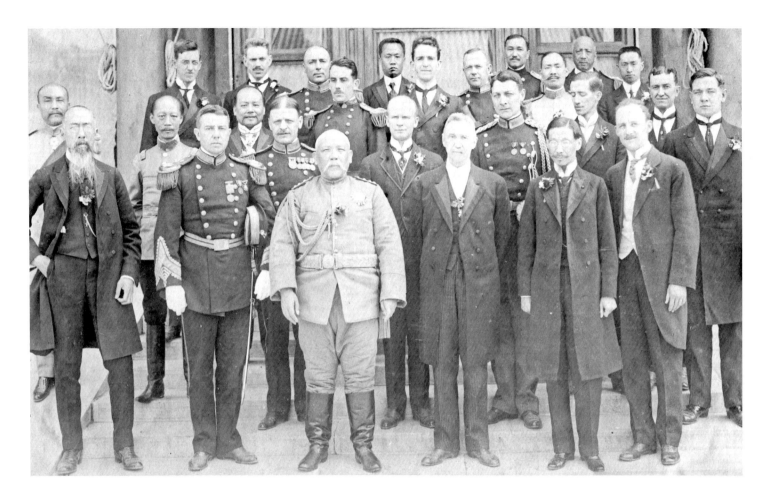

YUAN SHIKAI RECEIVING foreign envoys in Beijing soon after the founding of the Republic of China. On January 5, 1912, the new government issued a statement acknowledging the validity of the treaties signed by the Qing government prior to the revolution. Much of the negotiations over foreign recognition of the new Republic were centered on the reassurance of that commitment. The United States recognized the Republic of China on May 2, 1913, the first foreign power to extend full diplomatic recognition to the new Republic. To the left of Yuan is the U.S. envoy to China, William James Calhoun (1848–1916), a Chicago lawyer who served as ambassador to China from 1909 to 1913.

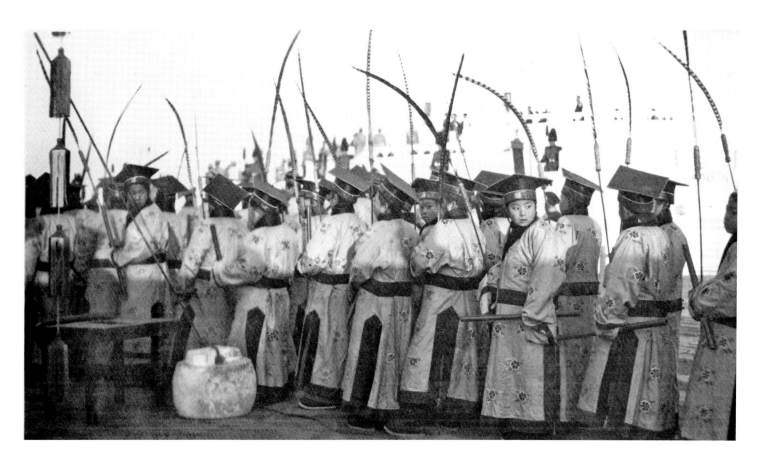

A CEREMONY WORSHIPPING CONFUCIUS (551–479 BCE), China's foremost philosopher and icon of the Chinese imperial order, in Beijing. After Yuan Shikai revised the constitution in May 1914 and proclaimed himself president-for-life of the Republic of China, the government ordered a series of nationwide ceremonies to honor Confucius. The largest ceremony after the revolution was held on September 28, 1914. Yuan also insisted on having Confucian teachings in the school curriculum nationwide. Yuan's reverence for Confucianism was not less than that of the emperors, who had worshipped Confucius throughout the imperial era. However, Confucianism in Yuan's time was about to come under an unprecedented attack. The New Culture Movement exploded on the scene in 1915 with the publication of the radical and extremely influential journal *New Youth* (*Xin Qingnian*) which declared "Down with Confucianism!"

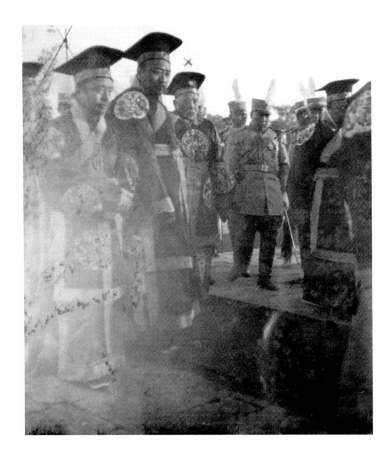

YUAN SHIKAI'S RULE from 1912 to 1916 was marked by his ambition to build a strong nation and consolidate his own personal power. Under Yuan, the government continued many of the late Qing reforms, including legal reform, agricultural development, compulsory education, centralization of the monetary system, suppression of opium, and a national survey of China's geological resources. While Yuan turned to the Western nations and Japan for guidance in his modernization programs (among his advisors was a team of talented and highly paid foreign experts), he sought traditional Chinese sources for solidifying absolute power. In December 1915, Yuan (in the middle, marked with an *x*) and other high-ranking officials in Beijing, dressed in traditional Ming dynasty ritual attire, went to the Temple of Heaven to worship. Ceremonies like this had been led by the emperor during imperial times to demonstrate that, according to a time-honored political tradition, the dynasty had the "Mandate of Heaven" to rule. Yuan's visit to the temple thus seemed to be an attempt to link his regime with the two-millennia-long imperial system. In fact, Yuan proclaimed himself emperor on New Year's Day 1916.

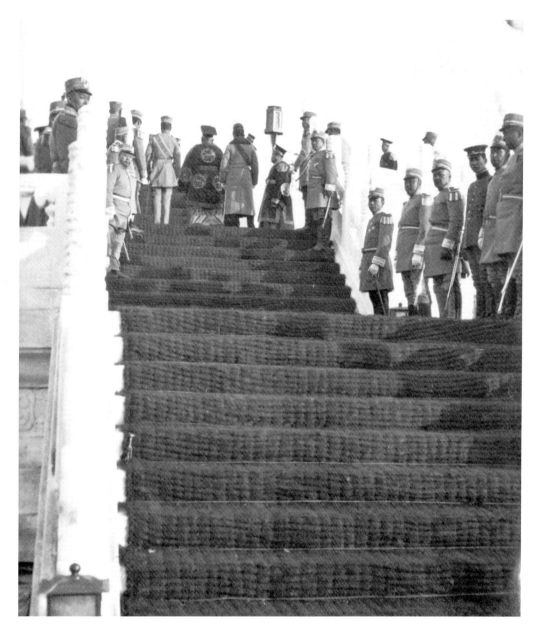

SURROUNDED BY HIS RETINUE, Yuan walks up the stairway to the altar of the Temple of Heaven in Beijing.

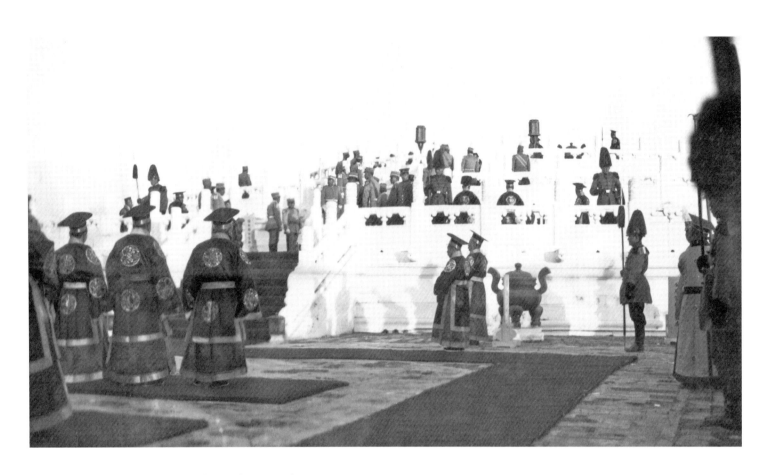

LIKE THE WORSHIP OF HEAVEN during the imperial era,
the ceremony is solemn.

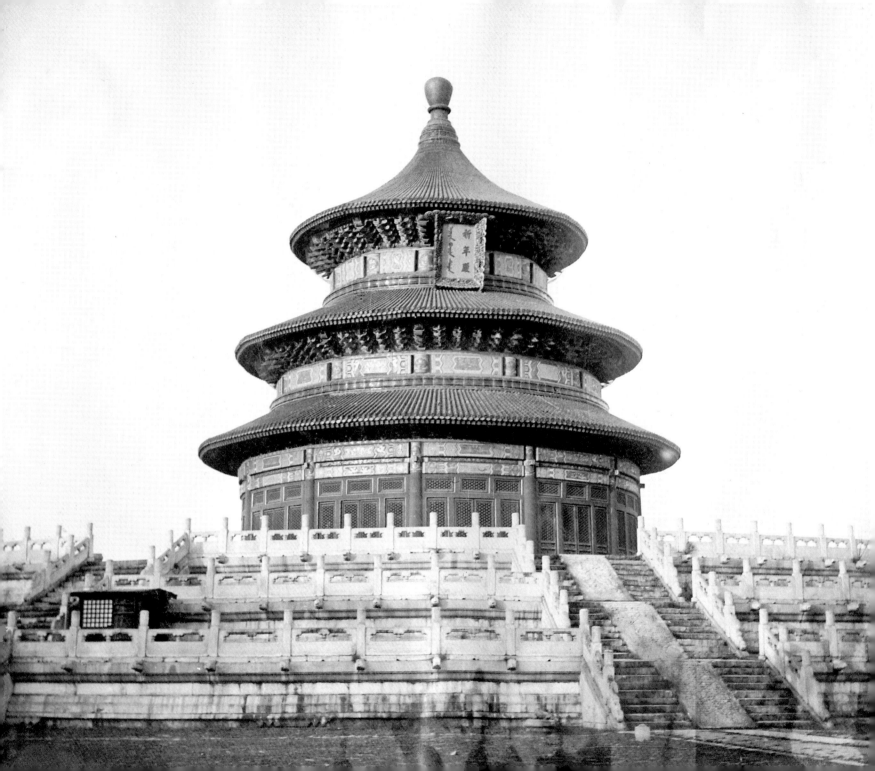

Opposite THE TEMPLE OF HEAVEN (built in 1420), one of the defining images of China, ca. 1912.

Overleaves FRANCIS STAFFORD VISITING the Ming imperial tombs in Nanjing on a donkey. The stone statues at the entrance to the imperial tomb are called *wengzhong*, named after a legendary Chinese giant who defeated the northern nomads in the third century BCE. Statues of military officers and palace guards were the tomb's most common effigies, but images of animals, especially elephants and camels, were also imperial favorites. Elephants and camels were seen as gigantic yet docile and therefore were chosen as symbols of a great country at peace. These statues, carved from blocks of solid stone and weighing about eighty tons, were powerful reminders of the majesty of the Ming dynasty (1368–1644). Similar statues were also erected in front of the famous Thirteen Imperial Tombs of the Ming dynasty near Beijing. The Ming dynasty, although overthrown more than two and a half centuries earlier, left an enduring legacy that inspired the 1911 Revolution, as reflected in a popular late nineteenth-century slogan that called for the Chinese people to "expel the Manchu barbarians and restore the Ming." Although eventually the 1911 Revolution adopted a greater premise—building a republic with racial harmony—anti-Manchu sentiment lingered in the early years of the Republic. After the revolutionary forces occupied Nanjing, representatives of the army visited the Ming tombs in a ceremony designed to inform the Ming ancestors that the "Manchu barbarians" had been expelled. In February 1912 Sun Yat-sen also paid a ceremonial visit to the Ming tombs when he stepped down as provisional president of the new Republic.

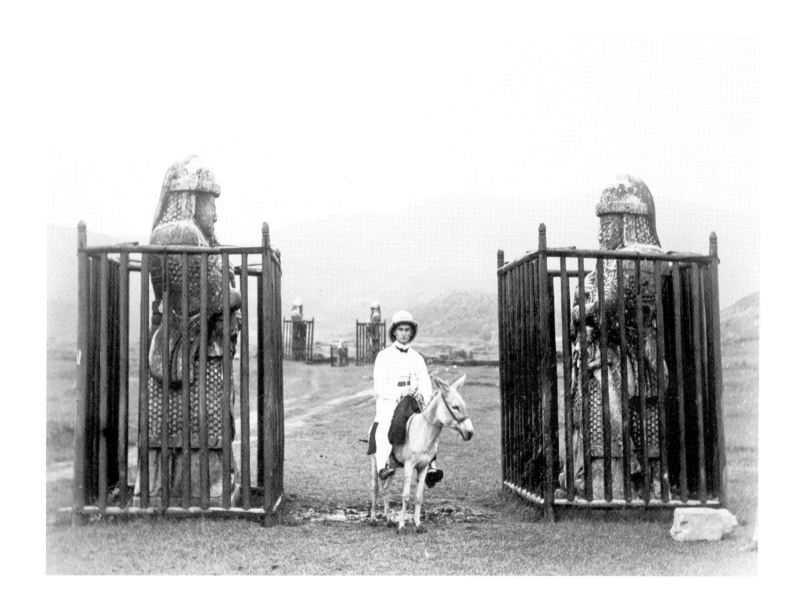

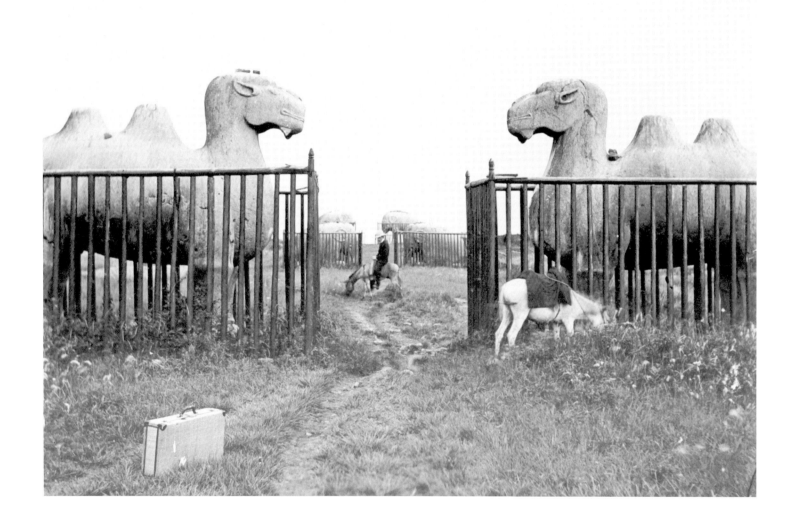

明太祖高皇帝之位

A STONE STELE dedicated to the founding emperor of the Ming
dynasty, Zhu Yuanzhang (1328–98, reigned 1368–98), in front of his
tomb in Nanjing. Zhu started from humble origins. He was born into
a poor peasant family and eked out a living as a mendicant before
he joined the rebels against the ruling Mongol Dynasty at the age of
twenty-four. In sixteen years he was able to claim the throne and found
a mighty dynasty. The saga of Zhu rising from beggar to emperor
is one of the most inspirational stories in Chinese history, motivat-
ing even modern politicians such as Communist leader Mao Zedong
(1893–1976).

4

A SOCIETY IN TRANSITION

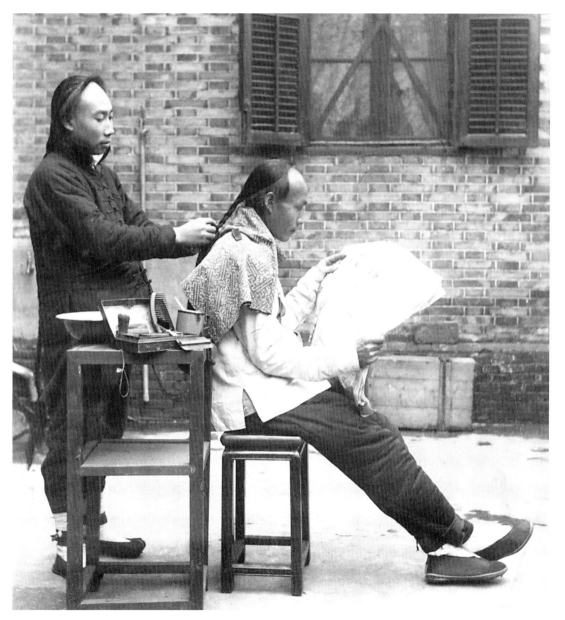

A STREET BARBER at work. The queue was a Manchu custom. After the Manchus conquered China in 1644, the government ordered Chinese men to follow the Manchu custom of shaving the front of the head and plaiting the hair into a queue as a symbol of submission to the new regime. At first, there was very strong resistance among the Chinese, but it was brutally suppressed and the imposed custom soon prevailed. Throughout the Qing period, the queue was the universal men's hairstyle in most parts of the empire.

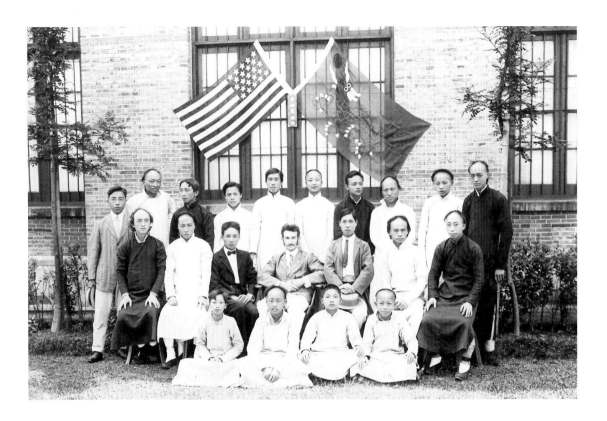

FRANCIS STAFFORD and his Chinese colleagues in front of their workplace, the Photographic Section of the Commercial Press, ca. 1910. The dragon flag on the right was adopted as the Qing national flag in the mid-nineteenth century when the government decided that if other states had national flags, China needed one too. Note that the hairstyles of nearly half of the Chinese in the picture would have been considered rebellious by the Qing rulers. Although few people at the time would have predicted the imminent collapse of the dynasty, the heterodoxy in hairstyles is an ominous sign of the regime's future. The queue was a symbol of submission that the Manchus demanded of every Chinese man. Anyone who dared to disobey could be executed, as a saying of the time made perfectly clear: "Either shave your hair or lose your head." By the nineteenth century, in Western eyes the "pigtail" had long been a symbol of all Chinese men. It was not until the beginning of the twentieth century, when the Qing dynasty had irreversibly declined, that some Western-educated Chinese started to cut off their queues as an act of defiance. But conservatives decried the new hairstyle as immoral and, since the dissidents were still a tiny minority, men without a queue were derided as "fake foreign devils" (*jia yangguizi*). Here in Shanghai and right under the dragon flag, the deviant hairstyles and Western suits reveal the erosion of the Qing's authority and the city's liberal atmosphere.

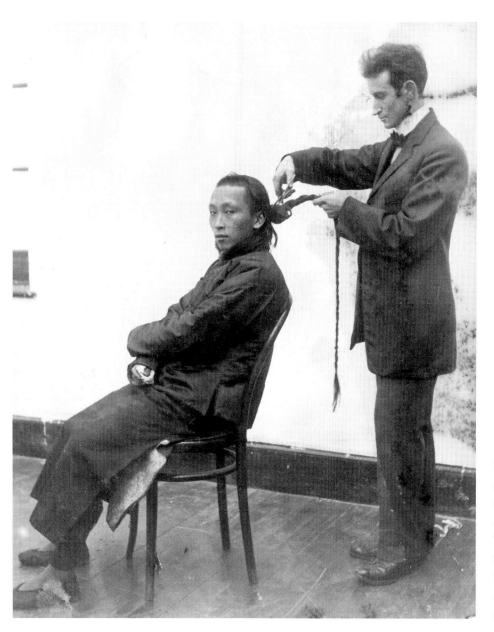

FRANCIS STAFFORD, cutting off the queue of a Chinese man, possibly an employee of the Commercial Press. Cutting off the queue was an obvious and powerful political statement. This picture appears to be posed, but letting a foreigner cut off the queue in this almost ritualistic way was more than a matter of putting on a show; it was a declaration of independence from the established Chinese political order.

SHORN OF HIS PIGTAIL, and with his new
Western hairstyle, this man has been trans-
formed into a "gentleman."

THE SHANGHAI CITY god temple, ca. 1912. The picture depicts a time of transition in hairstyles unique in Chinese history. While virtually all the men have cut off their queues, the hair on the front of their scalps has yet to grow back. Here and there in the crowd one can still see a few men wearing pigtails. Two policemen in uniform stand on each side of the stairway, an indication of modern policing in action. Most walled cities in traditional China have a temple dedicated to one or more local deities called Chenghuangye (literally, "Master of the city wall and moat") in the Daoist tradition. The antithetical couplet on the temple's front pillars read "Come here to the boundary where this world and the nether world meet; Go there to escape the destiny of fortune and misfortune," which reflect the Daoist notion of retreat and detachment from the earthly world.

IN FRONT OF THE ENTRANCE of the Commercial Press in Shanghai, the funeral procession of Xia Ruifang (1871–1914) is about to start. Xia was the founder of the Commercial Press, modern China's earliest and largest publishing house. His opposition to a new tax levied by the military government that controlled Shanghai after the revolution led to his assassination in front of the press's building on January 10, 1914. Reports on Xia's death and related news stayed in the headlines of Shanghai's major newspapers for three weeks and his funeral was a major event. Note the flowers decorating a cross on the hearse, an uncommon artifact in a Chinese funeral but one that spoke of Xia's conversion to Christianity. Xia, educated in Shanghai's American missionary schools, converted to Christianity as a child. He kept the faith all his life.

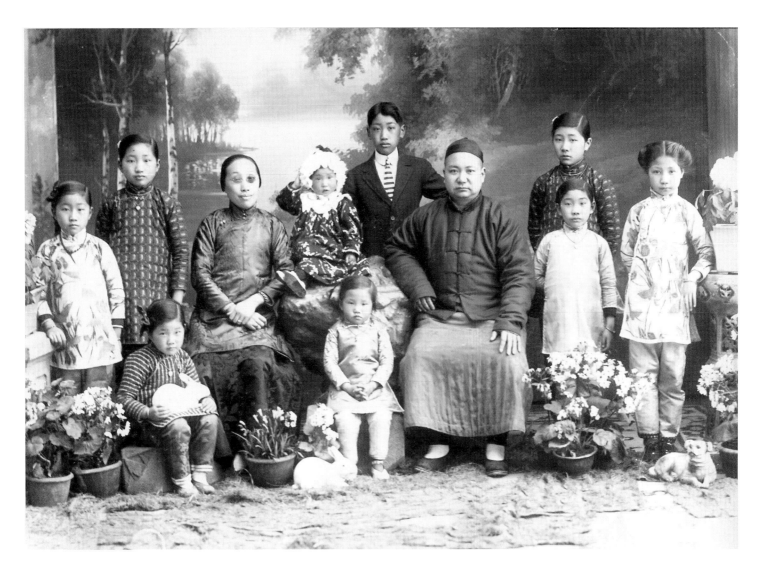

XIA RUIFANG (*front row, third from right*) and his family, ca. 1913.

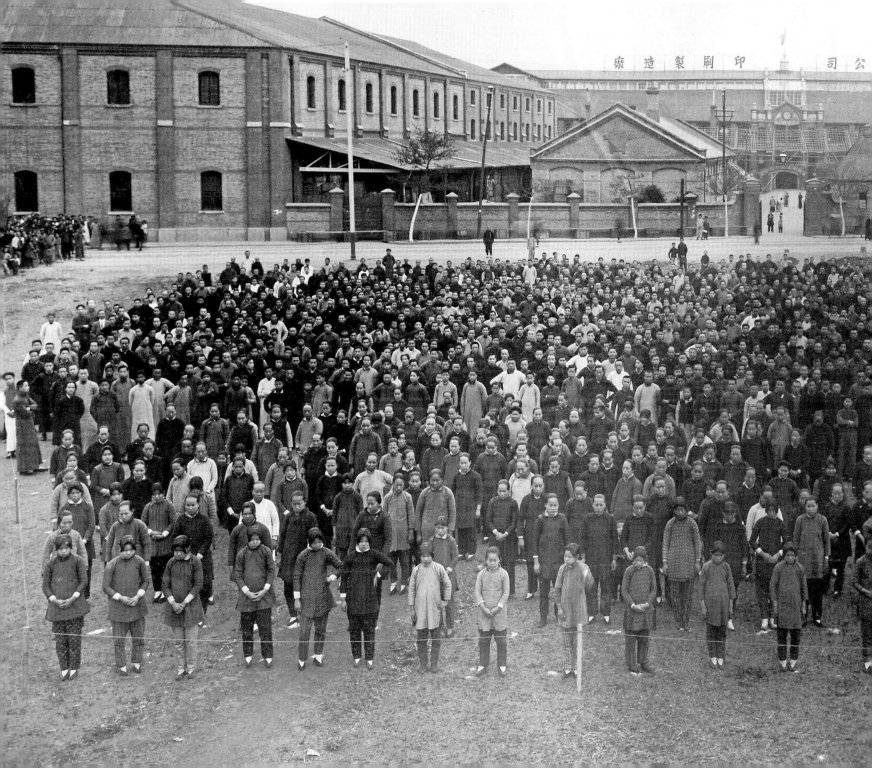

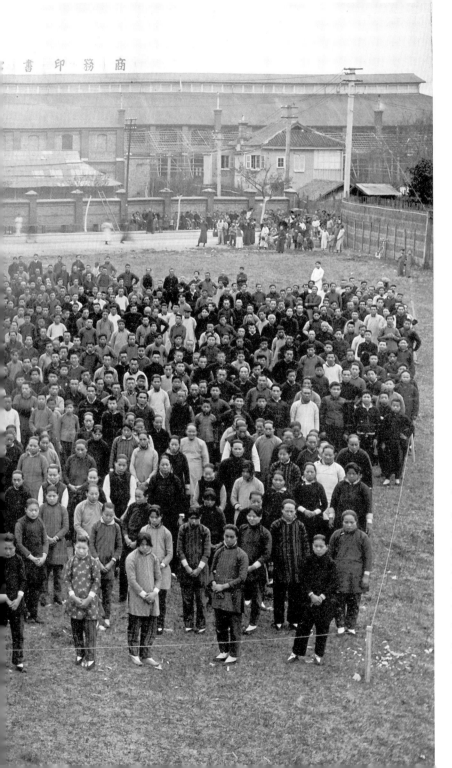

THE SHANGHAI COMMERCIAL PRESS started in 1897 as a small
alleyway workshop that employed only sixteen workers printing English
textbooks for beginners. The press grew quickly by printing Bibles and
textbooks for the many new schools that mushroomed during the New
Policies Reform. By 1905, the press had already become one of the fif-
teen largest modern enterprises in China. This picture of a gathering of
the staff in front of the press's main entrance was taken probably before
the funeral of Xia Ruifang in January 1914. At the time the press had
more than two thousand employees; about 10 percent of the workers
were women.

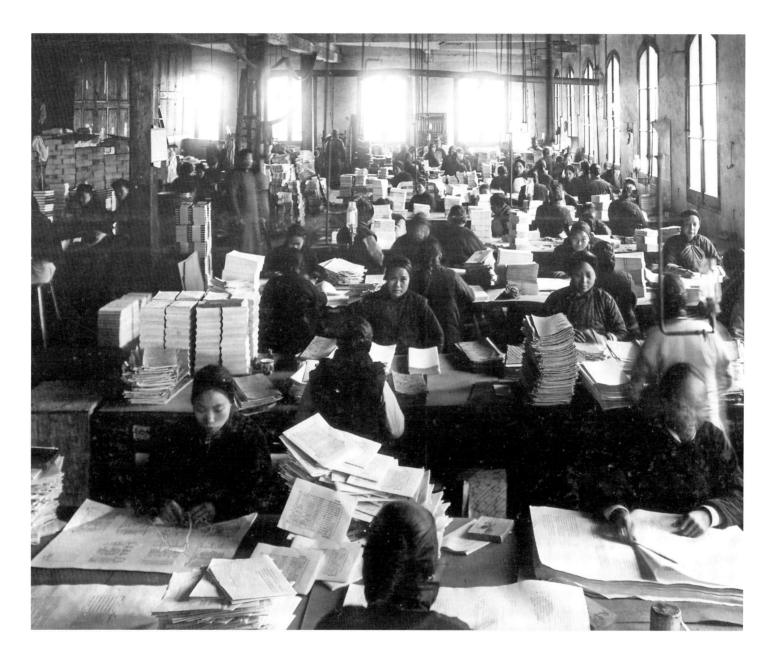

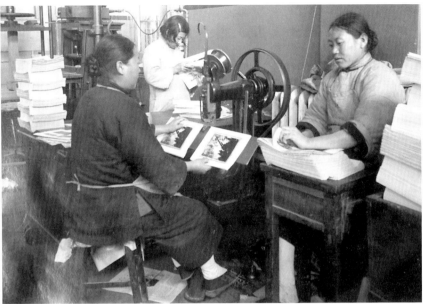

THESE WOMEN in Shanghai's Commercial Press were among China's earliest female industrial workers. Chinese women started to work in modern factories, mostly in textile mills, toward the end of the nineteenth century. The post-revolution years saw a boom of women entering the industrial labor force. By 1920, the textile industry alone employed 135,781 women, about 47 percent of its workforce. Compared to cotton mills, where women worked on their feet amidst row upon row of noisy machines, the Commercial Press offered better working conditions and a relatively light workload.

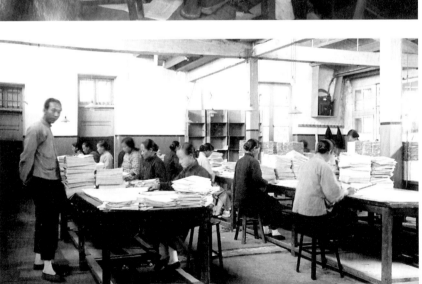

STILL, GENDER INEQUALITY is clearly visible in these workshops: while all the workers are female, the supervisors are men.

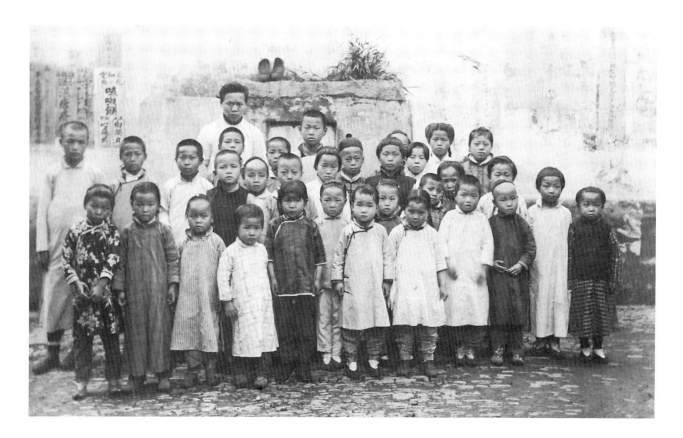

THE SCHOOLGIRLS in this photograph were among what was effectively the last generation of victims of China's millennium-long custom of footbinding. In contrast to the "pigtail" hairstyle that was imposed on the Chinese by the Manchus in the seventeenth century, footbinding had been a Chinese custom for nearly seven centuries before the Manchu dynasty. The Qing government officially banned the practice, and Manchu women never bound their feet. Nevertheless, during the Qing period footbinding became more common than in previous dynasties, giving credence to the conjecture that footbinding was in fact a political statement to show the Manchu rulers that "our men surrendered but not our women" (*nan xiang nü bu xiang*). Starting from the late nineteenth century, the custom was condemned and criticized by reform-minded intellectuals and foreign missionaries, which constituted an important stimulus for Chinese reformers. Footbinding largely ended after the 1911 Revolution, although it could occasionally be found as late as the 1930s. Here, on the eve of the revolution, one can already see signs of change: the teacher and several of the boys have Western-style haircuts and the class is coeducational, still a novelty to many Chinese at the time.

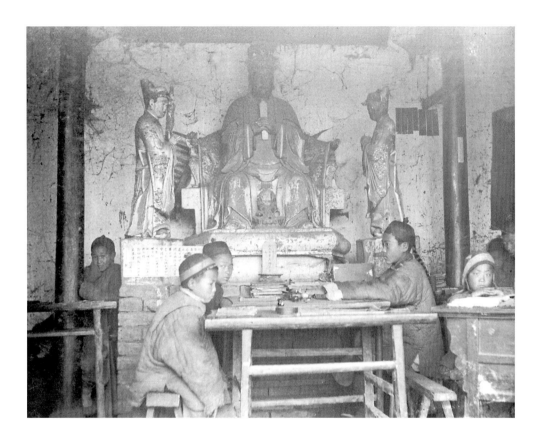

A CLASSROOM in a private school before the revolution. A statue of Confucius (551–479 BCE) dominates the classroom. The statues of lesser figures, Confucius's attendants, represent two of his best students, Yan Hui (521–490 BCE) and Zilu (542–480). Students bowed to the statues in the morning before classes started. It was in private schools such as this one that virtually all students before the twentieth century received their primary education. Except for some literature and history, the subjects taught in these schools were predominantly the Confucian classics, as the ultimate goal of education in late imperial China was to compete in the civil service examinations, which were entirely based on Confucianism. But Chinese education underwent rapid change in the first decade of the twentieth century. In 1905, as part of its New Policies Reform, the Qing government abolished the civil service examination system in favor a system of modern education. By 1910, 42,696 Western-style multi-curriculum schools, with a total enrollment of 1,300,739 students, had been established nationwide. The boys in the picture therefore are among the last generation of Chinese attending an old-style private school.

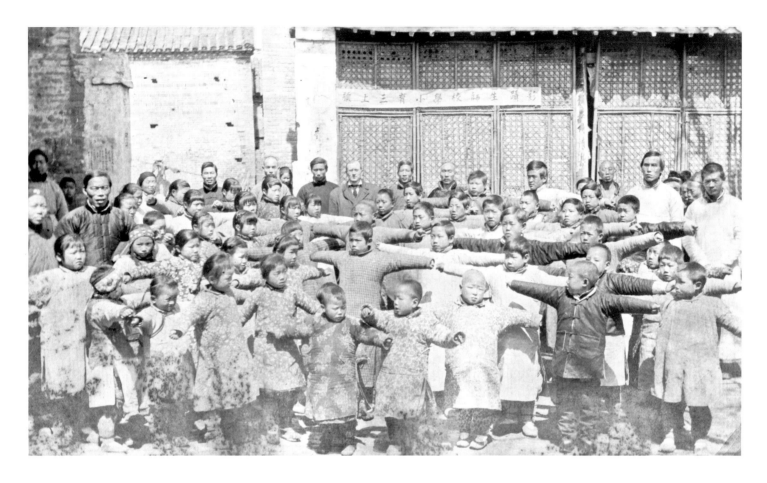

CoEDUCATION BECAME COMMON in the early Republic. Even in the remote hinterland, small private tutoring schools were transformed into modern elementary schools where boys and girls attended classes together. This co-ed school in Yingshang, a rural town in northern Anhui province, was called Sanyu or "Three Educations," a name reflecting a new standard for education in which the primary goal was for students to develop morally, intellectually, and physically.

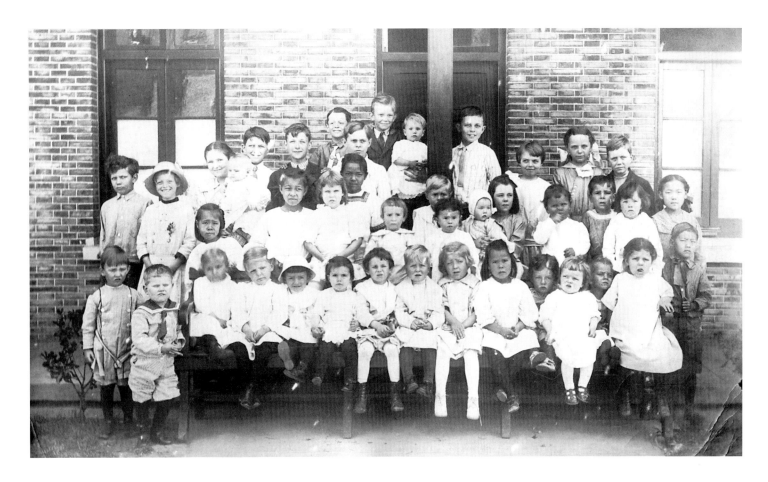

CHILDREN IN SHANGHAI'S THOMAS HANBURY SCHOOL and Children's Home, a boarding school on Boone Road (today's Tanggu Road) established in 1871 for children of mixed parentage: so-called Eurasian children. Many of them were born illegitimate and abandoned by their parents or were left without means of securing an education. The school was cofounded and sponsored by Thomas Hanbury (1832–1907), a Britisher who made his fortune in real estate in Shanghai. It had been run since 1890 by the Shanghai Municipal Council, of which Hanbury was a member. By the early twentieth century, the school had become increasingly cosmopolitan, accepting not just Eurasian children but poor children of many nationalities.

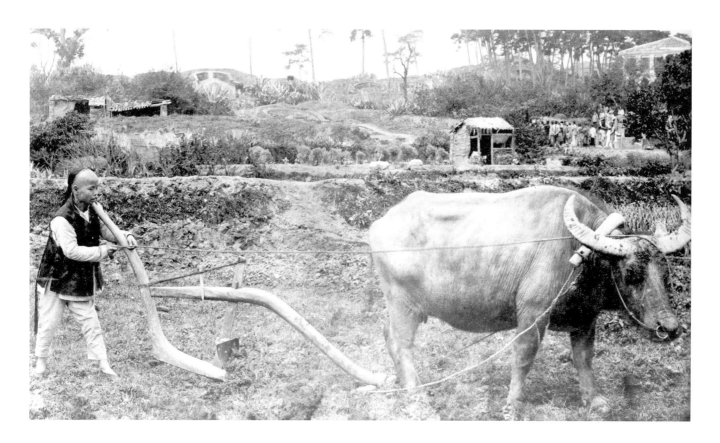

PLOWING BY OXEN. Rural scenes like this were depicted in *The Book of Songs* (*Shijing*), one of the earliest Chinese classics, dating back to 1000 BCE, and in the early twentieth century were still typical of many parts of the country. Boys helping on the family farm had been common in China for millennia. This contributed to the culture of valuing sons over daughters, because a son would not only start working in the fields at a young age, but would remain with the family, providing labor the rest of his life. A daughter, on the other hand, would typically be married out in her teens to another family. (For instance, Mao Zedong [1893–1976], who came from a modestly well-off peasant family in Hunan, recalled that his father put all his sons to work on the family farm. Mao started field work at age six.) The thatched huts in the background are outhouses with huge glazed earthen basins holding human waste. These sheds could serve as public restrooms, for anyone could use them, but they were mainly designated to store excrement, the essential fertilizer in traditional farms. Also in the background are a few semicircular graves. Placing cemeteries in the midst of farmland was common in most parts of China. The crowd in the far right background are apparently villagers attending a funeral.

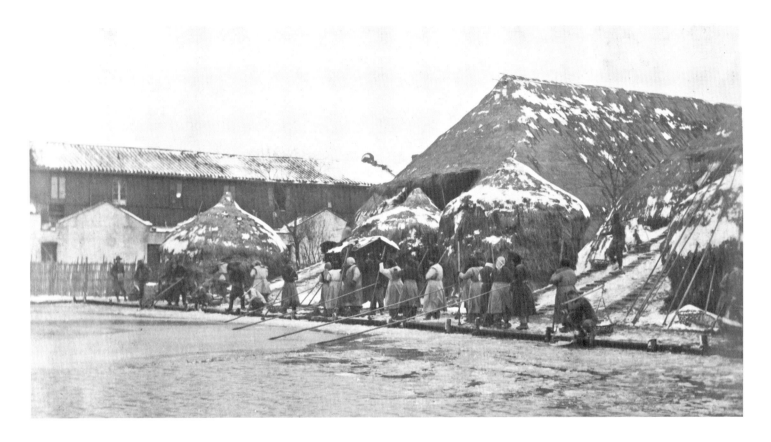

ICE COLLECTING was an old trade in China. It was recorded in *The Book of Songs*, dating to around 1000 BCE. The trade still thrived in the Qing and Republican periods. Starting in November, clean water was preserved in a reservoir for making ice. The best time for collecting ice was early January, when rivers and lakes in much of China were completely frozen. Here on a snowy day, villagers line up with long bamboo poles to break up the ice and pull floating chunks to shore. Others are carrying ice in bamboo baskets to cellars where it will be covered with thick layers of rice straw. Ice so preserved was ready for sale in the summer.

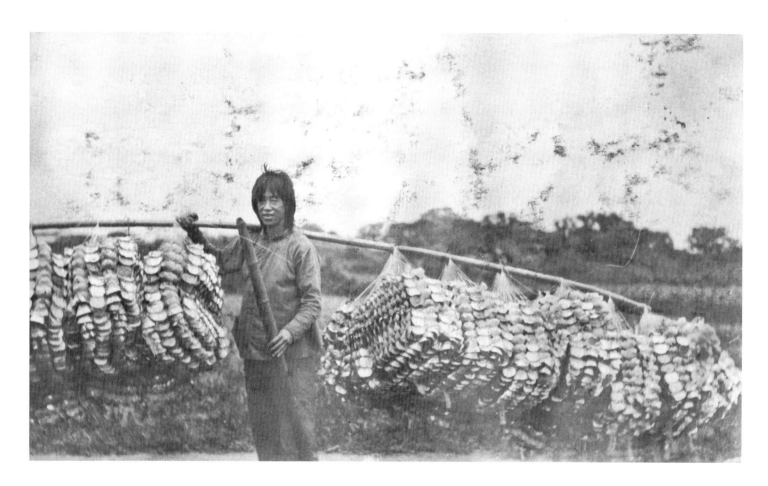

ANCESTOR VENERATION is one of the most prominent and oldest customs of China. It was recorded in the oracle bone inscriptions, the earliest Chinese writing, dating back to the Shang dynasty (ca. 1766–1045 BCE). In the early twentieth century, ancestor veneration remained essential to Chinese life. Ceremonies consisted primarily of kowtowing to icons of ancestors and offering food and money to the deceased for them to use in the netherworld. This man carries strings of ingot-shaped paper money for sale. Symbolizing the silver ingots used as currency in China for centuries, these objects were to be burned as offerings in funerals and memorial services. Ceremonies for an ancestor were held quite frequently: on the birthday of the deceased, the anniversary of his or her death, and at least four annual festivals. Since paper money was a must on these occasions, making and selling paper ingots was an established business and peddlers like this were a familiar sight everywhere in the country.

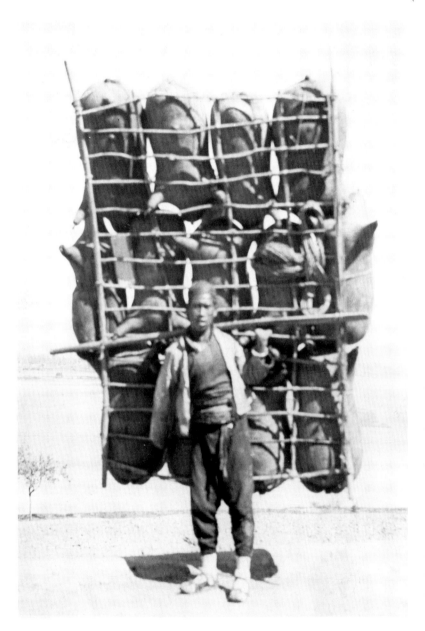

SHEEPSKIN (or sometimes ox-hide) rafts have been used to transport goods and passengers downstream on the Yellow River for centuries. No later than the sixteenth century, this ancient device was a form of mass transport, particularly in upper Yellow River valley areas where sheep were the most common livestock. Farmers inflated oil-soaked sheepskins and bound them to a wooden frame to make a portable ferry. The rafts varied in size, but a typical portable type used as a ferry, like the one carried by the man in this picture, was about three meters long and two meters wide. It was made of over twenty willow-tree branches and fourteen inflated sheepskins and weighed only a bit more than 12 kilograms (26 pounds). But it could carry five to six passengers and float with the current at a rate of about 200 kilometers (125 miles) a day.

A STREET PEDDLER selling wontons in a Shanghai alleyway. Peddlers serving a great variety of snacks on the streets and alleyways had become an institution in Chinese cities by the early twentieth century. With a bamboo shoulder pole, a peddler could carry along all his equipment—a stove, firewood, utensils, food ingredients, condiments, and a bucket of water—in residential areas and literally in a minute serve a bowl of steaming hot bites-to-eat to a customer. Such services largely vanished after the 1950s.

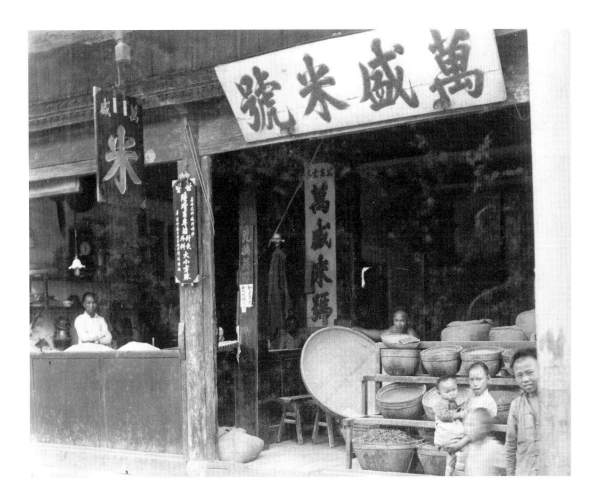

A RICE STORE named Wansheng ("Great Prosperity"). "Great prosperity" may describe just the owner's dream, but small businesses like this were certainly vitally important in the daily life of the common people. In the Republican era, Shanghai consumed one billion pounds of rice annually; there were rice stores on almost every block. It was like this in most cities and towns of China. Although rice was by far the most important staple food in the city, wheat and other food grains were also sold in stores like this. One can see rice piled up on the counter to the left and samples of various food grains displayed in big bamboo baskets at the far right. As was typical in the city, this two-story building was rented out to a number of businesses. The signs indicate that inside the building there is a clinic specializing in acupuncture and minor surgery and a money exchange service is available in the store.

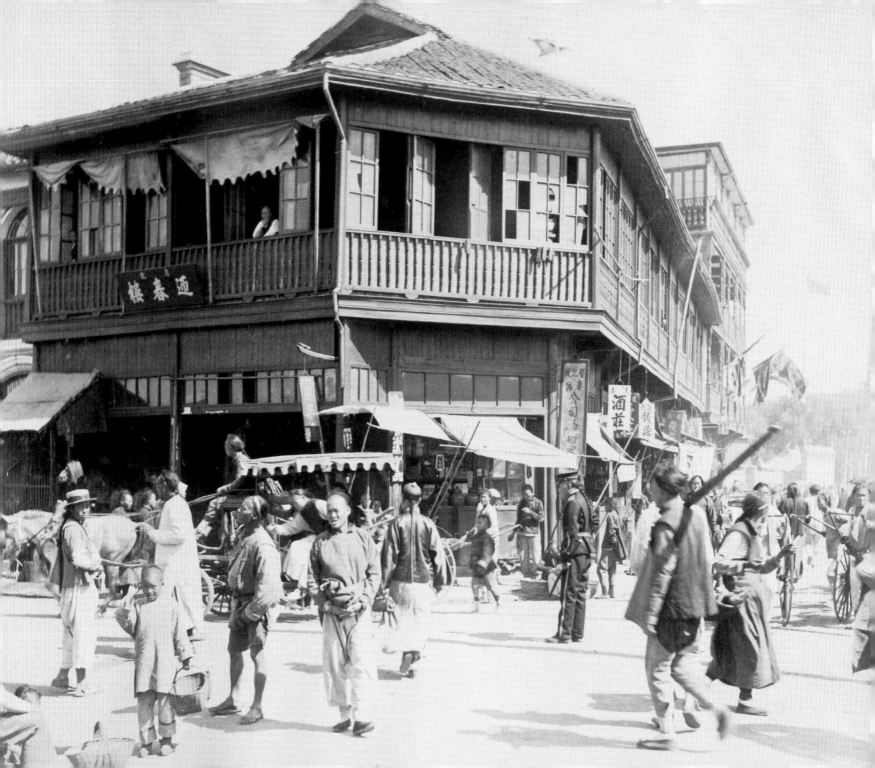

A STREET CORNER near the Little East Gate of Shanghai's walled "Chinese City." Bustling street scenes like this bring to mind the streets in the twelfth-century Chinese capital, Kaifeng, as depicted in the famous genre painting *Spring Festival on the River*. Busy, vibrant, and slightly bewildering, this street corner represents a typical scene in Chinese cities prior to the revolution. Grocery stores, teahouses, wineshops, street vendors, business offices, and traditional-style banks known as "money houses" (*qianzhuang*) all have found a place at this crowded intersection. Here rickshaw pullers are waiting for a fare, coolies are looking for a day job, and businessmen are in a hurry. Horse-drawn carriages, rickshaws, and pedestrians make their way on the street in no particular order. Yet a uniformed policeman is standing in the middle of the traffic. His presence indicates that a modern municipal administration has started to operate in the city, as part of the Qing government's New Policies Reform at the beginning of the twentieth century. The street is not necessarily unsafe: note children walking alone amidst the traffic, women resting at the curbside, and two men standing at the windows of a teahouse named "The Spring Chamber," seemingly quite enjoying the view.

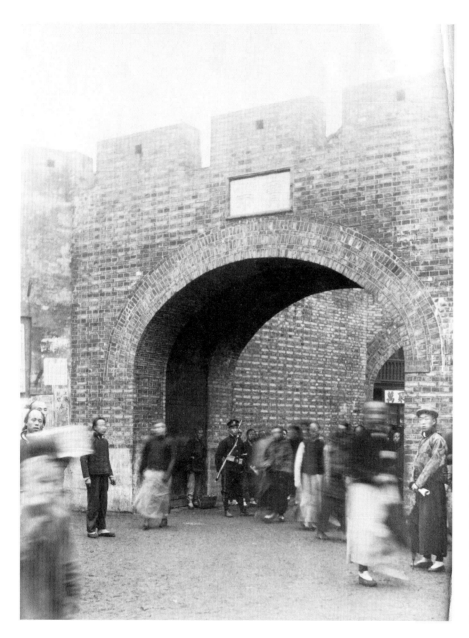

CHINA HAD ABOUT two thousand counties in the early twentieth century. Many county seats were walled cities. Pictured here is Baodaimen ("Gate of the Treasured Girdle"), also known as Xiaodong-men ("Little East Gate"), one of the eight gates of the walled city of Shanghai. The picture was taken in November 1911 when the revolutionaries were taking over the old Chinese city of Shanghai; note an armed soldier is guarding the gateway.

AFTER THE REVOLUTION, as part of early Republican reforms for modernizing municipal administration and urban infrastructure, city walls left from the imperial times were often seen as obsolete and an obstacle to modern traffic. In Shanghai, the city wall was torn down in 1914.

The Dragon Boat Festival in Shanghai. The Dragon Boat Festival, known in Chinese as the "Upright Sun" (Duanyang or Duanwu), is one of the three most important traditional festivals in China (the other two are Chinese New Year and the Mid-Autumn Festival). The festival may have originally been intended to propitiate sorcerers, dragons, or other malevolent forces, but since the fifth century it has been associated with the story of Qu Yuan (ca. 340–278 BCE), a prominent government minister and poet who drowned himself in the Miluo River in central China to protest the king's incompetent policy toward hostile states (at the time China was divided into seven rival states that were constantly at war with one another). A later-day legend goes that Qu's countrymen in the state of Chu, saddened by his death and unable to find his body, took "dragon boats" out to the river and threw thousands of fist-sized pyramid-shaped rice dumplings known as *zongzi* into the water, in the hopes that the fish would take the offering and not consume Qu's remains. Qu Yuan has been remembered as one of China's most heroic patriots. The day he died, the fifth day of the fifth month by the lunar calendar (which usually falls in late May or early June), has been observed by a number of special activities including boat races, such as this one at the confluence of the Huangpu River and Suzhou Creek. Note that despite the much-celebrated Western influence in the city, the dragon boat race right off the shore of the foreign concessions area has been undertaken in all its traditional fashion and has drawn numerous spectators.

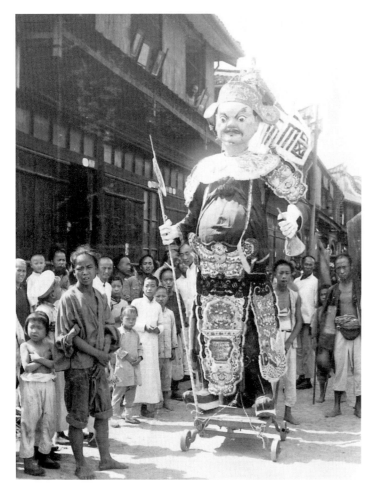

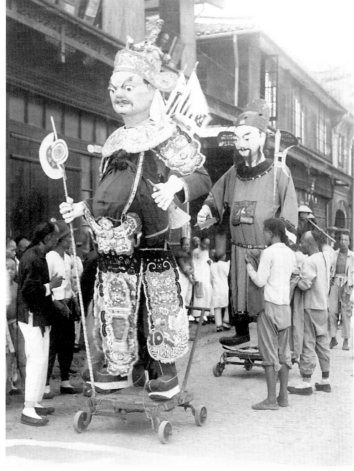

THE ZHONGYUAN FESTIVAL in the walled city of Shanghai. The festival is held on the fifteenth day of the seventh month of the lunar year in honor of the dead. A sort of Chinese-style Halloween, it features parades of effigies of demons and deities and sacrificial altars set up for the spirits from the netherworld. The effigy is Zhong Kui, the vanquisher of demons according to an eighth-century Chinese folktale. Zhong Kui had become a household name by late imperial times. His image was often hung on the door as an incantation to drive away ghosts and evil spirits. The effigy behind him is the King of Hell. Dressed in the attire of an official of the Song dynasty (960–1279), the king holds in his right hand a chop (an official stamp), with which it is believed he sealed his edicts that decide the life and death of ordinary mortals.

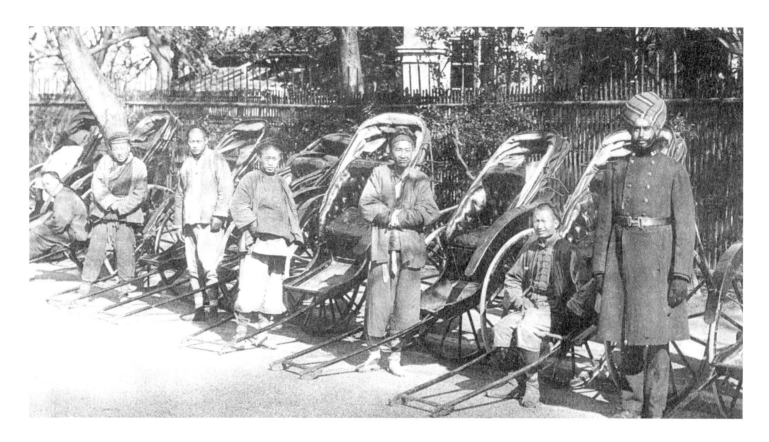

RICKSHAWS WAITING FOR FARES, Shanghai, ca. 1910. Rickshaws were the most common conveyances in early twentieth-century Chinese cities and were considered "insignias of Oriental backwardness." The International Settlement, the core of modern Shanghai governed by the British and Americans, had more than 8,200 registered rickshaws in 1907 for public hire; by 1930, the number had increased to 23,000. The British also employed hundreds of Sikh policemen (like the man in the turban on the far right) whose main duty was to control the rickshaw traffic. The number of Sikh policemen increased from 296 in 1900 to 1,842 in 1939.

Overleaf TRAFFIC ON THE BUND, Shanghai's famous waterfront boulevard. The clock tower is the Shanghai Maritime Customs, built in 1893. Trolley cars and human-powered vehicles such as rickshaws and wheelbarrows are running side by side on this modern, European-style thoroughfare.

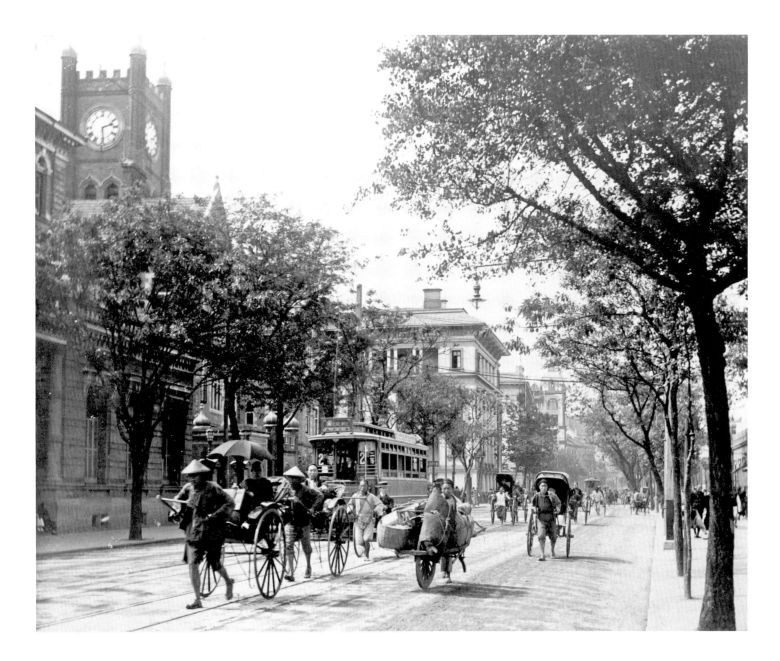

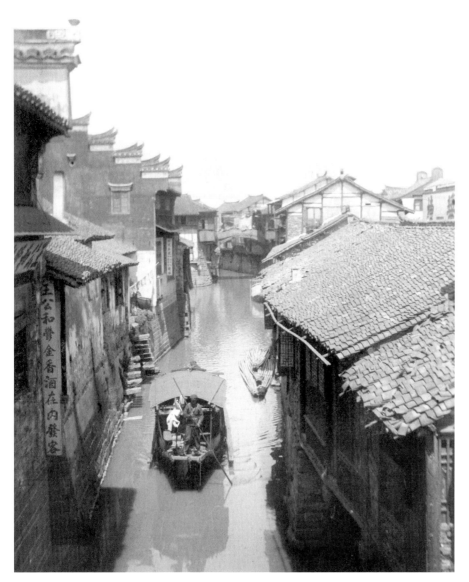

FOR ITS EXTENSIVE WATERWAYS and riverside homes, the lower Yangzi delta city of Suzhou is known as the Venice of the East. For centuries Suzhou has inspired poets and artists. Its rivers and creeks are practically the "streets" of the city. Note the bundles of bamboo flowing unattended along the river. This was a common method of transporting bamboo and lumber, as long as the destination is located downstream. The two-story houses along the canal are described in a romantic poem as "pillowing on the river." In reality, they are typical lower-middle-class residences. The usual arrangement is that the second floor was used as a dwelling and the first floor for a small business. Here, on the lower left, is a place selling tulip-flavored wine, and behind the house on the right is a "sauce and pickle" shop, where in fact all kinds of condiments and seasonings for everyday cooking were available.

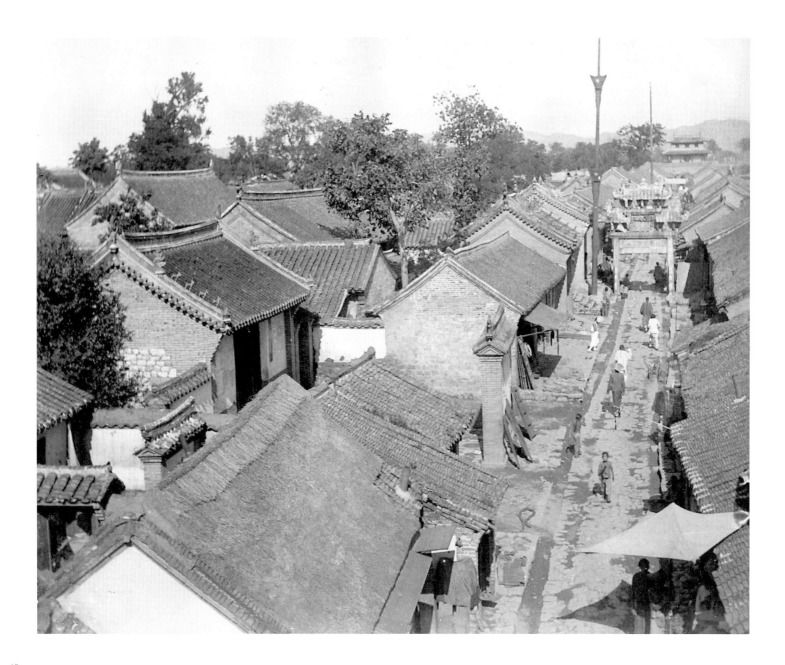

A FISHING VILLAGE on the island of Kongtong about five miles off the shore of Yantai, Shandong province. The island was the site of one of China's earliest coastal lighthouses, built in 1867 by order of Sir Robert Hart (1835–1911), then the Inspector-General of the Chinese Maritime Customs. The island's mild climate and beautiful beaches made it popular among the customs officers, who were all Westerners. Many of them wanted to get an assignment to work on the beacon. The village, however, remained Chinese in character. Note the macadam road, open sewers on both sides of the road, the removable plank doors of shops leaning on the walls, and, in particular, the archway in the middle of the road. Archways like this were often built with the sanction of the governor or even the emperor to honor a prominent member of the local community or a woman who was exemplary in following the Confucian moral code of chastity.

Overleaf MEMBERS OF A CHINESE YMCA visiting the famous Confucian temple in Jiading, a county seat about thirty miles northwest of Shanghai. The three identical pictures on the left show an angel descending from heaven to save a suffering soul. The vertical sign with eight Chinese characters reads "All Nations on Earth Will Become One Nation." While this was clearly a Christian message, it also dovetailed with the Confucian notion of an idealistic, united world known as the Great Harmony (*Datong*), which had been just recently reinterpreted by the reformist Kang Youwei (1858–1927). Note the U.S. flag crossed with the five-striped flag of the Republic of China, and behind them the YMCA flag (bearing Chinese characters). A field trip like this reveals a mixture of old and new and an attempt to blend Western influence with Chinese tradition at a time when the nation was in revolution.

A CHINESE CHRISTIAN copying the Bible. He is formally dressed and is burning three joss sticks on the table, a traditional ritual on solemn occasions to show one's reverence. The poster on the wall is a passage from the Bible that is translated, quite unusually, into not standard Chinese but the Shanghai local dialect: "For God so loved the world that He gave His only begotten Son, that whosoever believes in Him should not perish but have everlasting life. For God did not send His Son into the world to condemn the world, but that the world through Him might be saved. —John Chapter 3, Sections 16–17."

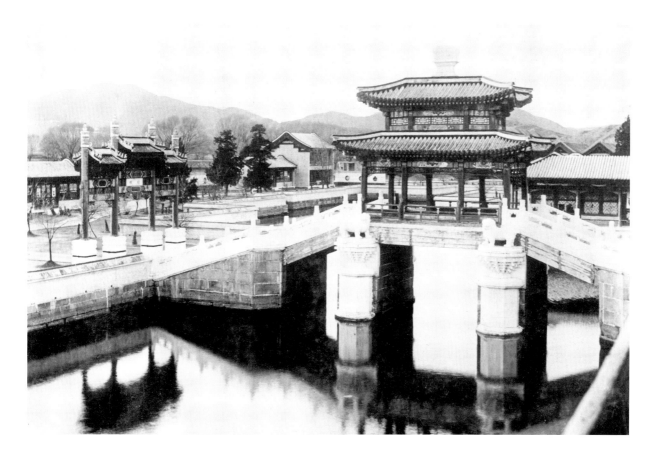

According to the peace agreement between the Republican government and the Qing court, the abdicated Qing emperor and his family were allowed to stay in the Forbidden City in Beijing, living much in the same fashion and lifestyle as royalty. Yet without huge budgets for maintenance, the palace and other imperial edifices began to decline. The emperor was finally driven out of the Forbidden City in 1924. This pavilion is at the center of an imperial garden called Diaoyutai, or "Fishing Altar," near the Forbidden City. Legend has it that this was a favorite fishing spot of the Jin emperor Zhangzong (reign 1190–1208), hence the name. After the Communist revolution, in commemoration of the tenth anniversary of the founding of the People's Republic, this garden was turned into a luxury hotel known as the Diaoyutai State Guesthouse, which hosted high ranking foreign visitors. Seventeen modern mansions were added to the garden but the traditional architecture was beautifully preserved. American presidents—from Richard Nixon to George W. Bush—were guests here on their state visits to China. In 2003, the Beijing six-party talks on the North Korean nuclear issue were held in this guesthouse.

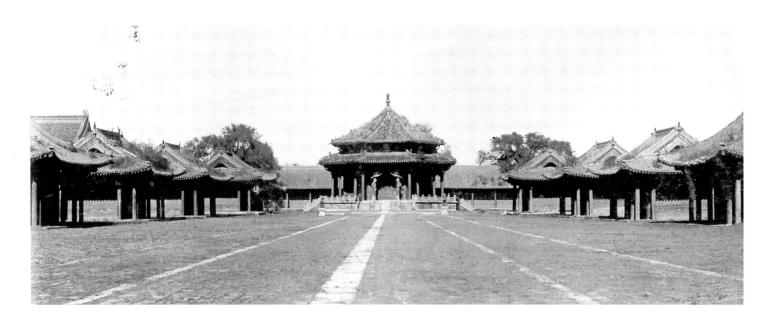

INSIDE THE MANCHU IMPERIAL PALACE in Shenyang, built in 1625. This was the hall where Manchu emperors held court rituals and discussed state affairs with ministers before the Manchus conquered China and established the capital in Beijing in 1644. A sacred place for the Manchus, the 67,000-square-meter royal residence had been carefully kept as "an auxiliary palace" of the Manchu court throughout the entire Qing dynasty. When the Qing was at the height of its prosperity, both Emperor Kangxi and Emperor Qianlong stayed in the palace on their tours to the Manchu homeland and held ceremonies there to revere the ancestors. The revolution left the palace to weeds and waste, as seen in this picture. The palace, however, has survived to this day and is listed as a United Nation's World Cultural Heritage Site.

Overleaf AFTER THE REVOLUTION, Chaotiangong, the palace in Nanjing where high-ranking government ministers and officials held ritual rehearsals for audiences with the emperor, was deserted. First built in 1384, and rebuilt in 1764 and 1865, this building has survived to the present day and is now the site of the Nanjing Municipal Museum.

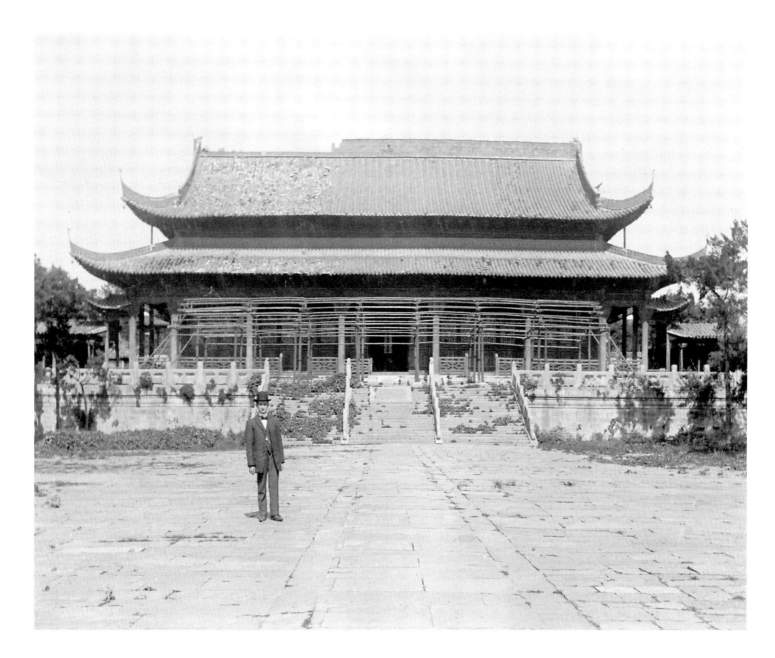

5

STAFFORD IN CHINA

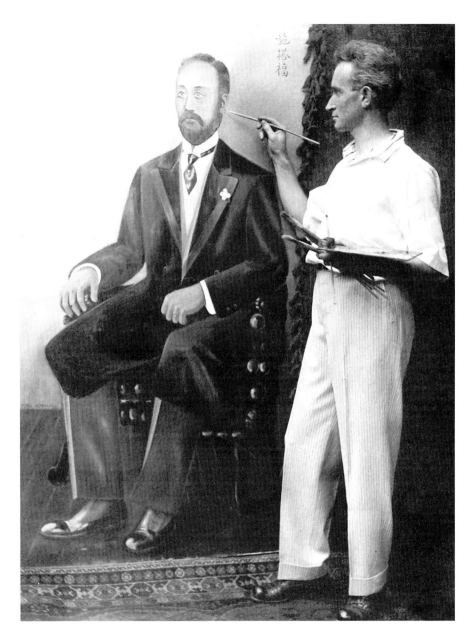

FRANCIS STAFFORD PAINTING a portrait of an unidentified man. The three characters on top of the painting are Stafford's Chinese name, Shi Tafu, a transliteration of "Stafford," meaning the Shi (a common Chinese family name) of "Towering Fortune." Chinese names are rendered surname first, followed by the given name.

Opposite STAFFORD SEEMS COMFORTABLE in both a Chinese silk long gown and a farmer's straw raincoat.

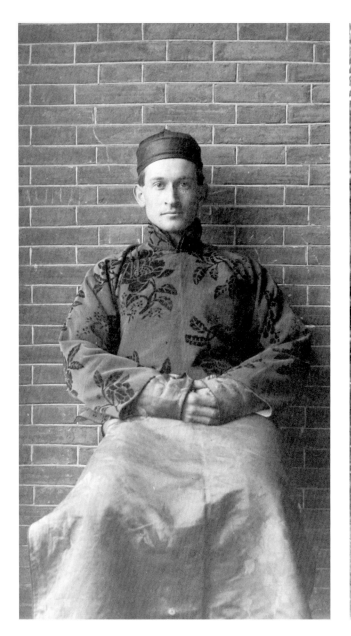
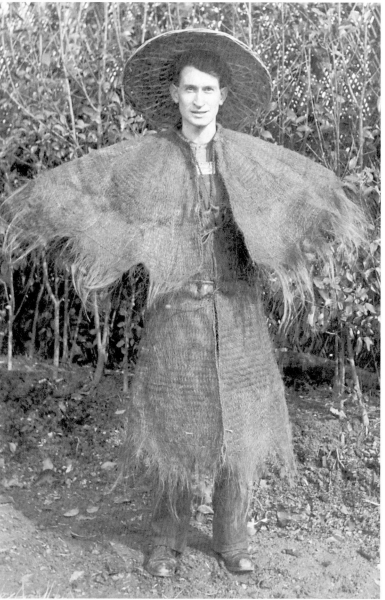

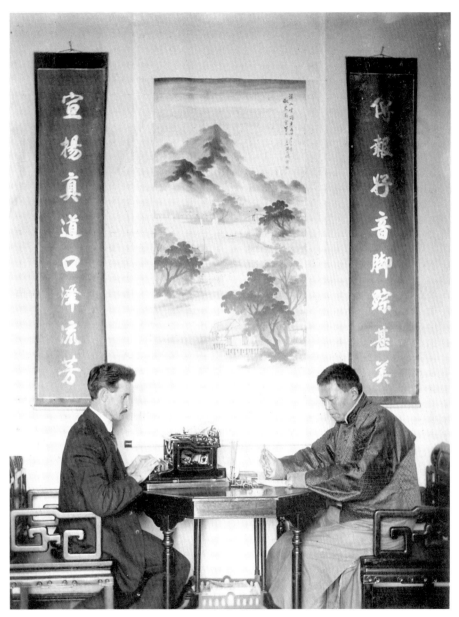

STAFFORD WITH A CHINESE GENTLEMAN.
This scene is apparently set up to illustrate some
interesting contrasts between the East and the West:
Western suit and tie versus Chinese long gown and
mandarin jacket, typewriter versus writing brush.
Even the decorations on the wall are somewhat con-
trasting: while the landscape painting expresses a
Daoist sense of harmony between man and nature,
the antithetical couplet on the scrolls praises the
Christian missionary work of bringing God's mes-
sage and disseminating His eternal truth.

Opposite STAFFORD, wearing morning dress
and top hat, with a Chinese pedestrian dressed in a
short jacket and puttees, the typical laborer's attire,
in Nanjing. Both men hold black umbrellas, sug-
gesting another scene meant to portray the contrast
between East and West. The background is the
remains of the front gate of the Ming palace, built
in 1366–67. This was the primary palace of the
first three emperors of the Ming dynasty until the
capital was moved to Beijing in 1421. For fifty-four
years, the emperors' edicts and decrees were sol-
emnly carried out through this gate, accompanied
by elaborate ceremonies.

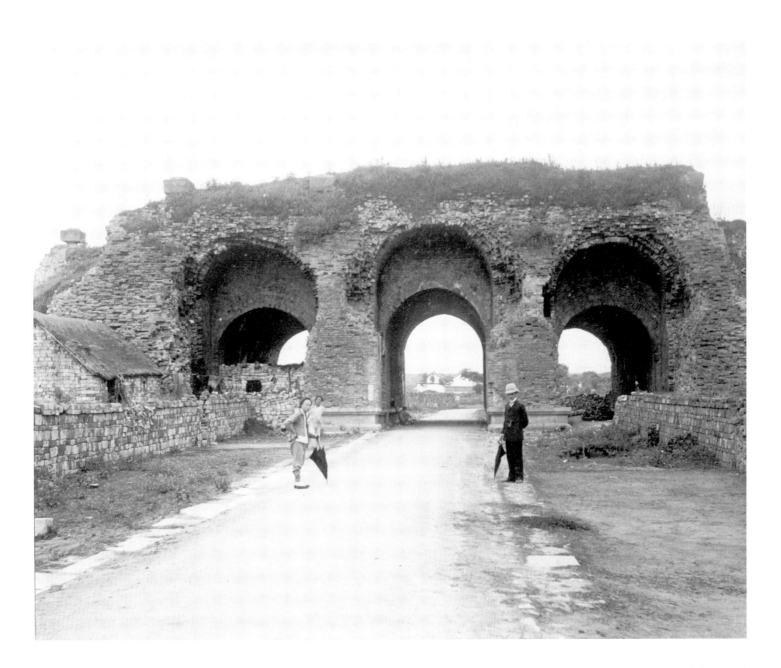

STAFFORD (*far right, lifting a hat*) with his colleagues at the Commercial Press, Shanghai. Stafford served as a senior photographer for the press from 1909 to 1913 and was credited with introducing color printing technology to China. Mary Gamewell wrote in 1916, anonymously referring to Francis Stafford, that "The Commercial Press was the first firm to introduce three-colour printing into China. . . . The newest addition to the plant is installation of three 'off-set' presses, the first in the Far East. An expert came out from America with them to set them up and instruct the Chinese workmen in their use."

STAFFORD (*front row, third from left*) with his colleagues in front of the Editing and Translation Institute of the Commercial Press. The institute was well known for compiling and publishing China's earliest modern textbooks, encyclopedias, anthologies, and other up-to-date books that were immensely popular and influential in the Republican era.

Those who served as heads of the institute included twentieth-century China's most prominent scholars, such as Cai Yuanpei (1868–1940), Zhang Yuanji (1867–1959), and Wang Yunwu (1888–1979). Some on the institute's staff became renowned intellectuals, such as the astronomer Zhu Kezhen (1890–1974) and the writer Mao Dun (1896–1981).

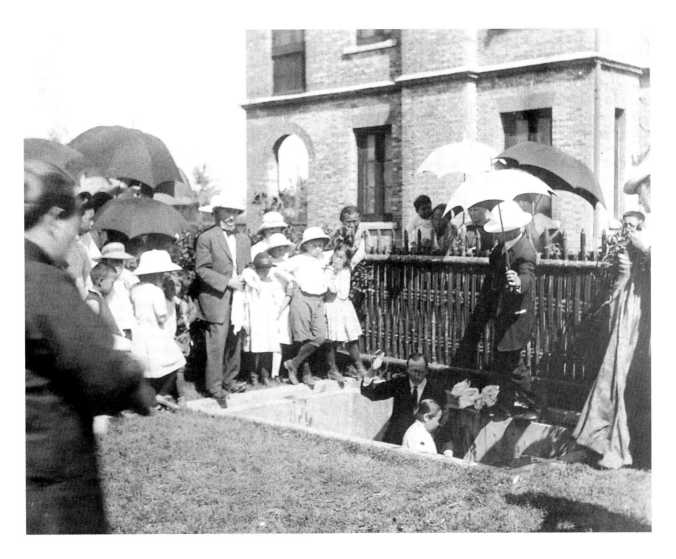

STAFFORD (*on the left, standing at the front of the crowd*) at a baptism. As a devout Christian, Stafford was actively involved in missionary work during his sojourn in China. During a time of revolution, bloodshed, and turmoil, religion had a particularly soothing effect in the lives of the common people. However, China was a difficult mission field. Although Republican China applied no restrictions against Christianity, by the 1949 Communist takeover there were fewer than 750,000 Protestants in a land of 550 million souls.

Timeline of Chinese History

Three Sovereigns & Five Emperors 三皇五帝 c. 2852 BCE–c. 2070 BCE

Xia Dynasty 夏 c. 2100 BCE–c. 1600 BCE

Shang Dynasty 商 c. 1600 BCE–1046 BCE

Zhou Dynasty 周 1046 BCE–256 BCE
 Western Zhou Dynasty 西周 1046 BCE–771 BCE
 Eastern Zhou Dynasty 東周 770 BCE–256 BCE
 Spring & Autumn Period 春秋 722 BCE–476 BCE
 Warring States Period 戰國 475 BCE–221 BCE

Qin Dynasty 秦 221 BCE–206 BCE

Han Dynasty 漢 206 BCE–220 CE
 Western Han Dynasty 西漢 206 BCE–9 CE
 Xin Dynasty 新 9–23
 Eastern Han Dynasty 東漢 25–220

Three Kingdoms 三國 220–265

Jin Dynasty 晉 265–420
 Western Jin Dynasty 西晉 265–317
 Eastern Jin Dynasty 東晉 317–420

Southern & Northern Dynasties 南北朝 420–589

Sui Dynasty 隋 581–618

Tang Dynasty 唐 618–907

Five Dynasties & Ten Kingdoms 五代十國 907–960

Song Dynasty 宋 960–1279
 Northern Song Dynasty 北宋 960–1127
 Southern Song Dynasty 南宋 1127–1279
 Liao Dynasty 遼 916–1125
 Jin Dynasty 金 1115–1234

Yuan Dynasty 元 1271–1368

Ming Dynasty 明 1368–1644

Qing Dynasty 清 1644–1912

Republic 1912–

People's Republic 1949–

A Chronology of the 1911 Revolution

THIS CHRONOLOGY PROVIDES READERS with a general timeline in which to situate the Stafford photographs. The "era of the 1911 Revolution" had no definitive time span. The chronology starts in 1905, the year Sun Yat-sen founded the Revolutionary Alliance in Tokyo, calling for a national revolution to end the monarchy. In the same year, the Qing New Policies Reform got into full swing. Republican China began with the rule of Yuan Shikai, who at the time was effectively the only politician capable of holding the country together and pursuing a program of nation-building. The death of Yuan in 1916 marked the beginning of a decade dominated by warlords, effectively ending the era of the 1911 Revolution.

1905

JULY 16 The Qing court appoints five high-ranking government ministers to form a mission to observe political systems and government institutions in Western countries and Japan.

AUGUST 20 The Revolutionary Alliance (Tongmenghui 同盟會) is founded in Tokyo. Sun Yat-sen (孫逸仙 1866–1925) is elected head of the organization with Huang Xing (黃興 1874–1916) as the executive director. The constitution of the Revolutionary Alliance calls for China to "expel the Manchu barbarians, restore the Chinese nation, establish a republic, and equalize land ownership."

AUGUST 31 Governor-general Zhang Zhidong (張之洞 1837–1909) and the New Army general Yuan Shikai (袁世凱 1859–1916) submit a co-signed memorial to the imperial court calling for an immediate end of the civil service examinations at all levels.

SEPTEMBER 2	Empress Dowager Cixi (慈禧 1835–1908) issues an edict officially abolishing the civil service examination system.
SEPTEMBER 24	The five-minister mission to the West is postponed because of the explosion of a bomb, set by the revolutionary Wu Yue (吳樾 1878–1905), at the Beijing Railway Station. The blast kills Wu and wounds two of the ministers.
OCTOBER 26	The Qing court regroups the five-minister mission.
NOVEMBER 26	The first issue of the flagship journal of the Revolutionary Alliance, *Min Bao* (民報 *The People's News*), is published in Tokyo. In the inaugural essay, Sun Yat-sen puts forward, for the first time to the public, his idea of Nationalism (*minzu* 民族 or "nationhood"), Democracy (*minquan* 民權 or "people's rights") and Socialism (*minsheng* 民生 or "people's livelihood")—later known as the Three Principles of the People (*Sanmin zhuyi* 三民主義).
DECEMBER 12	The five-minister mission departs from Beijing to learn from modern nations. In seven months the mission visits ten countries: Japan, Britain, France, Belgium, the United States, Germany, Austria, Denmark, Switzerland, and Norway.

1906

SEPTEMBER 1	Based on the reports of the five-minister mission, the Qing court issues an edict calling for the "Preparation of a Constitutional Government."
DECEMBER 16	The first military uprising against the Qing led by the Revolutionary Alliance breaks out in the border area between Jiangxi and Hunan provinces. It takes the government one month to suppress it.

1907

MAY 22	A military uprising led by the Revolutionary Alliance breaks out in Chaozhou, Guangdong province. It lasted only five days.
JULY 14	Qiu Jin (秋瑾 1875–1907), a revolutionary, teacher, and journal editor, is arrested in her hometown of Shaoxing, Zhejiang province, for organizing a military uprising against the Qing. She is publicly executed on the street the next day.

AUGUST 18 The Society for United Progress (Gongjinhui 共進會), a subgroup of the Revolutionary Alliance, is founded in Tokyo.

1908

MARCH 27 A military uprising organized by the Revolutionary Alliance breaks out in Qinzhou, a coastal city in Guangxi province. It takes the government one and a half months to suppress it.

APRIL 30 A military uprising led by the Revolutionary Alliance breaks out in Hekou, Yunnan province. It takes the government one month to suppress it.

JULY 22 The Qing court issues the *Regulations for Provincial Assemblies and Elections* (*Gesheng ziyiju zhangcheng ji yiyuan xuanju zhangcheng* 各省咨議局章程及議員選舉章程) as a major step toward establishing a constitutional government.

AUGUST 27 The Qing court issues the *Compendium of Constitutional Plans* (*Xianfa dagang* 憲法大綱), outlining a nine-year plan (1908–16) to establish a constitutional monarchy. The document, which has twenty-three clauses and is modeled after the 1889 Japanese constitution, is the first constitution in Chinese history.

NOVEMBER 14 Emperor Guangxu (光緒 reign 1875–1908) dies.

NOVEMBER 15 Empress Dowager Cixi dies.

DECEMBER 2 Emperor Xuantong (宣統; personal name, Puyi 溥儀, 1906–67) is enthroned.

DECEMBER Revolutionaries in Hubei province found the Society for Government by the Masses (*Qunzhi xueshe* 群治學社).

1909

JANUARY 9 The Qing court orders Yuan Shikai to retire to his hometown in Henan province.

JUNE Zhang Zhidong signs initial contracts with British, French, and German banking corporations for railway construction loans in Hunan and Hubei provinces.

OCTOBER Twenty-one provincial-level assemblies are established nationwide.

1910

APRIL 13 A rice revolt breaks out in Changsha, Hunan province. The next day, tens of thousands of angry and hungry city residents set fire to the governor's office.

SEPTEMBER 18 The Society for Government by the Masses is renamed the Martial Society (Zhenwu xueshe 振武學社).

OCTOBER 3 The Qing *Zizhengyuan* (資政院), a sort of proto-parliament, is established. It consists of a hundred members appointed by the Qing court and another hundred elected by provincial assemblies recently established nationwide.

NOVEMBER 4 The Qing court issues an edict announcing that the time for constitution preparation would be shortened, from the originally planned nine years to five.

1911

JANUARY 30 The Hubei Martial Society is renamed the Literature Society (Wenxueshe 文學社) and holds an inaugural meeting at the Yellow Crane Tower in Wuchang. By this time the society has more than three thousand members.

APRIL 27 An uprising led by Huang Xing starts on Yellow Flower Ridge (Huanghuagang 黃花崗) in suburban Guangzhou.

MAY 8 The Qing court forms a new cabinet headed by Prince Qing (Yikuang 奕劻, 1836–1918).

MAY 9 The Qing court announces its railway nationalization policy in which all railway lines across the country are to come under the ownership of the central government.

AUGUST 24 A general strike breaks out in Chengdu, Sichuan province, against the imperial railway policy.

SEPTEMBER 7 Sichuan Viceroy Zhao Erfeng (趙爾豐 1845–1911) orders the arrest of the Chengdu strike leaders and revolutionaries.

SEPTEMBER 8 Chengdu is placed under martial law.

SEPTEMBER 14 The Literature Society and the Society of United Progress have a joint meeting in Wuchang to set up a united leadership and to plan a military uprising in the city.

OCTOBER 9 As revolutionaries are making bombs in a house on the Alley of Benevolence in the Russian Concession in Hankou, Liu Tong (劉同), a brother of one of the bomb makers, Liu Gong (劉公), walks into the house while he is smoking. An ember from his cigarette accidentally detonates a bomb. Alerted, the Russian police raid the place, detain the Lius and the other people there, and transfer them to the Chinese authorities, together with rosters of the revolutionaries and other documents found in the house. The Qing government arrests over twenty suspects in the late afternoon and evening and executes three of them immediately. The leaders of the Literature Society and the Society of United Progress hold an emergency meeting in Wuchang and decide to launch the uprising at midnight.

OCTOBER 10 Two privates of the Eighth Engineer Regiment stationed in Wuchang, Jin Zhaolong (金兆龍) and Cheng Zhengying (程正瀛), shoot their lieutenant, Tao Qisheng (陶啓勝), at 8:30 p.m., firing the first shots of the revolution. By dawn the next day, the rebels have occupied the entire city of Wuchang.

OCTOBER 11 The revolutionaries establish the Hubei military government in Wuchang. A regiment commander, Li Yuanhong (黎元洪 1864–1928), is pressured into serving as governor of the new government.
The rebels occupy Hanyang.

OCTOBER 12 The rebels occupy Hankou. The three cities that constitute modern Wuhan—Wuchang, Hankou, and Hanyang—are under the control of the revolutionaries. The Qing court appoints the chief army commander Yinchang (蔭昌 1859–1928) and the chief naval commander Sa Zhenbing (薩鎮冰 1859–1952) to lead troops to Hubei to suppress the rebellion.

OCTOBER 14 The Qing court appoints Yuan Shikai as the viceroy of Huguang (Hunan and Hubei provinces) and puts him in charge of the military crackdown.

OCTOBER 17–18 The foreign diplomatic corps in Beijing and Hankou declare neutrality in the fight between the Qing government and the revolutionaries.

OCTOBER 27 The imperial army bombards Hankou. The rebels retreat from Liujiamiao (劉家廟 Temple of the Liu Family) to Dazhimen (大智門 / Gate of Great Wisdom) Railway Station.

OCTOBER 31 Imperial troops and the insurgents battle in the streets of Hankou. The city is set on fire and burns for four days.

NOVEMBER 1 The Qing court appoints Yuan Shikai the prime minister.
The Qing army retakes Hankou.

NOVEMBER 3 The revolutionaries occupy Shanghai.

NOVEMBER 4	The revolutionaries occupy Guizhou province.
NOVEMBER 5	The revolutionaries occupy Zhejiang province. The governor of Jiangsu declares "independence" from the Qing government. The Shanghai military government is established.
NOVEMBER 6	Guangxi province declares "independence" from the Qing government.
NOVEMBER 8	The New Army in Fuzhou, Fujian province, revolts and crosses over to the revolutionaries. Three days later the Fujian military government is established. Anhui province declares "independence" from the Qing government.
NOVEMBER 13	Yuan Shikai assumes the position of prime minister. Shandong province declares "independence" from the Qing government. The Thirty-third Regiment of the Seventeenth Division of the Qing army stationed in Lhasa, Tibet, revolts and sides with the republic.
NOVEMBER 27	The Qing army reoccupies Hanyang. Sichuan province declares "independence" from the Qing government.
DECEMBER 1	The Hubei military government signs a ceasefire agreement with Yuan Shikai.
DECEMBER 2	Revolutionary troops from Jiangsu and Zhejiang capture Nanjing.
DECEMBER 4	Representatives of the revolutionaries from various provinces choose Nanjing as the capital of the interim government of China.
DECEMBER 7	The Qing court grants full authority to Yuan Shikai to reach a settlement with the rebels. The next day, Yuan appoints Tang Shaoyi (唐紹儀 1862–1938) to head negotiations with the revolutionaries.
DECEMBER 18	The negotiations between Yuan and the revolutionaries, known as the "north-south peace talks," begin at the International Settlement in Shanghai. Tang Shaoyi and Wu Tingfang (Ng Choy, 伍廷芳 1842–1922) represent the imperial government (the "north") and the revolutionaries (the "south"), respectively.
DECEMBER 25	Sun Yat-sen, who was in Denver, Colorado, when the revolution broke out, arrives in Shanghai via Hong Kong from Europe, where he conferred with the British and French governments about the Europeans remaining neutral in the Chinese conflict.

| DECEMBER 26 | Sun presides over a meeting of the leaders of the Revolutionary Alliance at his residence in Shanghai's French Concession to discuss the establishment of a new government. |

1912

| JANUARY 1 | The Republic of China is founded. Sun Yat-sen assumes the position of provisional president of China. Sun sends a telegraph to Yuan Shikai acknowledging the weakness of his military power base and informing Yuan that he will step down from the presidency in favor of Yuan if he accepts the offer. |

| JANUARY 2 | China adopts the Gregorian calendar. |

| JANUARY 3 | The official inauguration of the provisional government of the Republic of China is held in Nanjing. |

| JANUARY 20 | The Nanjing provisional government issues stipulations for the dethronement of the Qing emperor. |

| JANUARY 26 | Forty-four senior commanders of the Beiyang army (the centerpiece of the New Army) send a telegram to the Qing cabinet urging the formation of a republic in China. |

| FEBRUARY 12 | The Qing emperor, Puyi, abdicates. |

| FEBRUARY 13 | Sun Yat-sen resigns and recommends Yuan to be his successor as the provisional president of China. |

| MARCH 10 | Yuan assumes the position of the provisional president of the Republic of China in Beijing. |

| AUGUST 25 | The Revolutionary Alliance is reorganized into the Nationalist Party (Guomindang 國民黨) in Beijing. Sun Yat-sen is elected president of the party, with Huang Xing and Song Jiaoren (宋教仁 1882–1913) as the senior directors. |

1913

| MARCH 20 | Song Jiaoren, a major critic of Yuan's government and a zealous advocate of modern party politics, is shot in the Shanghai Railway Station. The assassination is widely believed to have been ordered by Yuan. |

| APRIL 8 | The first popularly elected Chinese parliament convenes. The parliament consists of the House of Senators, with 247 seats (divided among provinces and districts), and the House of Representatives, with 596 seats (one seat for every 800,000 people). |

JULY 17	Jiangxi province declares independence from Yuan's government, a move that initiates the so-called the Second Revolution, a military campaign led by a few southern provincial leaders against Yuan.
JULY 15–SEPTEMBER 12	Six provinces and the city of Shanghai declare independence from Yuan's government: Jiangsu (July 15), Anhui (July 17), Shanghai (July 18), Guangdong (July 18), Fujian (July 19), Zhejiang (declares "neutrality," July 20), Hunan (July 25). Because the coalition of the southern jurisdictions is fragile and lacks a clear leadership, Yuan Shikai manages to suppress them all in just two months.
OCTOBER 10	Yuan Shikai assumes the position of president of the Republic of China.
NOVEMBER 13	The parliament is suspended for want of a quorum.

1914

JANUARY 10	Yuan Shikai dissolves parliament.
MAY 1	The Provisional Constitution of the Republic of China is officially promulgated.
JULY 8	Sun Yat-sen founds the Chinese Revolutionary Party (Zhonghua gemingdang 中華革命黨) in Tokyo, proclaiming the goal of the party to be "wiping out dictatorship and establishing a full republic."
SEPTEMBER 28	Yuan Shikai leads high-ranking officials to the Temple of Heaven in Beijing to worship Confucius.

1915

JANUARY 18	Japan presents Yuan Shikai with the Twenty-one Demands, a set of clauses aimed at securing Japanese hegemony over China.
MAY 9	With the Japanese demand for control over Chinese policy dropped, Yuan officially accepts the Twenty-one Demands (now thirteen clauses).
DECEMBER 12	Yuan Shikai announces the restoration of the monarchy.
DECEMBER 25	An anti-Yuan military campaign, led by generals Cai E (蔡鍔 1882–1916) and Tang Jiyao (唐繼堯 1883–1927), starts in Yunnan province. The province declares independence from Yuan's government.
DECEMBER 31	Yuan announces that the year 1916 would be the "first year of the Hongxian reign."

1916

JANUARY 6	An anti-Yuan uprising led by the Chinese Revolutionary Party breaks out in Huizhou, Guangdong province.
JANUARY 27	Guizhou province declares independence from Yuan's government.
FEBRUARY 23	Yuan Shikai announces a postponement of the monarchy.
MARCH 15	Guangxi province declares independence from Yuan's government.
MARCH 22	Yuan Shikai abdicates as emperor and reassumes the title of president, ending the so-called Hundred Days' Restoration.
APRIL 6	Guangdong province declares independence from Yuan's government.
APRIL 12	Zhejiang province declares independence from Yuan's government.
MAY 9	Shaanxi province declares independence from Yuan's government.
MAY 22	Sichuan province declares independence from Yuan's government.
MAY 25	Forces of the Chinese Revolutionary Party occupy part of Fujian and declare the province independent of Yuan's government.
MAY 29	Hunan province declares independence from Yuan's government.
JUNE 6	Yuan dies. Li Yuanhong succeeds to the presidency. China enters a decade of warlord rule.

Glossary

Anhui 安徽
Anyang 安陽
Aolüe (Tower) 奧略

Baodaimen 寶帶門
Beijing 北京
Beiyang 北洋

Cai E 蔡鍔
Cai Yuanpei 蔡元培
Chaotiangong 朝天宮
Chaozhou 潮州
Chen Qimei 陳其美
Cheng Zhengying 程正瀛
Chenghuangye 城隍爺
Chiang Kai-shek 蔣介石
Chun (Prince) 醇
Cixi 慈禧

Daotai 道臺
Datong 大同
Dazhimen 大智門
Diaoyutai 釣魚臺
Du Fu 杜甫
Duanwu 端午
Duanyang 端陽

Feng Guozhang 馮國璋
Feng Rukui 馮汝騤
Fengdu (Tower) 風度

*Gesheng ziyiju zhangcheng ji yiyuan
 xuanju zhangcheng* 各省咨議局章程
 及議員選舉章程
Gongjinhui 共進會
Guanchang xianxingji 官場現形記
Guangdong 廣東

Guangxi 廣西
Guangxu 光緒
Guangzhou 廣州
Guomindang 國民黨

Han 漢
Han-Ye-Ping (Company) 漢冶萍
Hankou 漢口
Hanyang 漢陽
Harbin 哈爾濱
Hebei 河北
Hekou 河口
Henan 河南
Hu Hanmin 胡漢民
Huang Xing 黃興
Huanghelou 黃鶴樓
Huanghuagang 黃花崗
Huangpu (River) 黃浦

Hubei 湖北
Huizhou 惠州
Hunan 湖南

jia yangguizi 假洋鬼子
Jiading 嘉定
Jiangnan 江南
Jiangsu 江蘇
Jiangxi 江西
Jin 金
Jin Zhaolong 金兆龍
Jingtu An 靜土庵
jinshi 進士

Kang Youwei 康有爲
Kangxi 康熙
Kongtong 崆峒
Kunshan 昆山

Li Baojia 李寶嘉
Li Hongzhang 李鴻章
Li Yuanhong 黎元洪
Liu Fuji 劉復基
Liu Gong 劉公
Liu Tong 劉同
Liu Yanyi 劉燕翼
Liujiamiao 劉家廟
Longhua 龍華
Lu Xun 魯迅

Ma Sijin 馬四金
mai er yu nü 賣兒鬻女
Mao Dun 茅盾
Mao Zedong 毛澤東
Meng Jiangnü 孟姜女
Miluo (River) 汨羅
Ming (dynasty) 明
Mingyuanlou 明遠樓
minquan 民權
minsheng 民生
minzu 民族
mu 畝

nan xiang nü bu xiang 男降女不降
Nanjing 南京
Natong 那桐

Pan Dawei 潘達微
Peng Chufan 彭楚藩
Pukou 浦口
Puyi 溥儀

Qianlong 乾隆
qianzhuang 錢莊
Qing (dynasty) 清
Qing (Prince) 慶
Qinhuai (River) 秦淮
Qinzhou 欽州
Qiu Jin 秋瑾

Qu Yuan 屈原
Qunzhi xueshe 群治學社
quzhu Dalu, huifu Zhonghua 驅逐韃虜, 恢复中華

Sa Zhenbing 薩鎮冰
Sanmin zhuyi 三民主義
Sanyu 三育
Shandong 山東
Shang (dynasty) 商
Shanhaiguan 山海關
Shekou 灄口
Shenyang 瀋陽
Sheshan 蛇山
Shi Tafu 施塔福
Shijing 詩經
Sichuan 四川
Song Jiaoren 宋教仁
Sun Baoqi 孫寶琦
Sun Wen 孫文
Sun Yat-sen 孫逸仙
Suzhou 蘇州

Tang Hualong 湯化龍
Tang Jiyao 唐繼堯
Tang Shaoyi 唐紹儀
Tanggu (Road) 塘沽
Tao Qisheng 陶啓勝
ti 體

ti-yong 體用
Tian Baorong 田寶榮
Tongmenghui 同盟會

Wang Yunwu 王雲五
Wansheng 萬盛
Weifeng (Gate) 威鳳
wengzhong 翁仲
Wenxueshe 文學社
Wu Tingfang 伍廷芳
Wu Yue 吳樾
Wuchang 武昌
Wushenmiao 巫神廟
Wusong 吳淞

Xi'an 西安
Xia Ruifang 夏瑞芳
Xianfa dagang 憲法大綱
Xiang (River) 襄
Xiaodongmen 小東門
Xin Qingnian 新青年
Xing Han Mie Man 興漢滅滿
Xinjiang 新疆
Xinzheng 新政
Xu Shaozhen 徐紹楨
Xuantong 宣統

yamen 衙門
Yan Hui 顏回

Yang Hongsheng 楊宏勝
Yangzi (River) 揚子
Yantai 煙臺
Yao 藥
Yikuang 奕劻
Yinchang 蔭昌
Yingshang 潁上
yong 用
Yuan Shikai 袁世凱

Zaifeng 載灃
Zhabei 閘北
Zhang Biao 張彪
Zhang Jian 張謇
Zhang Renjun 張人駿
Zhang Yuanji 張元濟
Zhang Zhidong 張之洞
Zhang Zhujun 張竹君
Zhangde 彰德
Zhangzong 章宗
Zhao Erfeng 趙爾豐
Zhenjiang 鎮江
Zhenwu xueshe 振武學社
Zhili 直隸
Zhong Kui 鍾馗
Zhonghua gemingdang 中華革命黨
Zhongyuan (festival) 中元
Zhu Kezhen 竺可楨
Zhu Yuanzhang 朱元璋

Zilu 子路
Zizhengyuan 資政院
zongzi 糉子

Further Readings

Bergère, Marie-Claire. *Sun Yat-sen*. Translated from the French by Janet Lloyd. Stanford, Calif.: Stanford University Press, 2000.

Bernal, Martin. *Chinese Socialism to 1907*. Ithaca, NY: Cornell University Press, 1976.

Boorman, Howard L., ed. *Biographic Dictionary of Republican China*. 5 vols. New York: Columbia University Press, 1967–79.

Cameron, Meribeth E. *The Reform Movement in China, 1898–1912*. Stanford, Calif.: Stanford University Press, 1931.

Cantlie, James, and Charles Sheridan Jones. *Sun Yat Sen and the Awakening of China*. New York: Fleming H. Revell, 1912. (Kessinger Publishing reprint, 2007.)

Ch'ên, Jerome. *Yuan Shih-k'ai, 1859–1916*. Stanford, Calif.: Stanford University Press, 1961. (Second edition 1972.)

Dingle, Edwin J. *China's Revolution, 1911 to 1912: A Historical and Political Record of the Civil War*. Shanghai: Commercial Press, 1912. (Haskell House reprint edition, 1972.)

Esherick, Joseph. *Reform and Revolution in China: The 1911 Revolution in Hunan and Hubei*. Berkeley: University of California Press, 1976.

——. "1911: A Review." *Modern China*, vol. 2, no. 2 (April 1976): 162–63.

Eto Shinkichi, and Harold Schiffrin, eds. *The 1911 Revolution in China: Interpretive Essays*. Tokyo: University of Tokyo Press, 1984.

——, eds. *China's Republican Revolution*. Tokyo: University of Tokyo Press, 1994.

Fairbank, John K., and Kwang-Ching Liu, eds. *The Cambridge History of China: Volume 11, Late Ch'ing, 1800–1911, Part 2*. Cambridge, UK: Cambridge University Press, 1980.

Fairbank, John K., and Denis Twitchett, eds. *The Cambridge History of China: Volume 12, Republican China, 1912–1949, Part 1*. Cambridge, UK: Cambridge University Press, 1983.

Fincher, John. *Chinese Democracy: The Self-Government Movement in Local, Provincial, and National Politics, 1905–1914*. New York: St. Martin Press, 1981.

Friedman, Edward. *Backward Toward Revolution: The Chinese Revolutionary Party*. Berkeley: University of California Press, 1974.

Fung, Edmund S. K. *The Military Dimension of the Chinese Revolution*. Vancouver: University of British Columbia Press, 1980.

Gamewell, Mary Ninde. *The Gateway to China: Pictures of Shanghai*. New York: Fleming H. Revell, 1916.

Gasster, Michael. *Chinese Intellectuals and the Revolution of 1911:*

The Birth of Modern Chinese Radicalism. Seattle: University of Washington Press, 1969.

Harrell, Paula. *Sowing the Seeds of Change: Chinese Students and Japanese Teachers, 1898–1912.* Stanford, Calif.: Stanford University Press, 1992.

Houn, Franklin W. *Central Government of China, 1912–1928: An Institutional Study.* Madison: University of Wisconsin Press, 1959.

Hsüeh, Chün-tu. *Huang Hsing and the Chinese Revolution.* Stanford, Calif.: Stanford University Press, 1961.

Hu Sheng, Liu Danian, and others. *The 1911 Revolution: A Retrospective after 70 Years.* Beijing: New World Press, 1983.

Karl, Rebecca E., and Peter Zarrow, eds. *Rethinking the 1898 Reform Period: Political and Cultural Change in Late Qing China.* Cambridge, Mass.: Harvard Council on East Asian Studies, 2002.

Lee, En-han. *China's Quest for Railway Autonomy, 1904–1911: A Study of the Chinese Railway-Rights Recovery Movement.* Singapore: Singapore University Press, 1977.

Levenson, Joseph. *Confucian China and Its Modern Fate.* 3 vols. Berkeley: University of California Press, 1958–1964, reissued as *Modern China and Its Confucian Past.*

Li Chien-nung. *The Political History of China, 1840–1928.* Translated from the Chinese by Teng Ssu-yü and Jeremy Ingalls. Stanford, Calif.: Stanford University Press, 1967 (c. 1956).

Liew, K. S. *Struggle for Democracy: Sung Chiao-jen and the 1911 Chinese Revolution.* Berkeley: University of California Press, 1971.

Ma, L. Eve Armentrout. *Revolutionaries, Monarchists and Chinatowns: Chinese Politics in the Americas and the 1911 Revolution.* Honolulu: University of Hawai'i Press, 1990.

MacKinnon, Stephen R. *Power and Politics in Late Imperial China: Yuan Shi-kai in Beijing and Tianjin, 1901–1908.* Berkeley: University of California Press, 1980.

McCord, Edward A. *The Power of the Gun: The Emergence of Modern Chinese Warlordism.* Berkeley: University of California Press, 1993.

McCormick, Frederick. *The Flowery Republic.* New York: D. Appleton, 1913.

Onogawa Hidemi, and Shimada Kenji. *Shingai kakumei no kenkyū* (Studies in the 1911 Revolution). Tokyo: Chikuma shobō, 1978.

Powell, Ralph. *The Rise of Chinese Military Power, 1895–1912.* Princeton, N.J.: Princeton University Press, 1955.

Prazniak, Roxann. "Community and Protest in Rural China: Tax Resistance and County-Village Politics on the Eve of the 1911 Revolution." PhD dissertation, University of California, Davis, 1981.

Price, Don C. *Russia and the Roots of the Chinese Revolution, 1896–1911.* Cambridge, Mass.: Harvard University Press, 1974.

Rankin, Mary Backus. *Early Chinese Revolutionaries: Radical Intellectuals in Shanghai and Chekiang, 1902–1911.* Cambridge, Mass.: Harvard University Press, 1971.

Reed, James. *The Missionary Mind and American East Asia Policy, 1911–1915.* Cambridge, Mass.: Harvard University Press, 1983.

Reynolds, Douglas R. *China, 1898–1912: The Xinzheng Revolution and Japan.* Cambridge, Mass.: Harvard Council on East Asian Studies, 1993.

Rhoads, Edward J. M. *China's Republican Revolution: The Case of Kwangtung, 1895–1913.* Cambridge, Mass.: Harvard University Press, 1975.

——. *Manchus and Han: Ethnic Relations and Political Power in Late Qing and Early Republican China, 1861–1928.* Seattle: University of Washington Press, 2000.

Roberts, Donald. *Donald Roberts Collection of the 1911 Chinese Revolution.* The collection contains block prints of news sheets on the 1911 Revolution collected and donated by Donald Roberts, an Episcopalian minister who taught history at St. John's University in Shanghai from 1915 to 1950. Princeton University Library.

Rudinger, St. Piero. *The Second Revolution in China, 1913: My Adven-*

tures of the Fighting around Shanghai, the Arsenal, Woosung Forts. Shanghai: Shanghai Mercury, 1914.

Saari, Jon. *Legacies of Childhood: Growing up Chinese in a Time of Crisis, 1890–1920.* Cambridge, Mass.: Council on East Asian Studies, Harvard University, 1990.

Schiffrin, Harold Z. *Sun Yat-sen and the Origins of the Chinese Revolution.* Berkeley: University of California Press, 1968.

——. *Sun Yat-sen, Reluctant Revolutionary.* Boston: Little, Brown, 1980.

Schoppa, R. Keith. *Chinese Elites and Political Change.* Cambridge, Mass.: Harvard University Press, 1982.

Sharman, Lyon. *Sun Yat-sen: His Life and Its Meaning.* Stanford, Calif.: Stanford University Press, 1968.

Spence, Jonathan D. *The Search for Modern China.* Second edition. New York: W. W. Norton, 1999.

Thompson, Roger R. *China's Local Councils in the Age of Constitutional Reform, 1898–1911.* Cambridge, Mass.: Harvard Council on East Asian Studies, 1994.

Wilbur, C. Martin. *Sun Yat-sen: Frustrated Patriot.* New York: Columbia University Press, 1976.

Wong, Young-Tsu. "Popular Unrest and the 1911 Revolution in Jiangsu." *Modern China*, vol. 3, no. 3 (July 1977): 321–44.

Wright, Mary Clabaugh, ed. *China in Revolution: The First Phase, 1900–1913.* New Haven, Conn.: Yale University Press, 1968.

Young, Ernest. *The Presidency of Yuan Shih-k'ai: Liberalism and Dictatorship in Early Republic China.* Ann Arbor: University of Michigan Press, 1977.

Yu, George T. *Party Politics in Republican China: The Kuomintang, 1912–1924.* Berkeley: University of California Press, 1966.

Zou, Rong. *The Revolutionary Army: A Chinese Nationalist Tract of 1903.* Translated from the Chinese by John Lust. The Hague: Mouton, 1968.

Index

queue, 138; in front of a bombed-out house, 99; with Qing imperial troops, 86; sitting on city wall of Wuchang, 100; visiting Ming imperial tombs, 131

Sun Baoqi, 118

Sun Wen. *See* Sun Yat-sen

Sun Yat-sen, 20, 122–23, 192; announces founding of ROC, 114; as provisional president of China, 124, 193; elected president of Nationalist Party, 192; founds Chinese Revolutionary Party, 194; founds Revolutionary Alliance, 187; with Huang Xing, 19, 80; on national flag, 109; at Palace Hotel, 38; revolutionary ideas of, 5, 17; and Three Principles of the People, 188; and Wu Tingfang, 118

Suzhou, 167

Suzhou Creek, 163

T

Taiping Rebellion, 102

Tang Hualong, 49

Tang Jiyao, 193

Tang Shaoyi, 118, 120, 191, 192

Tanggu Road, 151

Tao Qisheng, 190

teahouse, 159

Temple of Heaven, 127–28, 131, 193

Three Principles of the People, 5, 188

Tian Baorong, 105

Tongmenghui, 17, 187. *See also* Revolutionary Alliance

U

United League, 17. *See also* Revolutionary Alliance

W

Wang Yunwu, 182

Weifeng Gate, 20–21

Wengzhong, 131–32

Wenxueshe, 189

women: with children, 30; as factory workers, 145–47, 148, 159; and medical school in Shanghai, 84; as prisoner, 19

Wu Tingfang, 84, 118, 120, 192

Wu Yue, 187

Wuchang, 7; and Aolüe Tower, 42; as part of Wuhan, 9

Wuchang uprising, 3–5, 8, 15–17, 45–100

Wuhan: combat scene, 87–90; imperial artillery troops in battle, 74; Red Cross arrived, 80; revolutionary army recruitment, 56; as a triple city, 9; Yellow Crane Tower, 16; Zhang Zhidong, 42

Wushenmiao, 6

Wusong, 111

X

Xi'an, 3

Xia Ruifang, 142–43, 145

Xianfa dagang, 189

Xiang River, 56

Xiaodongmen, 160

Xin Qingnian, 126

Xing Han Mie Man, slogan, 100

Xinjiang, 4

Xinzheng. *See* New Policies

Xu Shaozhen, 112

Xuantong Emperor, 189. *See also* Puyi

Y

Yamen: Hubei, 48; Kunshan, 117; Shanghai, 103

Yan Hui, 149

Yang Hongsheng, 45

Yangzi River, 9, 30, 45, 53, 54, 56, 74–76, 82, 105, 106, 121

Yantai, 30, 169

Yellow Crane Tower, 16, 189

Yellow Flower Ridge uprising, 19, 189

Yikuang. *See* Prince Qing

Yinchang, 59, 190

Yuan Shikai: forced to retire, 73, 189; as New Army leader, 17, 123–24, 187; as Qing official, 8, 15; reform-minded, 4, 187; receiving foreign envoys, 125; and restoration of monarchy, 194–95; worshipping Confucius, 126–27; during the revolution, 189–93

Z

Zaifeng, 20

Zhabei, 109

Zhang Jian, 115

Zhang Renjun, 20

Zhang Yuanji, 182